God through the Looking Glass

Other Books by These Authors

William David Spencer and/or Aída Besançon Spencer
The Global God: Multicultural Evangelical Views of God
The Goddess Revival
Chanting Down Babylon: The Rastafari Reader
Dread Jesus
Joy through the Night: Biblical Resources for Suffering People
The Prayer Life of Jesus: Shout of Agony, Revelation of Love
Mysterium and Mystery: The Clerical Crime Novel
Beyond the Curse: Women Called to Ministry
2 Corinthians (Bible Study Commentary Series)
Paul's Literary Style

Bruce Whitney Herman
Golgotha: The Passion in Word and Image

Gwenfair M. Walters, editor
Towards Healthy Preaching

Celeste Snowber Schroeder
Embodied Prayer: Harmonizing Body and Soul
In the Womb of God: Creative Nurturing for the Soul

Richard Peace
Spiritual Disciplines Series:
1. Spiritual Journaling: Recording Your Journey toward God
2. Spiritual Storytelling: Discovering and Sharing Your Spiritual Biography
3. Contemplative Bible Reading: Experiencing God through Scripture
4. Meditative Prayer: Entering God's Presence

GOD through the LOOKING GLASS

Glimpses from the ARTS

William David Spencer
Aída Besançon Spencer

and

Bruce Whitney Herman
Norman M. Jones
Richard Peace
Celeste Snowber Schroeder
Jasmin Sung
Gwenfair M. Walters

A BridgePoint Book

paternoster

Baker Books
A Division of Baker Book House Co
Grand Rapids, Michigan 49516

Published by BridgePoint Books
an imprint of Baker Books
a division of Baker Book House Company

and

P.O. Box 6287, Grand Rapids, MI 49516-6287

Paternoster Press
P.O. Box 300
Carlisle, Cumbria CA3 0QS
United Kingdom

Printed in the United States of America

Library of Congress Cataloging-in-Publication Data

Spencer, William David, 1947–
 God through the looking glass: glimpses from the arts / William David Spencer, Aída
Besançon Spencer, and Bruce Whitney Herman . . . [et al.].
 p. cm.
 "A BridgePoint book."
 Includes bibliographical references (p.).
 ISBN 0-8010-5769-8 (paper)
 1. Christianity and the arts. I. Spencer, Aída Besançon.
II. Title.
BR115.A8S64 1998
261.5'7—dc21 98-21483

British Library Cataloguing-in-Publication Data
A catalogue record for this book is available from the British Library.
ISBN 1-900507-85-4

God through the Looking Glass

Dance,
for God is Love!

Sing to the Lord a new song,
Raise your voice with tam-
 bourine and lyre,
for the Lord has put down our
 enemies,
and our children study peace in
 the land—selah.

God builds of us a temple uni-
 versal,
All that God sustains praising.
Build in honor temple, church,
 cathedral,
Stone and mortar paean raising.
Weave great tapestries remem-
 bering,
All the works those hands are
 rendering,
Beating out ornamentation,
Symbolizing all creation.

If the sun is a mirror of divinity,
Light blazes forth in excelsis Deo
 its gloria.
If the sea is God's message of
 serenity,
It echoes from its fathoms
 reflectent pax profunda.
Let us paint what we have seen
 and heard,
to rumble off the canvas in a
 visual word.
We have heard God shout in the
 thunder,
whisper in the angelus across
 these twilight fields,

and so we paint the moment in
 its wonder,
harvesting its meaning as an
 orchard yields.
How can we not revel in our
 handiwork,
being ourselves the strokes of
 mighty brushwork?
We reflect what moments do not
 cease—
Sovereignty of glory, God of
 peace.

How does the poem speak?
How does the God say?
Weasel, weasel, weasel—
look beyond the hedge.
Rise up, mime! Look to it, actor!
Celebrate the universal
 Dramatist,
whose word is life and whose art
 is us.

Find me a form that I can use.
Sing me a song that I can keep.
Show me something true—
 eternal—
in the kaleidoscopic modality of
 my ages
give a means that transcends to
 Topic
and celebrates true power, yes,
 of Love.

Called outside, inside by lustrous
 beauty,
I wander through exquisite
 quintessence.
I am muted. Speak, Word.

 —William David Spencer

Contents

Preface

One out of every three children in school today eventually will be employed in some arts-related field. This is a shocking statistic recently released by the United States government's Education Commission on the States. The arts, now a 314 billion dollar industry, in both its nonprofit and for profit aspects, currently provides the same percentage of jobs in the United States as does the construction industry![1] As computer literacy changes our world, the face of the arts in commerce, communications, cultural development, and all the aspects of international interaction will intensively increase. For the culmination of the Third Hemispheric Summit of the Americas in 1994, which brought together the leaders of thirty-four democracies representing 736 million people, the host, United States President Bill Clinton, organized a huge concert featuring a top performer from each participating nation. As he explained, "We are gathered tonight as a family of nations, each with cultures that are unique and yet familiar to all of us. The arts help us to appreciate and to gain a deeper understanding of our hemispheric heritages as well as the ideas, the voices, the images that we share as members of the larger American family." According to Clinton, "Our nations grow ever closer as we delve into the souls of our culture through our artists."[2]

The arts help us to know more about ourselves. So we dance, sing, build, sculpt, paint, act, make films, videos, and computer graphics, and explore avenues of expression into the virtual, holographic beyond. As humans, we create. But a prior claim exists on our creativity. We ourselves are created beings, and each time we explore our creative side, we reflect something about the God who created us, about our fall from God's grace, sin and salvation, restoration, and God's universal intention for us. In our own beings we reflect the great Artist who makes and remakes us and who creates and re-creates the world around us.

In its right use, art can tell us so much about God, ourselves, and God's working with us and the unique worlds around us. That is the point of this book—to see God's reflection in our handiwork.

9

 Many fellow craftspeople whom God has shaped have helped us in turn shape this book. We thank all of them who have critiqued our art, our reflections and writings on art and theology, and shared with us their work. In securing printed references, the interlibrary loan department at Goddard Library of Gordon-Conwell Theological Seminary helped immensely. All of the contributors thank our students at our various institutions, who over the years have helped us shape these ideas in our courses. Heidi Hudson and Janae Valci helped us shape this manuscript in type. The faculty development fund at Gordon-Conwell Theological Seminary helped make the completion of the manuscript possible. And Bob Hosack and Brian Phipps, editors, were gracious and encouraging.

Glimpsing God in Art's Mirror
Introduction

William David Spencer

"Now we look at God through a poorly made murky mirror," writes Paul in 1 Corinthians 13:12, "but in heaven we will see God and ourselves as clearly as God sees us, and as completely" (my translation).

We have been looking at ourselves through murky mirrors since Adam and Eve lost sight of their priorities in Eden's garden. Science, anthropology, philosophy, and the arts are all mirrors in which we try to glimpse reflections of the face of heaven. The arts, particularly, are like a spyglass used to scan the terrain of the Holy Spirit, searching deeply into human creativity for the image of the great Creator in our subcreating.

In observatories across the globe, great telescopes have small mirrors that capture what the telescopes collect, organize, and magnify, thereby transmitting what the unaided eye cannot see. In the mirror of the arts, we see what our soul collects and magnifies about God.

When Alice tumbled through her looking glass, she fell into a fantastic world built on new premises and filled with strange new adventures. When we forage through the arts, we come upon new terrain, new worlds of cre-

ativity that open us up to new adventures of the Spirit. In these worlds God is reflected.

All of us, Genesis 1:26–27 tells us, have been created in the image of God. Therefore, anyone can reflect some truth about God. Theologians call that the doctrine of common grace. Anyone who contemplates life can observe truths about the nature of life, of God, of God's actions, and of the fight between good and evil that sometimes even some theologians, bound by the limitations theological systems impose, may preclude or obscure. If from nothing else, we can benefit from an artwork's poignant expressions of longing for God and for innocence, of the sighing for Eden, or of confusion about God's nature.

I often think of works of art, particularly books, as pools in a sea. The ocean along the shoreline of the Dominican Republic is like a beautiful quilt of blues and greens: deep azures, emeralds, powder and navy blues, forest and army greens. The creative expressions of those who have strained to see God compose a vast multihued sea. Some vision is crystalline and light; in it we perceive God sweeping by and we glimpse God's beauty. Another is deep and murky, a pit in which God's image is all but obscured. In still another a hideous monster leers out, lying in God's name. For me, Scripture serves as the stepping stones upon which to wade into the sea of the arts, where the beauty of the great heaven overhanging the world is reflected. And like water, the mirrored image in art can either be clear or disturbed and wavering.

The Scope of This Book

What do we explore in this book? Our goal is to understand God better through the mirror or looking glass of contemporary popular arts. We will explore who God is, what art is, how art communicates who God is and who we are as humans, and how the arts may be used or misused. While we recognize our context within the classic arts—the creative genetic pool, so as to say, from which the contemporary arts descended—our primary interest is in today's world. What are artists saying now? What are they creating and expressing in that creativity? How is God reflected in contemporary cultures?

We invest much effort in building a theology of the arts from the raw material of Scripture. Then we use it to understand not so much individual works of art, though we address many of these, but the concept of popular art itself. What is the Bible's perspective on the arts and what should be a Christian's perspective? How can we rightly divide sound artistic endeavor from the unsound? And what can we learn about God in the handiwork of our fellow creators?

Every writer in this book envisions God as the master artist, storyteller, singer, visual artist, dramatist, communicator, choreographer. The whole world is God's art, a continual proclamation of God's invisible eternal power, divine nature, glory, and goodness. Humans too are God's artwork, and because they are made in the image of the great Creator-Artist, they are also creative artists. Therefore, art is a natural part of life, a necessary nourishment for humans, a mirror in which we can catch glimpses of God in our human attempts to fathom eternity and in the quest for meaning.

In chapter 1 Aída begins our exploration by securing a definition of art and laying down our "biblical hermeneutic," that is, our Bible-based interpretive principles for analyzing the arts. She looks at creation as God's handiwork, the nature of God as a symbolizing artist, how the arts mirror that aspect of God's nature, and the place of art in life. She proceeds in chapter 2 to explore fiction, how contrived "lies" tell us eternal truths about God and people. She presents an analysis of George MacDonald's craft, showing why we need to evaluate fiction and how to follow a Christian literary criticism.

In chapter 3 I look at music, an area of insatiable interest to me. I examine what popular music reflects about God.

Bruce Herman, whose work has been displayed from Boston to St. Petersburg, Russia, is not only a keen artist but also author of *Golgotha* and professor and chair of the department of art at Gordon College. In chapter 4 Bruce contemplates his development as an artist and a Christian believer, illustrating the issues raised by contemporary visual art.

Gwenfair Walters, a church historian at Gordon-Conwell Theological Seminary with a keen interest in the history of pictorial art, particularly art used in worship, widens our perspective of the religious dimensions of art. In chapter 5 she examines whether and how God should be depicted visually.

Performing arts are well represented by Celeste Snowber Schroeder and Norman Jones. Celeste, a dancer and faculty member at Simon Fraser University, and an author, shows how God can be celebrated and understood through dance and movement in chapter 6. In chapter 7 Norman, a professor at Gordon College, expands on that view by analyzing how God can be grasped through the spoken word in movement—the dramatic arts.

Filmmakers and media experts Richard Peace of Fuller Theological Seminary and Jasmin Sung of Emmanuel Gospel Center, Boston, present an analysis of cinema in chapter 8.

Finally, in chapter 9 I explore how to minister through the arts, drawing from a course I teach, Theology and the Arts.

Included at the end of each chapter is a short activity, allowing you to explore personally each of the arts we cover. We are not interested in sim-

ply producing a textbook, looking at God and the arts as if coldly examining bugs pinned to pages. All of us are working artists who also teach. Rather than sitting aside and aloofly criticizing the artists of the church, we work shoulder to shoulder with them.

Why We Need to Ask, What Is Art?

To structure our search for glimpses of God in the arts, we have selected certain major genres as test cases. These are purely representative; the field of art is as vast as the sweep of human creativity.

My file on the various arts includes a multitude of crafts, products, and even shapings of nature put forth as art. In addition to the "standard" arts, such as music, theater, visual arts, literature, dance, film, and so forth, I have noted numerous productions and activities, such as:

American diners	holiday decorations
animation cells	jewelry
armor	journal and letter writing
bird-watching	landscaping
campaign buttons	liturgy, ritual, and prayer
carving	magic
ceiling art	martial arts
circus acts	medieval tournaments
clock making	museum arranging and curating
clothing and fashion	needlepoint
clowning	paper money design
comics	professional wrestling
commercials	puppetry
cooking	pyrotechnics
crocheting	quilting
customized and vintage autos	sand sculpture
decorative plates	skywriting
dolls	sports and games
embroidery	tattooing
flower arranging	tea ceremonies
hairstyling	toys

And these are only representative, for unmentioned are many national art forms around the globe, potential space age arts, and varieties of crafts that claim to cross over to art.

Every artist has a privately nuanced definition of art. Therefore, the first question this book must answer is, What is art? Is everything art? Or are there perimeters that include and exclude what can be called art? Can we

14

pose acceptable guidelines that help us determine, for example, where craft ends and art begins?

In our perspective, these questions, like all others, are tied not only to secular philosophy but also to the Bible's perspective. For a Christian, truth is articulated by the Scriptures and echoed in the best of the world's truth-seeking.

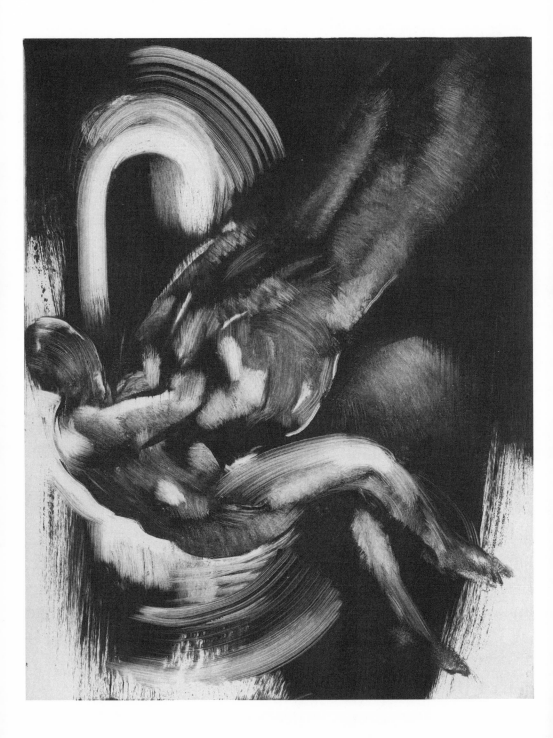

1 The Bible as Apologetic for Art

Aída Besançon Spencer

In the beginning, there is art. The master artist is God. The artwork is the world. Before God created, the earth was nothing and empty (Gen. 1:2). The Bible does not tell why God begins to create. All we can intuit is that the process is intimate, as when a mother hen broods over her chicks. So the Spirit of God "broods" or "hovers" over the "face" of the ocean. And when the creation is complete, God contemplates it. It is all good. All that God creates is good (Gen. 1:4; 1 Tim. 4:4). It is, moreover, delightful and aesthetically pleasing.

What Is Art?

Art is a type of communication through something arranged or created to represent what the artist perceives in the subjunctive (what could, would, or might happen) to be life or truth[1] and that someone presents as art because of its perceived form and beauty.

We might not usually think of God's creation as art, but if we look at the Genesis account of creation, we see that it illustrates each part of our definition of art, and, as we will see later, we find that God's creative act presents a strong apologetic for our involvement in the arts.

First of all, art is arrangement. The word *art* comes from the Greek *artuō*, "arrange," "prepare," "make ready." Art is poetics, making, producing *(poieō)*. In ancient Greece, an artist was an imitator, a mimic *(mimētēs)*, a representer of life. In contrast, God is the originator who creates life. God as the master artist creates matter out of nothing. We, created in God's image, merely arrange the matter around us.

In creation, God both creates and arranges. God arranges the separation of light from darkness to create time (Gen. 1:4–5). God arranges the waters within the atmosphere (Gen.

17

1:7). God arranges the flow of waters from the dry land into seas (Gen. 1:9–10). God makes produce. The earth, by God's command, produces the seed of plants and mammals (Gen. 1:11–12, 24). The waters of the seas, by God's command, produce living creatures, and the waters of the air, by God's command, produce birds (Gen. 1:20–21). Creation, arrangement, production all intertwine in a marvelous organic manner to result in self-willed, individually running works of art.

Second, *Webster's New Universal Dictionary* defines art as "the making or doing of things that have form and beauty."[2] What God creates—light, atmosphere, moon, stars, living creatures, humans—has form and beauty and, therefore, is art, even though no human may have been present to call the original work *art*.

So the Book of Genesis describes God as creating and arranging, part of our definition of art. And what God creates and arranges is art because it has form and beauty. But where in the creation account is the representation of truth? And where is the communication? The answer is that humans are God's representation of truth and God's communication about God.

Because humans are created in God's image (Gen. 1:27), they imitate or represent God. They represent God's loving communication: Even as the three persons of the Trinity are in loving communication, so the two persons of humanity were created to communicate in love. They represent God's unity in diversity: As the Godhead is both an "I" and an "us" (Gen. 1:26), humankind is "male and female" (Gen. 1:27). And they represent God's authority: As God cares for the earth and for us humans, we are to care for the earth (Gen. 1:28; 2:15).

Humans are God's living metaphors in that they can create (though not out of nothing) little humans, even as God created the world. Procreation is a synecdoche, a part representing the larger action of creation. In these and other ways, humans represent God.[3]

God's artwork communicates who God is. Humans become defaced art when they sin, art that has been chipped but not crushed. But even after the fall, they still represent God (Gen. 5:1), though not as perfectly as before, and they still are beings of possibility. From other biblical writings, we learn that all of God's creations represent and communicate aspects of God's nature (Rom. 1:20): "The heavens are telling the glory of God; and the firmament proclaims his handiwork" (Ps. 19:1 RSV).[4] Through the creation, God communicates what life could be like and what the Creator is like.

God, then, steps back and contemplates the world, holding up a cosmic thumb, sighting along the lines of creation and judging, "That's good." And through thousands of years humans have contemplated and appreciated God's works as art.

Art and the Bible

The Bible, God the master artist's record of self-revelation, also celebrates art and portrays it as a natural part of life. Examples of all the genres of art we will study in this book may be found in the Bible: fiction, music, visual arts, dance and movement, and drama. (Movies and other visual media combine some or all of these genres using modern technology.) Highlighted here are musical arts, visual arts, and lingual arts.

Musical Arts

In the Bible, singing, playing instruments, and dancing often occur together to express joy.[5] Beginning with Jubal's playing of the lyre and pipe (Gen. 4:21), both the wicked and the good use these arts. Children have parties (Job 21:7–12); the misguided Israelites dance as they give credit for their successes to their handmade calf (Exod. 32:4, 19); maidens dance at vineyards and in merrymaking (Judg. 21:21; Jer. 31:4, 13); and God sings a love song (Isa. 5:1). Dance, in these examples, is simply a rhythmic turning or whirling expressing emotion and thought.

The first piece of music explicitly called a song in the Bible is sung to the Lord after the Israelites crossed the Red Sea. It is a thankful celebration of God's help (Exod. 15:1–19) and expresses great emotion. The Israelites, formerly a powerful people, had been terribly oppressed by the Egyptians (Exod. 1:8–11). When they finally gain their liberty, they leave Egypt, only to find themselves pursued by hundreds of enemy warriors, who trap them against an impassable sea. The powerless Israelites are then supernaturally delivered while their powerful enemies are overcome. In response, Moses leads the community in a song praising their savior, the Lord, personified as a warrior (Exod. 15:3).

Song and dance are also part of prophesying. After Moses and the Israelites finish singing, Miriam, the prophet, commands the other women to sing to the Lord, who is to be highly exalted for that day's outcome (Exod. 15:20–21). They sing, dance, and hit their hand drums. Elsewhere in the Bible, women also sing and dance with each other as they welcome the victorious Israelites, who have defeated their enemies with God's help.[6]

The importance of art in everyday life is illustrated by the institution of a priestly order of praise by David and the prophets Gad and Nathan.[7] After he is anointed king and brings the ark of the covenant to Jerusalem, David sets aside some of the Levites in Asaph's order as a grand orchestra, financially supported by all the people, to perform twice a day (1 Chron. 16:37–42; 23:30). These Levites are singers, harpists, and cymbal players, chosen because of their dexterity, piety, and birthright. In addition, whole

families within the order, including men and women, work on specialties for this ministry of praise (1 Chron. 25:5–6). David's exhortation to these godly musicians at the installation of the priestly order is preached in the form of a song, explaining that their ministry should be a means of thanksgiving, supplication, evangelism, education, exhortation, and confession (1 Chron. 16:8–36).

At the gala installation, the priests have 120 trumpets (2 Chron. 5:12). The Levites honor David's creativity by also using his instruments (2 Chron. 29:26). In the services, both in the tabernacle and in everyday life, the Levites use almost every instrument we are familiar with today except for piano and organ: stringed instruments such as harps, lutes, and three-strings, hand drums or tambourines, rattlers, cymbals, trumpets, horns, bells, and flutes.[8] All of these are gadgets created by humans to make noise.

Asaph's order of praise remains to this day. It is continued by the devout rulers of Israel: Solomon (2 Chron. 8:14), Josiah (2 Chron. 35:15), and Nehemiah (Neh. 12:45–47). Paul reinstitutes it in the New Testament. Since the priesthood under the new covenant includes all believers (1 Peter 2:5, 9), Asaph's order is now open to all believers.

The new covenant order of praise functions to educate, give thanks, and supplicate. Paul and Silas sing their hymns of prayer in the airless depth of a prison while their fellow inmates listen (Acts 16:25). Playing instruments and singing are ways in which Christians can be filled with Christ's teachings and Christ's Spirit.[9] Praise is communal and individual, literal and metaphorical. When singers and musicians are united in heart praising God's goodness and eternal mercy, God's glorious presence will fill the participants (2 Chron. 5:13–14).

Visual Arts

The visual artist plays a major role in the Old Testament. God commands that portrayals of angels be made for the ark in the temple (Exod. 25:18–20). God commands Ezekiel the prophet to dramatize God's message to the Israelites by engraving a picture of Jerusalem on a tile (Ezek. 4:1). And God commands Moses to make a bronze serpent as a means of healing those bitten by serpents (Num. 21:8–9).

But the visual artist's most important role is in the building of the movable tabernacle and Solomon's temple. The master artist Bezalel and his assistant Oholiab are called by God to work on the tabernacle. Bezalel is filled with God's Spirit and is given wisdom, knowledge, and skill (Exod. 31:3–6; 38:22). He is skilled in cutting stones and carving wood. Oholiab is skilled in the weaving of colors. Although Bezalel personally appears to build the ark of the covenant (Exod. 37:1), he and Oholiab function as teachers

and coordinators of a communal artistic venture (Exod. 35:30–34). Everyone in the community who is willing is explicitly invited to participate (Exod. 35:22). Just as the cheerful givers in New Testament times are invited to share freely their financial resources with others (2 Cor. 9:7), so everyone in Old Testament times whose heart is stirred up and whose spirit is willing is invited to take part in creating this beautiful symbol of God's presence (Exod. 35:5, 21, 29).

The wise artists of the tabernacle are skilled engravers, weavers, sculptors, carpenters, sewers. When Solomon builds the stationary temple, he too needs a master artist who is filled with wisdom, understanding, and skill to supervise the work (1 Kings 7:13–14; 2 Chron. 2:13–14). Hiram, whose mother is Jewish but whose father is from Tyre, is a worker in brass, gold, silver, iron, stone, wood, and linen. Before God's glory fills either the tabernacle or the temple, not only do musicians sing, play, and dance, but visual artists cut, sew, and build (Exod. 39:32–38; 2 Chron. 5:13).

The tabernacle and the temple are not simply functional. They are also beautiful. The priestly garments, for example, are made to have both glory and beauty (Exod. 28:2). This beauty is a synecdoche, a sign of God's great beauty (Ps. 27:4), and a prolepsis, a sign of God's new Jerusalem. The new heaven and earth will be as attractive as a bride, and God's glory will be as evident as the brilliance of a precious jewel (Rev. 21:2, 11, 18–21).

Lingual Arts

The people of the Bible passed along important information to succeeding generations not only by writing it down but also by reciting it or repeating stories. Even when information was written down, it often was read aloud and then recited again and again. Even as musical and visual arts can serve well in this process of remembering and exhorting, lingual arts (*lingual* having to do with the tongue, a sound, or a letter representing a sound[10]) such as drama, story, and poetry are also effective means of advancing God's work. Thus, we should not be surprised to find the Bible is full of dramas and stories and poems.

Indeed, the Bible is not primarily a collection of abstract essays. It is primarily historical narrative. Almost 60 percent of the New Testament is narrative (the Gospels and Acts). Some biblical writings are poetry, such as the Song of Solomon. Psalms are metaphorical patterns to praise God and plead with God. Originally they were sung, and like other songs, are means of thanking God, asking God to meet needs, and exhorting believers. Other writings are replete with symbolic language, such as Revelation and parts of Daniel.

Even fiction is used in the Bible to communicate God's message better. For example, how can the prophet Nathan tell King David, who could order

his death in an instant, that God is displeased with him? How can he tell his king that he had sinned terribly by murdering Uriah and stealing his wife, Bathsheba, thereby dishonoring God's name, God's people, and himself? Only one way—through a story. By telling David a story whose characters are analogous to David, Uriah, and Bathsheba, but not didactically so, Nathan allows David to identify with Uriah, the very person the king had victimized. After he hears the story, David's anger is "greatly kindled against the man . . . 'The man who has done this deserves to die'" (2 Sam. 12:5 NRSV). He has no idea that the man he would condemn to death is himself! Nathan follows his fictional story (2 Sam. 12:1–4) with a nonfictional explanation of the story's meaning (2 Sam. 12:7–12). Using both genres, Nathan is able to persuade David of his sin (2 Sam. 12:13).

The same technique is used to approach David again, this time using drama. When David does nothing to bring about the return of his son Absalom, who had fled after killing his brother Amnon, his military advisor Joab sends for a wise woman from Tekoa to enact a drama. She pretends to be a mother whose son is about to be taken from her and killed for murdering his brother. She pleads for his life, because he is her dead husband's only remaining heir. Again, David unwittingly judges himself: "As the LORD lives, not one hair of your son shall fall to the ground" (2 Sam. 14:11 NRSV). Like Nathan, the wise woman follows the fictional story (2 Sam. 14:4–7) with a nonfictional explanation (2 Sam. 14:13–17). And David decides to allow Absalom to come back to Jerusalem (2 Sam. 14:24).

Even Jesus, God incarnate, uses fiction as one of his major teaching devices. When a stranger in a crowd demands that Jesus tell his brother to divide their inheritance with him, Jesus responds in a direct, nonfictional way: "Guard against all greed." But he does not stop there. He goes on to tell a story (Luke 12:16–20), which he concludes with an explanation (Luke 12:21–34).

For Jesus, stories often cause spiritual growth in the faithful while remaining obscure to the faithless (Luke 8:10). When the religious leaders question Jesus' authority, Jesus answers with a question (Luke 20:3–4), followed by a story: A person "planted a vineyard, rented it to some farmers and went away for a long time" (Luke 20:9–18 NIV). These religious leaders perceive they are analogous to the characters, but unlike King David, they do not respond by asking for forgiveness. Nevertheless, the story clarifies for them Jesus' perspective on their role in God's reign and God's forthcoming judgment.

God Is a Symbolizing God

When we open the Book of Genesis to its first chapter, we find God is not directly described. Rather, we learn of God as God creates, contemplates,

and concludes that creation is good. We learn of God by observing God's behavior. We hear God's voice recorded in the ancient writings, but we never see God. Why? Because God has no form (Deut. 4:15–20; Isa. 44:9–20). Unlike humans, God is Spirit (John 4:21, 24; Ps. 139:7; Acts 17:24–29). Therefore, we must observe God's actions and listen to God's self-descriptions. One major means of communication God uses to bridge the chasm between spirit and form is symbolic language. "I am your shield" (Gen. 15:1 NRSV). God is the rock (Deut. 32:4). God is the shepherd (Ps. 80:1). Even when God becomes incarnate, we still do not see God's full glory (Phil. 2:6–8). So God, incarnate, continues to use symbolic language. Jesus is the bread of life, the light of the world, the gate for the sheep, the good shepherd, the resurrection and the life, the true vine (John 6:35; 8:12; 10:7, 11, 14; 11:25; 15:1).

A symbol is "something that stands for or represents another thing; especially, an object used to represent something abstract."[11] God usually creates art that is both functional and symbolic in itself. But sometimes God creates purely to symbolize a certain truth.[12]

Symbolism in Exodus

During Moses' extended conversations with Pharaoh of Egypt, ten natural occurrences are brought about as signs of God's presence and encouragement to allow the Israelites to celebrate a festival in the desert in honor of the God of Israel (Exod. 5:1–3). Only one of these natural occurrences is not announced to Pharaoh. This is the three-day period of darkness that precedes the last plague, the death of the firstborn son or animal (Exod. 11:5): "And the Lord said to Moses, 'Extend your hand toward the heavens, and darkness will be upon the land of Egypt—even a darkness to be felt.' And Moses extended his hand toward the heavens, and a deep darkness was in all the land of Egypt three days. A man did not see his brother, and a man did not rise from beneath it three days, but to all the children of Israel there was light in their dwelling" (Exod. 10:21–23, my translation).

What is the purpose of this singular event? Since it is the only unannounced sign—one which Pharaoh was not given the opportunity, as he was given before with the previous signs, to prevent by letting the Israelites go—one might argue that its purpose is primarily symbolic. As an image it suggests several levels of meaning.

First, since three straight days of darkness are unusual, they likely caused much discomfort and fear. When Pharaoh sees that light shines where the Israelites live, associating this difference with the other signs, which did not affect the Israelites, he responds by deciding to let the Israelites depart with their lives but with none of their herds. Therefore, the darkness func-

tions in the same manner as the nine other natural events: as a sign of God's presence and as an encouragement for the release of the Israelites.

Second, the darkness serves as a portent of the great disaster to come: the last and most devastating plague, the death of the eldest son. Using a literal rendering of the Hebrew idiom, we may translate verse 23, "A man did not see his brother and a man did not rise," rather than the more generic "they could not see one another." In this distinction between a man and his brother we may already have a suggestion that one male will be distinguished from another in the plague to come.

Third, the three days of darkness loom in contrast to the Israelites' requested three-days' journey into the wilderness. Because Pharaoh does not want to grant three days of feasting, the Egyptians are justly given three days of nonfeasting.

Fourth, like art, the darkness is created and communicates and represents larger truths. It has a terrifying form and beauty. It powerfully demonstrates God's capacity to symbolize.

Symbolism in the Crucifixion

In the New Testament we find a similar symbolic communication. Matthew, Mark, and Luke record a three-hour period of darkness that begins around noon immediately before Jesus' death: "And it was already about [the] sixth hour, and darkness came upon the entire region until [the] ninth hour when the sun eclipsed" (Luke 23:44–45, my trans.).[13] The darkness during the crucifixion seems to have no function in the narrative other than a symbolic one. Like the darkness in Egypt, it is unannounced. It serves as a sign of God's presence. It instills fear in those present. The centurion responds by praising God and saying, "Certainly that person was righteous" (Luke 23:47, my trans.); "Truly this person was God's Son" (Mark 15:39; Matt. 27:54, my trans.). The multitudes return home beating their chests (Luke 23:48), indicating it also provides a symbol to them of a miscarriage of justice.

Like the darkness in the Exodus record, this darkness serves as a warning of a great disaster to come, the death of a firstborn son. While the darkness in Egypt recalls the Israelites' request for a three-day-long journey, the three-hour period of darkness at the crucifixion seems to point forward to the three days in the tomb. Norval Geldenhuys interprets the darkness in this manner:

In Gethsemane [Jesus] chose finally to bear the punishment for the sin of mankind. And because this punishment is everlasting death, Jesus had on the cross to experience absolute forsakenness of God, and the pangs of hell itself. It was a time of utter spiritual darkness that the Son of God had to pass through, as the Substitute for the guilty world. Therefore it was also inevitable that the

24

world of nature, the creation of God through the Son (John i.3), should on that day be radically affected. And so darkness came over the whole earth from twelve to three o'clock and an earthquake rent the rocks in the vicinity (Matt. xxvii.51).[14]

This leads us to the question, Is the darkness in Exodus also a symbol of the three days in the tomb? The many parallels between the two events might lead us to think so. At the crucifixion, God's own firstborn receives the same punishment God rendered to the unresponsive Egyptians. The Israelites were taught that their own firstborn sons should have been killed along with the Egyptians' firstborn sons and animals. Only the lamb's blood smeared in obedience on the door frames protected them (Exod. 12:5, 12–13). For thousands of years the Israelites symbolized this lesson by dedicating Levites to temple service and offering animal sacrifices and redemption money to protect their firstborn children.[15]

The three days of darkness occur before the Passover, an event in which the killing of a lamb represents a vicarious death to come (1 Cor. 5:7). Jesus enters Jerusalem at the same time as thousands of lambs for the Passover celebration. He dies during Passover itself (Luke 23:54). During the three days of darkness one Egyptian "did not see his brother" and another "did not rise from underneath it three days." We might say the Exodus darkness is like a tomb, and the Egyptians had not yet gone through their punishing death experience.

God's Symbols Are Real

A modern reader might ask if these accounts of darkness and plagues are merely fictional devices employed to indicate great calamities or if we are to believe they actually occurred. The correspondence of the ancient naturalistic Roman historian Thallus, who disagreed with the Christian Julius Africanus (c. A.D. 220) and contended that the crucifixion darkness was caused by a natural eclipse, indicates both were aware that an unusual darkness had occurred. Africanus argued that no eclipse of the sun is possible with a full moon, nor is any recorded in the meteorological records of that time.[16] What is striking is that the cause and significance of the darkness were disputed, not its reality.

Most commentators seem to agree at a minimum that the Exodus plagues refer to actual occurrences. G. H. Davies writes, "There is no doubt that a series of disasters took place in Egypt, and these disasters were severe and came quickly after one another."[17] Bernhard Anderson believes that "Israel's ancient faith undoubtedly was based on the experience of actual events which facilitated the escape of slaves from Egypt."[18] William Neil states that "the basic facts would seem to be a combination of unusual natural disas-

ters."[19] Philip C. Johnson concludes: "Most scholars agree that the darkness was probably caused by the *hamsîn,* the fierce sandstorm so dreaded in the East. The hot dry wind, like the blast of a furnace, fills the air with sand and dust, so that the sun is blotted out. The heat, the dust, and the static electricity make conditions almost unbearable physically. Added to this is the effect on mind and spirit of the thick and oppressive darkness. This plague concluded the manifestation of God's wonders and was a forbidding prelude to the final act of judgment."[20]

Though they may affirm the reality of darkness at the exodus and the crucifixion, few biblical commentators discuss its symbolic significance. However, if the biblical student understands that the God portrayed in the Bible is a symbolizing God from whom we receive our own capacity and desire to symbolize, then such a student is prepared to see real events on a symbolic level.

The Place of Art in Life

The Bible presents a wonderful apologetic for art. It shows us that God is the master artist who creates works of art, that art is a natural part of life and an effective means of advancing God's work, and that God is a symbolizing God. Furthermore, because God created humans in God's image, we inherit from God the capacity to subcreate and symbolize. Even Susanne Langer, an atheistic philosopher, writes: "Not higher sensitivity, not longer memory or even quicker association sets man so far above other animals that he can regard them as denizens of a lower world: no, it is the power of using symbols—the power of *speech*—that makes him lord of the earth."[21]

Christians need not apologize for being involved in the arts. Doing so is like apologizing for our need for air. In fact, because of our very nature, we need to subcreate and symbolize. We can see examples of this need in the experiences of people who have endured great difficulty. What keeps these people sustained over time? Often it is some form of art. South African Winnie Mandela kept her sanity in prison by imagining she was writing a letter to her husband, Nelson Mandela, and imagining she was receiving a letter from him every day. In the Bible, when Saul's spirit was tormented, he was soothed by David's music (1 Sam. 16:14–23).

Art is not an optional part of life. Though some of us have been particularly gifted and called to create art, if we are fully human, each of us is an artist in one way or another:[22] communicating by arranging or making what we conceive to be truth in some symbolic manner.

Suggestions for Exploration

1. Read Genesis 1:1–27. Divide the group into three parts, each part studying one third of the passage: verses 1–8, verses 9–19, and verses 20–27 (optional: Gen. 2:21–25).

Read the verses aloud. Write the definition of art from this chapter on an overhead, blackboard, or poster. In what ways is God an artist, and in what ways is God not an artist? Have the small groups share their findings with the whole group.

2. Again in three small groups, read the following passages aloud. Look at the immediate contexts of each passage. (Passages in parentheses are optional.) Answer the following questions.

What art forms are described?

What is the moral character of the artist?

What is the function of the art form?

How is the art form related to serving God?

Are any precedents set that should be followed today?

Musical Arts	Visual Arts	Lingual Arts
Gen. 4:21	Num. 21:8–9	2 Sam. 12:1–14;
Job 21:7–12	Exod. 20:4–5; 25:17–20;	14:1–17, 24
Exod. 15:1–21; 32:4, 19	28:2, (3–43); 31:1–11;	Ezek. 17:1–10,
Judg. 5:1; 11:34; 21:21	35:5–36:8;(36:9–38:23);	(11–24)
1 Sam. 10:5–13; 16:14–23;	39:21–23	Luke (1:46–55;
18:6–9	1 Kings 7:13–14, (15–45)	8:4–10); 10:25–37;
2 Sam. 6:5, 12–16	Prov. 31:24–25	12:13–21, (22–34);
Pss. 30:11–12; 81:1–3;	Isa. 44:9–17	20:1–19
149:1–3;150:1–6	Ezek. 4:1–3	
2 Kings 3:15–16	(2 Chron. 2:13–16;	
Isa. 5:1, 11–12;	4:11–18)	
(24:6–9; 30:29)	Acts 9:36–39	
Jer. 31:4, 13	Rev. 21:2, 10–14,	
(Lam. 5:15)	(18–21)	
1 Chron. 15:16–28;		
16:4–7, (8–36), 37, 41–42;		
23:30; (25:1–8)		
2 Chron. 5:12–14;		
8:12–14; (29:25–26);		
35:1, 15		
Neh. 12:45–47		
Luke 7:31–34; 15:23–27		
Acts 16:25		
Col. 3:16–17		
Eph. 5:18–21		

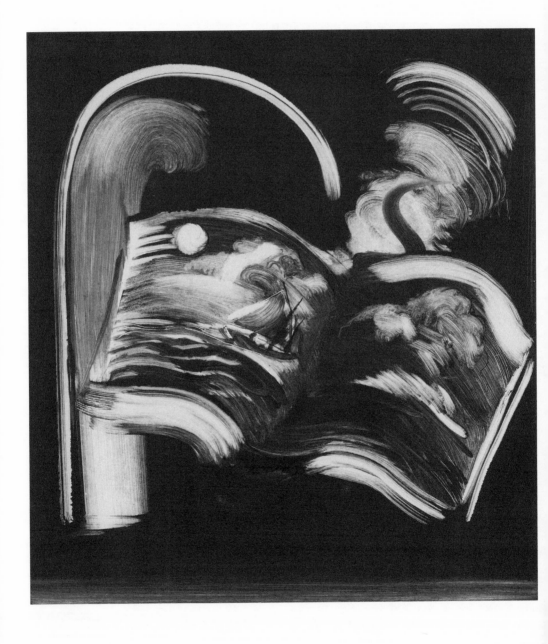

2 Fiction as a Looking Glass

Aída Besançon Spencer

Who is God? As Christians we turn to authoritative sources of God's self-revelation to answer this question. We believe that the universe has only one authentic God who through the years has in many ways revealed who God is through actions, adjectives, metaphors, and, when the time was best, by becoming incarnate. The records of God's revelation are historical claims that must be evaluated and trusted, not personal relative opinions that at best can be merely respected. Ultimately, the nature of God must be clearly discerned from the Bible, a book that claims to record God's revelations. Why, then, would a Christian read and value fiction?[1]

The Value of Fiction

The Bible Uses Fiction

Fiction is valuable to Christians, first and foremost, because the Bible uses it. Indeed, it is modeled on the Bible and on God, who ultimately is the author of the Bible.

As we have seen, the symbolizing God of the Bible uses many metaphors to help us understand God's character. God is a vine planter who carefully, lovingly, and attentively plants, prunes, and guards the vine but, when no fruit appears, is willing to remove all protection.[2] God is a generous sower who separates weed from wheat at harvest time.[3] God is a landowner of a vineyard who wants to collect produce from the tenants and who gives his workers all the same pay regardless of the amount of time they have worked (Matt. 20:1–16; 21:28–46).

In all these and many other short stories, the narrator has made sure to keep the tension between a "merciful and gracious" God and a just God "who will by no means clear the guilty" (Exod. 34:6–7 RSV). This paradox in God's nature is an

essential element both in God's self-revelation in adjectives and parables and in fully "truthful" fiction.

Fiction Is Powerful

Fiction is valuable because it is powerful. We have seen how fiction worked to convict King David when nothing else would (2 Sam. 12:1–13). Fiction done well can also reach people who would never open a Bible or a nonfiction Christian book. When in the 1800s even Christians in the northern United States were beginning to reconsider ownership of slaves as a guaranteed constitutional right, Harriet Beecher Stowe wrote *Uncle Tom's Cabin* to "show to the world slavery as she had herself seen it." Anne Terry White writes: "No novel before or since stirred [the United States] so deeply—while throughout the civilized world it sold in millions of copies." In 1852 eight power-presses, running day and night, were barely able to keep pace with the demand. The Earl of Shaftesbury wrote to Stowe: "None but a Christian believer could have produced such a book as yours, which has absolutely startled the whole world." Even President Lincoln said to Stowe that she "wrote the book that made" the Civil War.[4] Writing during a time when people who wrote nonfiction were frequently killed by their opponents, Stowe considered her book a response to God's demand to liberate the African race.

One reason narrative is so effective is the power of role models. The reader of a narrative identifies with people in the story and extends the story to include himself or herself.[5] Open-minded readers of *Uncle Tom's Cabin* identified with George when he concluded, "It was on [Uncle Tom's] grave, my friends, that I resolved, before God, that I would never own another slave while it was possible to free him."

Fiction Is a Tool for Fleshing Out Ideas

Some people might ask, Why use fiction when a more direct nonfiction approach is available? In fiction, the author selects, isolates, and makes patterns from the raw materials of life or from the Bible.[6] Think of any moment of time. As I sit here in my office I can hear my pencil moving, cars dashing down a main road, a neighbor talking. I can see a bleary sky, different colored books in bookcases, a half-opened closet, an empty cup, a silent telephone, a purse on the floor. On what do I focus? What has importance? Can I find any pattern or meaning? To create fiction, an author picks from many possible stimuli to flesh out ideas about life. In a novel an idea or concept can become a directing force which can affect a cast of representative human characters. The writer can explore the way things truly are or the way things should be.

Aristotle explains: "Since the past represents life, as a painter does or any other maker of likenesses, [a writer] must always represent one of three things—either things as they were or are; or things as they are said and seem to be; or things as they should be" (*Poetics* XXV). He adds that Homer in writing an *Odyssey* "did not put in all that ever happened to Odysseus, his being wounded on Parnassus, for instance, or his feigned madness when the host was gathered (these being events neither of which necessarily or probably led to the other), but he constructed his *Odyssey* round a single action" (*Poetics* VIII).

Some people find the concepts of existentialism appealing. But when Sartre fleshes it out in *Nausea* or *No Exit,* it indeed looks "revolting" and "constrictive." Others find goddess worship liberating. However, novels such as *The Mists of Avalon* show how fatalistic it is.[7]

Fiction Is a Vehicle for Examining Life Vicariously

In fiction, authors can set their ideas in a hypothetical situation. Both author and reader can see what ideas look like without suffering physically. Author and reader can thereby see beyond their own immediate needs and examine life. They "escape" from the thousands of overbearing and confusing stimuli to dwell on the meaning of it all.

C. S. Lewis illustrates this idea by commenting on H. G. Wells's *First Men in the Moon,* when Bedford finds himself

> shut out on the surface of the Moon just as the long lunar day is drawing to its close—and with the day go the air and all heat. . . . And here, I expect, we come to one of the differences between life and art. A man really in Bedford's position would probably not feel very acutely that sidereal loneliness. The immediate issue of death would drive the contemplative object out of his mind: he would have no interest in the many degrees of increasing cold lower than the one which made his survival impossible. That is one of the functions of art: to present what the narrow and desperately practical perspectives of real life exclude.[8]

Fiction Helps Us Communicate and Contemplate Ideas

Fiction allows us to communicate and contemplate our ideas, to celebrate them and draw out and emphasize true significance. In all of the novels I have read by Margaret Scherf, I do not remember any direct religious statement by the Methodist minister and detective, Martin Buell. Nevertheless, the solution to each crime depends on the distinction between sin and virtue. Sin is the self-realization of evil when we compare ourselves to God. Virtue is seen when we compare ourselves to other

people. All of us can find some virtue in ourselves if we look hard enough to find a more evil person. Yet all of us will see ourselves as sinful if we compare ourselves with God, who alone is perfect. In Scherf's books all her murderers are close friends of the detective. At first this seems shocking and unrealistic. But it is consistent with God's truth and with experience. Most people who are murdered are killed by someone they know.[9] Scherf's permeating idea is captured by the title of her first book, *Always Murder a Friend*.[10]

Good fiction can even help readers appreciate Bible accounts. Desensitized by familiarity with Bible stories, readers of the Bible can miss the surprise the original readers may have sensed, for example, when reading the accounts of a bush that keeps burning but remains unconsumed (Exod. 3:2–3); of a righteous man who refuses to divorce his fiancee, whom he mistakenly thinks has committed adultery (Matt. 1:19–25);[11] or of God coming to earth in a barn made for animals (Luke 2:7). A fictional retelling of such stories can restore the original effect.

Even works by writers who are not Christians can help illuminate truths or distortions about God's nature, actions, or the fight between good and evil. We may benefit from poignant expressions of the longing for God or confusion about God's nature. In a course on images of God in fantasy literature, we always assign David Lindsay's *A Voyage to Arcturus* because at least one or two students in every class will tend to treat matter as evil, as Lindsay does, even though that is not a biblical idea.[12] They might never discover their hidden heresy apart from experiencing it in this less direct manner.

Fiction Opens Readers to Adventure

Fiction is also worthwhile because it reminds us of the adventure that might otherwise elude us. C. S. Lewis explains:

> In real life, the idea of adventure fades when the day-to-day details begin to happen. Nor is this merely because actual hardship and danger shoulder it aside. Other grand ideas—homecoming, reunion with a beloved—similarly elude our grasp. . . .
>
> In life and art both, as it seems to me, we are always trying to catch in our net of successive moments something that is not successive. . . . But I think it is sometimes done—or very, very nearly done—in stories. I believe the effort to be well worth making.[13]

G. K. Chesterton was a master at writing about the fantasy present in our very backyard. In *Manalive* he begins by writing about how a breeze can transform a dreary life:

Many a harassed mother in a mean backyard had looked at five dwarfish shirts on the clothes-line as at some small, sick tragedy; it was as if she had hanged her five children. The wind came and they were full and kicking as if five fat imps had sprung into them; and far down in her oppressed sub-consciousness she half remembered those coarse comedies of her fathers when the elves still dwelt in the homes of men. Many an unnoticed girl in a dank, walled garden had tossed herself into the hammock with the same intolerant gesture with which she might have tossed herself into the Thames; and that wind rent the waving wall of woods and lifted the hammock like a balloon, and showed her shapes of quaint cloud far beyond, and pictures of bright villages far below, as if she rode heaven in a fairy boat. Many a dusty clerk or curate plodding a telescopic road of poplars thought for the hun-dredth time that they were like the plumes of a hearse, when this invisible energy caught and swung and clashed them round his head like a wreath or salutation of seraphic wings. There was in it something more inspired and authoritative even than the old wind of the proverb; for this was the good wind that blows nobody harm.[14]

Fiction well used should give us adventurous eyes as we look closer at our everyday world.

Jesus reminded his listeners not only to look at the easily ignored poor and sinners (Matt. 21:31–32; Luke 4:18) but also to live with most atten-tion on each day, for "Tomorrow will worry about itself" (Matt. 6:34 NIV). Jesus also taught from nature eternal truths about God. C. H. Dodd explains that Jesus saw "an inward affinity, between the natural order and the spir-itual order" because both were created by God.[15] Fiction can remind us that we can look at the world around us for images of God and of God's truths.

Fiction Is Enjoyable

God is a God of joy. Therefore, we too should enjoy ourselves. Umberto Eco, in his *Postscript to The Name of the Rose,* writes:

I wanted the reader to enjoy himself, at least as much as I was enjoying myself. . . .

The reader was to be diverted, but not di-verted, distracted from prob-lems. . . . [The reader] after he has enjoyed reading about himself in the novel, should somehow have understood something more, become another per-son. In amusing himself, somehow, he has learned. The reader should learn something either about the world or about language: this difference distin-guishes various narrative poetics, but the point remains the same.[16]

People who enjoy fiction can do so because they understand the differ-ence between fact and fiction and appreciate both in their place. They use

fiction to interpret the world for their opinions but use fact to undergird those opinions.

Fiction Develops the Imagination

Fiction develops the imagination.[17] How many novels have brought readers to places they might never reach? C. S. Lewis and Edgar Rice Burroughs are writers who sent characters to the planet Venus.

To appreciate fully Lewis's *Perelandra,* the reader must focus on imagining all five senses but especially touch and smell, because sight is less important in a cloud-covered world. When the character Ransom arrives on Venus:

> His first impression was of nothing more definite than of something slanted— as though he were looking at a photograph which had been taken when the camera was not held level. And even this lasted only for an instant. The slant was replaced by a different slant; then two slants rushed together and made a peak, and the peak flattened suddenly into a horizontal line, and the horizontal line tilted and became the edge of a vast gleaming slope which rushed furiously towards him. At the same moment he felt that he was being lifted. Up and up he soared till it seemed as if he must reach the burning dome of gold that hung above him instead of a sky. Then he was at a summit; but almost before his glance had taken in a huge valley that yawned beneath him—shining green like grass and marbled with streaks of scummy white— he was rushing down into that valley at perhaps thirty miles an hour. And now he realized that there was a delicious coolness over every part of him except his head, that his feet rested on nothing, and that he had for some time been performing unconsciously the actions of a swimmer. He was riding the foamless swell of an ocean, fresh and cool after the fierce temperatures of Heaven.[18]

Burroughs sends Carson Napier to Venus also. Napier lands on a tree. Sight is of little help to him: "The light from below had increased a little as I descended, but not much; it was still dark about me. I continued to descend. It was tiresome work and not without danger, this climbing down an unfamiliar tree in a fog, at night, toward an unknown world. . . . The illumination was increasing rapidly now, the clouds were thinning; through breaks I caught glimpses far below, glimpses of what appeared to be an endless vista of foliage, softly moonlit—but Venus had no moon."[19]

Without imagination we cannot believe God exists. Historical proofs for God's existence are, of course, the cornerstone of the Christian faith, but imagination and trust are needed to build one's house on that cornerstone. Imagination is often regarded as a sense of the impossible, but it is also a grasp of the possible, the unseen, the hoped for. Before one can become a Christian, one must posit that God *may* exist.

When I was in college, that is exactly what I did. I was alone in my dormitory room, looking out the window. The sky was a clear blue. The landscape was beautiful. I thought if God had not created all of this beauty, life indeed had a morbid irony. I simply did not know if God exists! So, I thought, if God exists, God would hear my prayer. I bent down on my knees and asked God, "If you exist, please show yourself." A few weeks later another student invited me to an InterVarsity Christian Fellowship meeting. And in the love of those Christians, I found Jesus (John 13:35). Imagination freed me to consider God's presence and to look for God's presence in the people around me.

Fiction works. It helps us see beyond our own immediate needs, helps communicate, and helps develop the imagination, a capacity that prepares us to receive God's revelation.

Evaluating a Work of Fiction

No novel can present an error-free view of God, no matter how devout the writer, nor do fiction writers claim to reveal authoritatively the nature of God. Yet fiction, as one aspect of God's creation, the looking glass or mirror of God's character, can be an aid to learning about God as long as it is carefully evaluated. In fact, many of the techniques used in interpreting fiction are also helpful for interpreting the Bible.

Interpretation

The best way to interpret a novel is to reread it, looking for an impression or hypothesis. In fiction, looking for some detail that at first seems irrelevant can open up a text. In the same way, rereading a Bible book for its central purpose is the key to understanding it. An initial impression or hypothesis must be verified by data and weighed against the whole work.[20]

The good interpreter evaluates a work from within itself, rather than strictly from without. The reader enters the world created by the writer and only after "living" in it for a while stands outside it to evaluate it. W. H. Auden explains, "History, actual or feigned, demands that the reader be at one and the same time inside the story, sharing in the feelings and events narrated, and outside it, checking these against his own experiences."[21] C. S. Lewis adds that literary readers criticize the lens after looking through it, not at it. They judge a work by its "power to do the work it was made for."[22]

While within the author's world, the reader must look for the author's perspective, because not every word in a novel is necessarily the author's

opinion. Shakespeare is often quoted as believing: "This above all: to thine own self be true, and it must follow, as the night the day, thou canst not then be false to anyman" and "Neither a borrower, nor a lender be; for loan oft loses both itself and friend, and borrowing dulls the edge of husbandry" (*Hamlet*, act 1, scene 3). These proverbs, and many others, are said by Polonius, one of the biggest windbags in all of literature. Because Polonius is a character who does not necessarily represent Shakespeare's point of view, unless his words are supported by some other character or final action, they cannot be assumed to be Shakespeare's opinion.

Similarly, not every word in the Bible is necessarily God's perspective. In narrative passages, the reader needs to discover God's perspective on the events. Sometimes that perspective is explained in an aside. Sometimes it is modeled by a person. Sometimes it does not become clear until the very end of the book. For instance, the writer of 2 Kings explains God's perspective in periodic asides such as: "The people of Israel continued in all the sins that Jeroboam committed; they did not depart from them until the LORD removed Israel out of his sight, as he had foretold through all his servants the prophets. So Israel was exiled from their own land to Assyria until this day" (2 Kings 17:22–23 NRSV). Fidelity to God is modeled by people such as Josiah, who "did what was right in the sight of the LORD, and walked in all the way of his father David; he did not turn aside to the right or to the left" (2 Kings 22:2 NRSV). The Book of Ruth is an example of a work's meaning not becoming clear until the end, where it lists the ancestors of Jesse, the father of David (Ruth 4:22). Moreover, even the entire book of Ruth is a commentary on the entire book of Judges, showing what believers could be like during those evil times.

Style and Content

In fiction and in the Bible, style or the form of writing can help disclose content. Margaret Parker answers the question, How does one unlock God's Word? "By treating it as 'literary language' which 'engages our senses, feelings and imaginations as well as our intellects.'" Literary language has imagery, drama, analogy. Imagery "activates our senses." Drama "arouses our emotions." Analogy "captures our imagination." "Literary language," she writes, "has the power to move us and change us."[23] Thus, for example, when the apostle Paul exhorts the Philippians to dwell on the beautiful, he does so in a beautiful way: "Finally, brothers and sisters, everything that is true, everything honorable, everything just, everything pure, everything pleasing, everything auspicious, if anything virtuous, and if anything praiseworthy, these things consider! Whatever also you learned and received and heard and saw in me, these things do; and the God of peace will be with

you" (Phil. 4:8–9, my trans.). Paul reinforces his message by having us dwell on the qualities even before we know what we are supposed to consider and do.[24]

Good fiction interpretation, like good Bible interpretation, is inductive, presupposing the best of an author, assuming consistency until proven otherwise. C. S. Lewis explains: "A work of [whatever] art can be either 'received' or 'used'. When we 'receive' it we exert our senses and imagination and various other powers according to a pattern invented by the artist. When we 'use' it we treat it as assistance for our own activities. The one, to use an old-fashioned image, is like being taken for a bicycle ride by a man who may know roads we have never yet explored. The other is like adding one of those little motor attachments to our own bicycle and then going for one of our familiar rides."[25]

After traveling with authors through adventures created by their minds, the reader needs to step back and look at both content and style: what is said by how it is said. *Poiēma*, what is made or created, is the style. *Logos*, what is said, is the content or message.[26] Both aspects should be studied separately and together.

Style

A novel as a work of art may or may not be well crafted despite presenting a good message. According to *Webster's Dictionary*, *fiction* comes from the Latin *fingere*, "to form, mold, devise."[27] Is the novel well formed? When evaluating the style of a work, five aspects of *poiēma* should be considered: consistency, reality, atmosphere, achievement of intention, and development of plot.

Consistency. Is the world created by the author consistent? Aristotle writes, "Stories should not be made up of inexplicable details" (*Poetics* XXIV.20). For example, Emily Collins is a missionary in a mystery series. In *Congo Venus*, one of the books in the series, the author, Matthew Head, describes Collins as prudish and inflexible, a likable but cultural missionary. Yet she glibly approves another character's decision to become a pimp, living off the proceeds of prostitution: "Well, why not, if it makes everybody happy?"[28] Such a reaction from such a character is inconsistent.

Reality. The world and the characters of a fictional work should appear so real you can imagine being in that world and meeting the characters. The rhetorician Longinus cites Euripides as an example of an ancient writer who succeeds in establishing the reality of a fantastical world in *Phaëthon*:

> "This heard, young Phaëthon caught up the reins,
> Slashed at the flanks of his wing-wafted team,
> And launched them flying to the cloudy coombs.

> Behind, his sire, astride the Dog-star's back,
> Rode, schooling thus his son. 'Now, drive thou there,
> Now this way wheel thy car, this way.'"

Would you not say that the writer's feelings are aboard the car, sharing the perilous flight of those winged horses?

On the Sublime (XV.3–4)

The other night Bill and I watched the rerun of an episode titled "Crimes of the Hart," from the 1970s *Hart to Hart* television series. A refreshing aspect of Jonathan and Jennifer Hart is their reality. Robert Wagner and Stefanie Powers portray their characters so well we forget they are acting. Moreover, the characters portray an attractive, loving, give-and-take of equals that is refreshing for television. Unfortunately, the same episode has inconsistencies in its fictional world. When the car of the assassin is used by our hero, the police never check it for ownership. When the assassin is killed by his boss, no one explains how the boss knew the assassin would be at a certain restaurant. For reality of characters, the episode is superb. For consistency with the way things happen in life, it needs work.

In contrast, another detecting couple is Pam and Jerry North in the 1950s novel *Dead as a Dinosaur*. Authors Frances and Richard Lockridge do an excellent job of depicting real characters consistent with life, especially Pam North and her relationship with her husband, Jerry. By showing continual breaks and omissions in her speech, as is common with people who are well acquainted, the authors express well Pam's intuitive, associative, concrete, multifarious thinking, as in this conversation:

> "All right," Jerry said, after they had left the office. "What was all that about? . . ."
> "She came," Pam North said, "because she wants to be reassured."
> "Reassured?" Jerry said.
> "That the world is real," Pam said. "That she can get through to it. Because, you see, she can't really." Pam paused. "Also that she is right about her uncle, probably," Pam added. "You see, she isn't sure, either." She paused. "I don't really know why *he* came," she said.[29]

Pam's words are written in a stream of consciousness that gives a certain reality to her character.

Atmosphere. A third aspect of *poiēma* is atmosphere or setting. Has the author been able to create a sense of atmosphere? How does that atmosphere make the reader feel? Has the reader experienced not simply the noun but the adjective, not just death but the deathly, not just a new person or place but otherness?

Our son, Steve, when he was fifteen, wrote a lyric poem that we think does communicate an interesting atmosphere. It uses atmosphere to communicate the feelings of despair found in suicide songs, replacing their negative solution (filling emptiness with a lethal knife blade) with a positive solution (filling emptiness with the Spirit of God):

> Deep in the forest
> beyond all the creatures
> lives a beast.
> He screams but no one hears him.
> He cries but there's no answer.
> "I can't control myself.
> The beast lives in me,
> He yells but I can't hear him,
> He cries but it's in vain.
> I take the knife to my chest,
> just one stab to end the pain."
>
> "I've lost everything,
> nothing left to gain.
> My soul's a bottomless pit,
> I want you to come inside.
> I want you to fill me up.
> I know you're perfect,
> I know I am not.
> It's just the one thing I ask,
> because without you, God,
> there would be nothing left of me."
>
> "Nothing Left of Me"

By creating atmosphere, the author ensures an appreciative reader will reread the work. C. S. Lewis uses the helpful description of the "quality of surprisingness" as opposed to "narrative lust." A novel worth rereading will have this quality:

We do not enjoy a story fully at the first reading. Not till the curiosity, the sheer narrative lust, has been given its sop and laid asleep, are we at leisure to savour the real beauties. Till then, it is like wasting great wine on a ravenous natural thirst which merely wants cold wetness. The children understand this well when they ask for the same story over and over again, and in the same words. They want to have again the "surprise" of discovering that what seemed Little-Red-Riding-Hood's grandmother is really the wolf. It is better when you know it is coming: free from the shock of actual surprise you can attend better to the intrinsic surprisingness of the *peripeteia*.[30]

39

Rhetorician Longinus agrees: "For the effect of genius is not to persuade the audience but rather to transport them out of themselves. Invariably what inspires wonder casts a spell upon us and is always superior to what is merely convincing and pleasing. For our convictions are usually under our own control, while such passages exercise an irresistible power of mastery and get the upper hand with every member of the audience" (*On the Sublime* I.4).

Intention. Good fiction writers achieve their intended effect through words and style.[31] Their images are clear. Readers identify with the right characters. The movie *Batman* (1989), directed by Tim Burton, was a masterpiece of atmosphere. However, when Michael Keaton, normally a good actor in his own right, became Batman, he simply was not as interesting as Jack Nicholson's Joker. Therefore, many children were more attracted by the Joker than Batman, even though that may not have been the producer's intention.

In good fiction, the style never overbalances the purpose. Readers should never become so attentive to style that they lose sight of the total communication. P. G. Wodehouse, who was awarded a doctorate by Oxford University for his writing style, was a master of humor. The humor arose from portraying people in an unaffected but affectionate manner. For example, Wodehouse's Bertie Wooster begins one account: "I'm not absolutely certain of my facts, but I rather fancy it's Shakespeare—or, if not, it's some equally brainy bird—who says that it's always just when a fellow is feeling particularly braced with things in general that Fate sneaks up behind him with the bit of lead piping."[32]

The style must also be appropriate to its intent. Longinus explains, for example, that "parenthyrson" is "emotion misplaced and pointless where none is needed, or unrestrained where restraint is required. For writers often behave as if they were drunk and give way to outbursts of emotion which the subject no longer warrants. Such emotion is purely subjective and consequently tedious, so that to an audience which feels none of it their behaviour looks unseemly. And naturally so, for while they are in ecstasy, the audience are not" (*On the Sublime* III.5). One reason for the popularity of Alice Walker's *The Color Purple* is her ability to write appropriate to characters' personalities. Celie, a young uneducated girl, writes accordingly: "Dear God, He beat me today cause he say I winked at a boy in church. I may have got somethin in my eye but I didn't wink. I don't even look at mens. That's the truth. I look at women, tho, cause I'm not scared of them. Maybe cause my mama cuss me you think I kept mad at her. But I ain't. I felt sorry for my mama. Trying to believe his story kilt her."[33]

Plot. A good story is well structured. In a traditional or classical format, a plot has a beginning, middle, and end, or to put it another way, a prelude, development, climax, and conclusion.

Development of Plot

According to Aristotle, Greek plot-making came from Sicily in the fifth century B.C. (*Poetics* V). The prelude is when the leader of a performance of a Greek song would state the theme the chorus would elaborate.[34] The "tying" of the plot is the complication. Aristotle thinks the climax arises at the point that immediately precedes the change from bad to good or from good to bad. In contemporary plot manuals, the climax is the actual turning point or culmination of the action. The dénouement or the "loosing" is "from the beginning of the change down to the end" (*Poetics* XV, XVIII). In the mystery genre of today, it is the clarification of a plot, the solution. Edgar Allen Poe, who began the modern mystery, explains: "Nothing is more clear than that every plot worth the name must be elaborated to its dénouement before anything be attempted with the pen. It is only with the dénouement constantly in view that we can give a plot its indispensable air of consequence or causation, by making the incidents, and especially the tone at all points tend to the development of the intention."[35]

A good plot has unity; the episodes logically follow each other. Aristotle concludes that the well-written piece must be "whole and complete in itself, with a beginning, middle and end, so that like a single living organism it may produce its own peculiar form of pleasure" (*Poetics* XXIII).

Edgar Rice Burroughs's novels are well plotted, full of action and atmosphere, but since so many of the novels originally came out in chapter magazine series, they have almost no dénouements. C. S. Lewis's *Perelandra* begins and ends with the dénouement (chaps. 1–2, 15–17). Ransom reaches Venus and enjoys its beauty. The first tying or complication is the advent of Weston. The climax—according to Aristotle, the point that precedes the change—occurs when Ransom decides he has to kill Weston or "Unman" (chap. 11). The modern climax comes when he actually kills the Unman (chap. 14).

Content and God's Truth

In chapter 1 we suggested that art is not only something created but also a means of communication. As readers we need to ask what an author is communicating. With what do we agree or disagree? Christians, especially, should evaluate what they read from a biblical perspective.

The Bible is replete with violence and rape, idolatry and evil, yet few sane people ever suggest that God wants people to be evil. *Poiēma* and *logos,* style and content, must come together to reveal what is the final point of any book. When the violence and sexual promiscuity of Sodom and Gomorrah are described, the reader is appalled (Gen. 19:1–26). When Lot entreats the angels to enter his home, the reader is relieved. And when God destroys Sodom and Gomorrah, the reader is enlightened.

The way a plot concludes reveals the author's views on life. After reading the work, does the reader find that the author expresses in an image, a character, a conversation, an event in microcosm the significance of the work? Are there any biblical allusions? If so, what is their intent? Are good and evil accurately portrayed? What is the moral climate? To be concrete, as Madeleine L'Engle asks, "Do we want the children to see it?"[36]

Leland Ryken suggests three key questions for a Christian criticism:

1. Does the interpretation of reality in [a] work conform or fail to conform to Christian doctrine or ethics?
2. If some of the ideas and values are Christian, are they inclusively or exclusively Christian?
3. If some of the ideas and values in a work are Christian, are they a relatively complete version of the Christian view, or are they a relatively rudimentary version of Christian belief on a given topic?[37]

A Christian analysis is not the only way a book can be analyzed. A book may suggest a psychological analysis or a sociological analysis, but every Christian should always include a theological analysis. A danger in not doing so lies in the fact that, in fiction, evil may look more attractive than good, an effect that promotes a false view of life. As philosopher Simone Weil writes: "Nothing is so beautiful and wonderful, nothing is so continually fresh and surprising, so full of sweet and perpetual ecstasy, as the good. No desert is so dreary, monotonous, and boring as evil. This is the truth about authentic good and evil. With fictional good and evil it is the other way around. Fictional good is boring and flat, while fictional evil is varied and intriguing, attractive, profound, and full of charm."[38]

A Case Study

George MacDonald is renowned for his ability to portray authentic goodness in his fiction. W. H. Auden agrees: "To me, George MacDonald's most extraordinary, and precious, gift is his ability in all his stories, to create an atmosphere of goodness about which there is nothing phony or moralistic."[39] A study of MacDonald's *The Princess and Curdie* reveals it as an exam-

ple not only of goodness portrayed effectively in fiction but also of a balanced relationship between style and content.

In the beginning of *The Princess and Curdie* MacDonald gives the reader a subtle *poiēma* which is a microcosm of all he intends to say, the *logos*. These few narrative paragraphs at first appear to be nonessential. But after rereading the novel, the reader discovers that these paragraphs hold the key to his story. Even as Jesus, the stone that was ignored and thrown away, became the cornerstone (Luke 20:17), so an incidental description, image, or conversation can be the key to the entire message of a novel.

The narrator of *The Princess and Curdie* tells the reader why mountains are "beautiful terrors."

> They are portions of the heart of the earth that have escaped from the dungeon down below, and rushed up and out. For the heart of the earth is a great wallowing mass, not of blood, as in the hearts of men and animals, but of glowing hot melted metals and stones. And as our hearts keep us alive, so that great lump of heat keeps the earth alive: it is a huge power of buried sunlight—that is what it is. Now think: out of that cauldron, where all the bubbles would be as big as the Alps if it could get room for its boiling, certain bubbles have bubbled out and escaped—up and away, and there they stand in the cool, cold sky—mountains.[40]

In this passage the narrator is talking at the literal level about mountains. In fact, the whole story of *The Princess and Curdie* could be described as a story about mountains.

But on the second or figurative level in this passage, the narrator uses personification, the giving of human attributes to nonhuman beings, objects, or ideas.[41] The narrator heightens the terror of mountains by personifying them as giants who rush up out of the earth. And indeed, if a giant were suddenly to rush up and stand next to us, we would be terrified! As a good writer MacDonald creates this personification with suggestive descriptions that characterize the earth as alive, compare the depth of the earth to a human heart, and portray the mountains as prisoners who have escaped a dungeon and stand like giants against the sky. The word *dungeon* also reminds the reader of medieval castles, an image MacDonald will develop.

The narrator continues:

> Think of the change, and you will no more wonder that there should be something awful about the very look of a mountain: from the darkness—for where the light has nothing to shine upon, it is much the same as darkness—from the heat, from the endless tumult of boiling unrest—up, with a sudden heavenward shoot, into the wind, and the cold, and the starshine, and a cloak of snow that lies like ermine above the blue-green mail of the glaciers; and the great sun, their grandfather, up there in the sky; and their little old cold aunt,

the moon, that comes wandering about the house at night; and everlasting stillness, except for the wind that turns the rocks and caverns into a roaring organ for the young archangels that are studying how to let out the pent-up praises of their hearts, and the molten music of the streams, rushing ever from the bosoms of the glaciers freshborn. Think too of the change in their own substance—no longer molten and soft, heaving and glowing, but hard and shining and cold. Think of the creatures scampering over and burrowing in it, and the birds building their nests upon it, and the trees growing out of its sides, like hair to clothe it, and the lovely grass in the valleys, and the gracious flowers even at the very edge of its armour of ice, like the rich embroidery of the garment below, and the rivers galloping down the valleys in a tumult of white and green! And along with all these, think of the terrible precipices down which the traveller must fall and be lost, and the frightful gulfs of blue air cracked in the glaciers, and the dark profound lakes, covered like little arctic oceans with floating lumps of ice. All this outside the mountain![42]

This giant is not simply any giant but royalty. The giant has a cloak of snow like ermine, blue-green mail, hair, armor, embroidery, and tassels of white and green. The giant is not alone, but lives in a castle with an extended family: the "great sun, their grandfather" and "their little old cold aunt, the moon, that comes wandering about the house at night" and the wind, "a roaring organ for the young archangels that are studying how to let out the pent-up praises of their hearts, and the molten music of the streams." If the first passage heightens the terror of mountains, this passage heightens the beauty.

The narrator continues:

But the inside, who shall tell what lies there? Caverns of awfullest solitude, their walls miles thick, sparkling with ores of gold or silver, copper or iron, tin or mercury, studded perhaps with precious stones. . . . caverns full of water, numbing cold, fiercely hot—hotter than any boiling water. From some of these the water cannot get out, and from others it runs in channels as the blood in the body: little veins bring it down from the ice above into the great caverns of the mountain's heart, whence the arteries let it out again, gushing in pipes and clefts and ducts of all shapes and kinds, through and through its bulk, until it springs new-born to the light, and rushes down the mountain-side in torrents, and down the valleys in rivers—down, down, rejoicing, to the mighty lungs of the world, that is the sea, where it is tossed in storms and cyclones, heaved up in billows twisted in waterspouts, dashed to mist upon rocks, beaten by millions of tails, and breathed by millions of gills, whence at last, melted into vapour by the sun, it is lifted up pure into the air, and borne by the servant winds back to the mountain tops and the snow, the solid ice, and the molten stream.[43]

The narrator continues to use personification: "as the blood in the body: little veins" and "the mountain's heart, whence the arteries let it out again."

Some of the personification is a little more subtle. The water after it "springs new-born to the light" "*rushes down* the mountain-side in torrents," possibly referring to tears, later also described as "the underground waters" that "gush" from the heart.[44] The beautiful terror of a royal giant has a paradoxical side to it. The sea, "the mighty lungs of the world," takes the "tears" and tosses, heaves, twists, dashes, and beats them, eventually lifting them up "pure into the air." Is this not an image of doing laundry, taking clothes and rubbing them against rocks to remove the dirt? MacDonald repeats the imagery later in the novel.[45] The giant has great passion—tears. These tears eventually become pure, an allusion to MacDonald's view that suffering can edify in the long run.

The narrator continues:

> Well, when the heart of the earth has thus come rushing up among her children, bringing with it gifts of all that she possesses, then straightway into it rush her children to see what they can find there. With pickaxe and spade and crowbar, with boring chisel and blasting powder, they force their way back: is it to search for what toys they may have left in their long-forgotten nurseries? Hence the mountains that lift their heads into the clear air, and are dotted over with the dwellings of men, are tunnelled and bored in the darkness of their bosoms by the dwellers in the houses which they hold up to the sun and air.[46]

In the last paragraph, the narrator surprises most readers by using feminine pronouns. Usually, giants and royalty in armor are portrayed as men. But here it is a woman, a mother with children. The mountains are personified as a human giant, strong, wealthy, awful, royal; in fact, a strong, awesome, beautiful but terrifying, royal, female personage who sustains life and brings precious gifts of jewels to her children.

Thus, these mountains are not just any giant but a personification of one of the main characters of the novel: the grandmother, Queen Irene.[47] In *The Princess and Curdie* the grandmother is an image of God, in the biblical tradition of a wise woman (Prov. 8:1–21; 2 Sam. 14:1–24; 20:14–22). She can sustain life.

What significance does this opening section have in light of MacDonald's overall goals for this novel? He personifies nature to express God's personal, continual, and powerful presence. In the opening section MacDonald dramatizes Romans 1:19–20: "What can be known of God is manifest among [humans]; for God made it manifest to them. For [God's] unseen attributes, namely God's everlasting power and deity, are being seen thoroughly since the creation of the world, being perceived by means of the things God has made" (my trans.).[48] Later in the novel MacDonald's writing is more explicit when he describes the grandmother: "All the beauty

of the cavern, yes, of all he knew of the whole creation, seemed gathered in one centre of harmony and loveliness in the person of the ancient lady who stood before him in the very summer of beauty and strength."[49]

MacDonald also expresses this same idea in a nonfictional manner in a letter to his wife: "The beautiful things round about you are the expression of God's face, or, as in Faust, the garment whereby we see the deity."[50] Rolland Hein writes of MacDonald: "Everything 'on God's earth' is 'an outward and visible sign of an inward and spiritual grace,' in the sense that all circumstances and objects that surround a man on any given day of his life are invested by God with the potential to speak to him. Whether or not the potential that resides in a specific thing is realized by a specific man depends upon that man's present stage of spiritual development, his sensibility, and his attitudes."[51]

Why was MacDonald not more explicit in his introductory narrative? One of the main themes in *The Princess and Curdie* is the importance of perception. Belief or trust is needed before truth can be perceived. A superficial glance at the world around us will not result in perceiving creation as a mirror of God's power and deity. In the same way, a superficial glance at MacDonald's world will not result in perceiving MacDonald's intent. MacDonald's *poiēma* has mirrored his *logos* in an effective fictional piece. Yet the style is not so overbearing that it keeps readers from reading the novel simply as an interesting story.

Suggestions for Exploration

1. Write in the first person an incident (real or imagined) from your childhood or adolescence that was important to you.

2. Rewrite the incident in the third person and from the point of view of someone else in the story.[52]

3. Look at every verb in your account. Can you replace any adjectives, adverbs, or nouns by using a more descriptive verb?

4. Do you use any metaphors or allude to any of the five senses? Can you add any metaphors or references to the senses to connote the meaning you intend?

5. Does your piece further God's reign? Would you like to rework it to do so? What Christian truth do you elaborate?

6. Pick a topic for a short story. If possible, fictionalize and develop the incident you wrote about in suggestion 1. Choose a setting, especially one you know well. Choose characters. Write one paragraph to one page on each character's life, personality, and endearing traits.

7. What is the main point you will communicate? How will you show this point through the development of your plot? What events cause com-

plications? What will be the climax for the plot? What images will you hide in your plot as clues for the discerning reader to determine what really is happening?

8. Choose a point of view from which to tell the story: third person (omniscient or main character); first or second person (main or minor character).[53] The first sentence should hook the reader. The ending should give the reader a sense of satisfaction. You may be a writer who writes a whole story under inspiration. If so, after you have written the story, go back and check each of the above items.

3 God in the Music Box Mirror

William David Spencer

In 1994 thousands of Cubans fled their homes in makeshift rafts and flooded into refugee camps in Florida, Panama, and Honduras. One refugee explained the mass escape to *New York Times* reporter Maria Newman: "There is nothing left for me here. There are no jobs, there is not enough food. Here everything is for the tourists. Cubans see none of what the tourists have access to here, not the food, nor even the music of Cuba itself."[1] As a result this man and his brothers cast their fates on the waters, braving sharks at sea and nearly inevitable imprisonment in refugee camps to escape Cuba.

Why had they found life intolerable in Cuba? No jobs, no food, no music: no sustenance for the body, no sustenance for the spirit. For them, music is as necessary as food and the livelihood to secure both food and music—nourishment without which the body weakens while the spirit withers. The music staff, for these Cuban refugees, is part of the staff of life.

These desperate people were right on target biblically, for music was playing when life itself began. Though with sin other songs rose to din the primal song of praise to God, the song that honors God today echoes the paean to God at the time of creation.

In the Beginning

Music at Creation

When God, the great construction worker, set the cornerstone of the earth and laid its foundation, the morning stars blasted away and the heavenly choir screamed for joy (Job 38:7)—God's radio on the job site.

We might not readily associate God with such a heavy metal or hard-core level of noise, conditioned as we are by Plato's image of a celestially measured "music of the spheres"—a music

quietly beating time while the universe revolves around God as its still point.[2] But the Hebrew words in Job 38:7 suggest something just that raucous. *Rānan*, the first verb of the sentence, means "to cry aloud, to shout with joy, to rejoice, to lament, to wail, to give a ringing cry." The Masoretic text renders it "sang," as do the main translations of the Bible (KJV, NIV, NRSV, NAS, NEB), while the Jerusalem Bible prefers "singing." If this is singing, it is a raucous type: "When the stars of the morning cried out a ringing shout-song of joy" (my trans.).

The second verb in Job 38:7, *rûʾa*, is perhaps even noisier; it means literally "to be noisy, to shout with joy, to raise a cry, to lament, to give a blast with a clarion or horn, to shout in triumph or applause or with loud public music, to shout in praise, or to raise a war cry." So the second part of the verse reads literally, "and the children of God blasted joy or praise in triumph." Nothing quiet is going on here at God's tumultuous, musically scored creation extravaganza.

Lamech's Boast

The church, however, has not always been comfortable with such boisterous praise—or with contemporary music. The church has a good reason for its caution, of course. Since the origin of humanity popular music sometimes has been at odds with the values of faith.

Genesis 4:23–24 is the first record in Scripture of a song composed by a human—Lamech's boast. It is a primeval piece of what the ancients knew as the boasting song, what today we would call gangsta rap.[3] Across the millennia it has echoed, resounding around the world in various forms, such as the boasting songs in traditional African culture kept alive today by the griots, those wonderful traditional singers of French-speaking Africa and their counterparts throughout the continent.

Lamech's archetypal song is so ferocious it breaks out of what had been the ancient pattern. In this bloodthirsty chant, the unsavory bigamist Lamech, brother of Tubal Cain, the founder of the nation that first used the lyre and pipe (ancient predecessors of the guitar and brass), puts himself in the position envied by Sam Cooke's protagonist in "Another Saturday Night." He's "swinging," "two chicks on his arm"! Strutting before his two wives, Adah and Zillah, he crows about his prowess in a style contemporary gangsta rappers, the heirs of seminal gangsta group NWA, would emulate:

> Adah and Zillah,
> Hear my voice!
> Wives of Lamech,
> Listen to what I say,

> Because a man have I murdered for my wound,
> And a male child for bruising [or scarring] me.
> If seven times Cain is to be avenged,
> Then Lamech seventy and seven times!
>
> (my trans.)

Though it starts with the tight structure of the matched pairs of traditional Syro-Palestinian poetry, Lamech's lyrical form disintegrates as his claims get more extravagant. By the end of the chant, he is claiming that if his ancestor Cain is avenged sevenfold for an offense, he will be avenged seventy-seven, even killing a youth for merely wounding him.[4]

If today's Nigerian reggae star Majek Fashek in "Majek Fashek in New York" warns that anyone who causes him trouble will be paid back double, Lamech has wreaked his vengeance nearly fourscore times more! Certainly not values the family of faith encourages!

Moses' Boast

Yet almost as ferocious as Lamech's song is the next song recorded in Scripture. Though poetry is quoted on such occasions as Isaac's blessing of Jacob (Gen. 27:28–29) and songs are referred to by Laban in Genesis 31:27, the next song actually quoted in Scripture is by none other than Moses the liberator, in Exodus 15:1–18.

Interestingly, this is a boasting song too, but it boasts about the Lord. It is a shout of triumph that cries a message contrary both to the laments Israel wailed to God in Exodus 3:7 and to the boasting song of Lamech. For this boasting song brags of God's ability to exact revenge, provide succor, and triumph gloriously in battle:

> I will sing to the LORD,
> for he is highly exalted
> The horse and its rider
> he has hurled into the sea.
> The LORD is my strength and my song;
> he has become my salvation.
> He is my God, and I will praise him,
> my father's God, and I will exalt him.
> The LORD is a warrior;
> the LORD is his name.
>
> Exodus 15:1–3 NIV

If Lamech has blown away a teenager, God has blown away an army—Pharaoh's army, to be exact. And God has washed it down a lot more than

51

simply giving those "dirty 'gyptians" a "bath," as Larry Norman chuckled in his "Moses in the Wilderness." As the prophetess Miriam and her backup singers affirm, when Miriam picks up her tambourine and leads what appears to be a call-and-response chorus, God has heaved "horse and rider" to their deaths in the sea (Exod. 15:1–18).

Except for the soothing tunes by Israel's future pop star–king David to quiet the manic Saul, these two ferocious songs of Genesis frame the chorus (and sometimes cacophony) of scriptural songs: the boasting songs of fools, like Lamech, that are not worth hearing (Eccles. 7:5) and the triumphant paeans to God's might by Moses, Miriam, Deborah, Hannah, Mary, David, and the psalmists.

Theology in Song

Old Testament Songs

The Hebrew word used for song is *shîr* or *shirāh*, but a variety of other words indicate whether the song is intended to praise *(zimrāh)*, or to be a mocking, derisive parody *(meginnāh)*, or to be accompanied by a stringed instrument *(nāgan)*. The main function of song in the Old Testament, of course, is to praise God. Further, the Creator God is an inspiration or source of music ("God . . . gives songs [*zimrāh*] in the night" [Job 35:10, my trans.]; a subject of music ("The Lord is my strength and song" [Exod. 15:2, my trans.]); and an audience of music ("sing unto the Lord" [Isa. 42:10, my trans.; see also Neh. 12:46, Ps. 144:9, and many other psalms]).

By far the bulk of the Old Testament songbook is by David, who poured a steady stream of praise songs to the chief musician and the tabernacle orchestra. His output is preserved for us in such psalms and shiggaions (wildly emotional, enthusiastic songs or dithyrambs) as Psalms 3–9, 12–13, 15, 18–24, 29–30, and dozens of others; some seventy-three in all are attributed to him. The sons of Korah weigh in with such songs as Psalms 45–49 and 84; Asaph with Psalms 50, 73, 75–77, and 79–80; and other miscellaneous psalmists add their compositions—from the famous (Moses in Psalm 90) to the lesser known (Ethan in Psalm 89) to the anonymous (Psalms 91–100).

Psalms and other scriptural songs are particularly honored in the Bible as vehicles of specific revelation, sometimes as prophecies (see Psalms 2, 16, 22, 69). Often psalms provide insights into God's nature. In the music box mirror of these songs, God's nature is reflected.

For example, we learn in Moses' and Miriam's songs at the victory at the Red Sea that God triumphs gloriously in history (Exod. 15:1, 21) and that God saves in a temporal way and provides power to God's people (v. 2).

We also learn that the Lord uses natural elements to defeat those who would oppose God (v. 10), that God is awe inspiring in splendor and performs wonders (v. 11), and that God has steadfast love for God's people (v. 13). Moses' song is one of the earliest appearances of the key term *hesed* (lovingkindness), which describes a central attribute of God. And the song proclaims that God will rule forever (v. 18).

God's Reflection in the Psalms

The Book of Psalms, of course, is a mixed bag of songs, prayers, and poems. The Hebrew name for psalm, which is a more general term for making music, *mizmôr,* is derived from a word attempting to capture the sound of humming. The word came to mean "intended to be accompanied by plucking an instrument" (*psalmos,* another onomatopoeic word in Greek). In Psalms an entire theology of God's nature is revealed through the experiences of various psalmists.

To give examples, God, we learn in Psalms, is the glorious creator (Psalm 8), who not only causes children to be born to humans (113) and satisfies human longings (63) but also satisfies the desires of all living things (145). God establishes the world (93) and rules the earth (47). In fact, God rules all nature and all other rulers temporal and spiritual (95), gives rulership of the earth to humans (8), and even numbers and names the stars (147). God is perfect (38), majestic (93), and unique (86).

In Psalms we learn that although God is omnipotent (135), and omniscient and omnipresent (139), God is particularly interested in humankind. God rewards those who live just and kind lives of respect for God and other people and punishes those who do not (1). God gives security to those who take refuge in God's care (91) and guards the good (97), loving those who hate evil (97).

Because God is holy (99) and righteous (129), God judges (50) justly (75) and is angry with those who break God's laws (78). But God is also forgiving (6) and merciful (38), like a shepherd or farmer who restores (80). God will not forsake the faithful or repentant (94), is ever mindful of God's covenant with people (111), and is faithful to all promises made (145).

Wise (103) and terrifying (114), surrounded by mystery (97), God is worthy of worship (96). Though God prefers a faithful heart over religious ritual (40), God also enjoys singing, dancing, drumming and instrumentation (149), and even crashing cymbals (150) in praise.

God's steadfast love (48) lasts forever (118).

These and other themes are repeated throughout Psalms. In a sense Psalms echoes the experience of Moses and the Israelites: that when all looks lost, God will step in and deliver the innocent if they cry out. There-

fore, the plethora of songs throughout the biblical text are tributes to God's victories and expressions of human exultation at them.

God's Reflection in the Conquest of Canaan

Triumphant songs like Moses' abounded during the conquest of Canaan. Israel celebrated much by song; for example, striking water at a successful well (Num. 21:17–18). In this musical record of their experiences, the Israelites followed earlier traditions (see, for example, the song of their predecessors the Ammonites in Num. 21:27–30). But what stands out in Israel's music is the song that celebrates God and God's great acts.

Moses' song in Deuteronomy 32, for example, proclaims that God's ways are just and that God is without deceit (v. 4), facts Israel learned over and over after its deliverance from Egypt. This is the God who decrees nations (v. 8), to whom all prosperity is owed (vv. 10–15). Israel, and all who wish to receive God's favor, had better heed this warning song, for God is jealous (v. 19) and punishes unfaithfulness by withdrawing attention and favors (v. 20).

This is a ferocious, serious song. When Moses gave it to Israel to commit to memory and pass on, he ordered the people to take it to heart (Deut. 32:46). Those who heeded the words of this song throughout Israel's history were able to sing a similar song of triumph, learning these truths about God while others around them despaired.

Deborah, for example, bolstered the reluctant Barak as he led Israel into battle, and together they celebrated a mighty victory over the army of the Canaanite king, Jabin. At the smashing of the Canaanite forces, Deborah and Barak lifted a song to bless the Lord (Judg. 5:1, 9), to celebrate the Nazarite vows and the return to faithfulness of Israel (v. 2 RSV), and to recognize God's intercession in war (vv. 4–5, 20) and God's willingness to work again with God's faithful people (vv. 11–13). The theme in this song and in Moses' songs is one that resounds again and again in Scripture: Because God is the good's true strength, even a peasantry can defeat a great army. God reverses positions of power.

God's Reflection in Historical Narrative

Hannah discovers God's tendency to exalt the humble and demote the haughty, and celebrates it in her song of triumph. She extols God's uniqueness (1 Sam. 2:2), that God knows and weighs the value of human actions (v. 3). Therefore, God raises the humble and powerless and puts down the arrogant and powerful (vv. 4–8), even giving and taking life (v. 6), cutting off the evil but sustaining the faithful (v. 9), for God is a judge (v. 10).

As we can see, Old Testament songs are personal and national responses to what God has revealed about God's nature and, particularly, what God

has done. The Bible's songs highlight and celebrate mighty acts of God. James in his New Testament epistle recommends that people should sing when they are happy (James 5:13), and this is what these great believers do.

By the time in Israel's history that David dances before the ark of the covenant (1 Chronicles 15), both David and Israel have many reasons to thank God, and David's psalm of gratitude in 1 Chronicles 16:1 summarizes all the great acts of God that came before, culminating in the gift of the land of Canaan. This sense of gratitude seems to be the essential element of Israel's psalmody. Though many songs of sorrow will be sung in captivity (see Psalm 137 and the Book of Lamentations) and many pleas for deliverance and vindication will still rise (Psalm 94), each song will be built on the same assurance of God's steadfast love that is expressed in 1 Chronicles 16:34. This theme runs through the use of psalms, whether formal psalms of praise (2 Chron. 5:13), doxological endings of prayers (2 Chron. 6:41–42), responses to God's protection (Isa. 26:1–21), oracles of a prophet (Zech. 13:7–9), or citations from Psalms in New Testament sermons and epistles as illustrations of the nature of God.[5] Even John, who seems the least musical of New Testament writers, judging from the general absence of quotations from Psalms in his writing, notes in 3 John 11 that God is to be identified with the good—an echo of Psalm 37:27–28. The Old Testament themes of purification and deliverance by God's steadfast love remain constant into the new covenant. The Book of Psalms is the repository, developing all these themes and retelling the great things God has done.

New Testament Songs

New Testament songs are built on these Old Testament models and celebrate how God reveals God's character in present days. Mary's poetic magnificat in Luke 1:46–55 celebrates the same reversal of the humble and proud that marks Hannah's prayer of praise. Mary extols God's mercy (v. 50), God's manifestation of power (v. 51), and God's faithfulness to God's covenant people (v. 55).

Zechariah's poetic prophecy identifies God's deliverance as the provision of a mighty savior for redeeming God's people (Luke 1:69). That savior, Jesus, will be met with shouts and songs of blessing (Mark 11:9–10; Luke 19:38), and well might this be, since Revelation reveals that blessing the name of the Lord is the chief content of the songs raised before the throne of the mighty God.

The earth has heard this praise of the angels before, when the heavenly hosts praised God and proclaimed God's gift of peace to those stunned shepherds in the fields near Jesus' birthplace (Luke 2:14). The vision of Revelation is filled with this mighty roar of acclamation. Day and night the angels

celebrate God's holiness and eternalness (Rev. 4:8), God's worthiness to be honored for creating and sustaining all things (Rev. 4:11), Christ's sacrifice for redemption (Rev. 5:9–10), and Christ's worthiness to be honored (Rev. 5:12–13). So God is continually thanked (Rev. 7:12).

Even some Old Testament songs continue to be sung in heaven. The song of Moses is chanted, now augmented by the song of the Lamb—a tribute to the Christ who has fulfilled the deliverance presaged by Moses (Rev. 15:3–4).

In Revelation God's judgments are revealed (Rev. 15:4). Laments rise from those who oppose God, while heaven rejoices in the fall of God's opponents (Rev. 18). And with opposition to God collapsing, the cacophony of foolish songs in praise of evil ceases and all songs praise God. "Hallelujah!" lifts the cry in Revelation 19:1, and it continues after the final war with evil into an eternity of rejoicing in God.

Seeing how much is revealed about God through the medium of the psalms, we see why they are important in the Bible and why the called of God give them so much attention, from the humblest of peasants like Mary to the most splendid of kings like Solomon.

Foolish Songs and Wise Songs

Solomon certainly inherited David's musical ear. We do not have a record of how many songs David composed, but Solomon wrote one thousand and five, according to 1 Kings 4:32. Sadly, few of his greatest hits are recorded in the Old Testament text: the prayer in Psalm 72, Psalm 127 (the "song of ascents," in which he followed the style his father used in Psalms 122, 124, and 131), and, of course, his major Song of Songs. These examples are a fraction of his output (compared to David's recorded contributions), which makes us wonder how many of his songs were composed in his later years, after he had followed his foreign wives into idolatry. He probably had a mixed song bag. Some would be the songs of his wisdom, praising God, and some might fit into the category of foolish songs, praising another deity.

Foolish songs are a subset of music found in the Bible, and this subset has a variety of subcategories, including the mocking songs of the scornful (Lam. 3:14; Job 30:9), the barroom ballads of drunkards (Ps. 69:12; Isa. 24:9), and the empty ditties of fools (Eccles. 7:5; Prov. 25:20).

Another subset of music in the Bible is wise songs. As we have seen, the "new song" of the psalmists resounds throughout the Bible. In Ephesians 5:19 and Colossians 3:16, Paul identifies some subcategories of wise songs: psalms, hymns, and spiritual songs—praise songs that edify the church on earth.

Psalms, as we noted, were songs of praise accompanied by stringed instruments plucked with the fingers instead of a pick *(plectrum)*, a technique

used by harpists in the past and by today's finger-licking folk singers. One can see why the harpist David favored this form.

Hymns *(humnos)* were the traditional songs of praise to God or, in Greek history, to the gods or heroes.

Spiritual songs *(ōdē)* or odes seems to be a catchall term for song, lay, ode, joyful songs, songs of praise, and even poems, magic songs, songs of birds, and "various songs associated with particular employments or conditions."[6] Scripture specifies that these odes be spiritual ones.

As the Bible warns, the music of Babylon and its sinful will end with its fall (Rev. 18:22), but the song dedicated to God will ring out in the joyful praise of the righteous forevermore. So one side of our musical frame is built to last; the other sandy side, built to fall. What is the foundational difference? The subject of the song of the ungodly is their own might; the song of the godly is about God's power and the human response to it. And God's call is looking for a response.

When Jesus characterizes Israel's refusal to play along with God, he alludes to a funeral dirge and a popular dance tune. Apparently appropriating a popular children's song from the downtown of Jesus' time, he likens Israel to children singing to one another: "We played a flute tune to you and you did not dance; we sang a dirge and you did not cry" (Luke 7:32, my trans.). Like his father, Jesus demands a response.

Whether dancing or wailing, whether using music composed as a song on the spot, as did Moses or Deborah , or picked up from a popular hit, as did Jesus , the saints have always used music to celebrate God's power and record their responses to it. For God, making a joyful noise *(rûʾa* again in Ps. 100:1) is what counts.

Images of God in Popular Music

As we look across the sweep of popular music since biblical times, we see contemporary parallels to the scriptural categories of foolish songs and wise songs. Therefore, we find a variety of perspectives on God expressed in today's worldwide music scene.

Afro-Caribbean Images

Today's global music may hearken back to gospel music, folk music, or the music of other religions. For example, when we were visiting Jamaica in May 1998 and teaching at the Caribbean Graduate School of Theology in Kingston, a "reggae revival" was going on in popular music that is intensely impacting the popular culture. High-profile conversions to Jesus

Christ by such world famous Jamaican performers as musical stateswoman Judy Mowatt, a former member of the I-Three (Bob Marley's female vocal contingent and winners of Jamaica's coveted Musgrave Award for 1997), superstar Carlene Davis ("Jamaica's Reggae Songbird"), best-selling reggae dancehall deejays Papa San, Lieutenant Stitchie, and Junior Tucker, as well as the island's foremost producer, Tommy Cowan, have rocked the world of Afro-Caribbean music. Seemingly overnight, huge gospel sections have appeared in record shops formerly dedicated exclusively to Rasta and secular reggae. Public buses and taxis are emblazoned with decals announcing "Jesus is the Answer" and "Fear God." Two new religious radio stations and "Love TV," a religious television station added to Jamaica's other three networks, pour out the gospel message of the Grace Thrillers and Jamaica's many wonderful Christian musicians, and traffic jams up for hours when gospel performers like Ron Kenoly headline a concert before thousands in a huge natural amphitheater operated by performer-turned-pastor David Keane and the charismatic Family Church on the Rock. As reporter Reginald Allen observes in the *Sunday Gleaner,* Jamaica's premier newspaper, "The popularity of gospel music has surged in sharp contrast to other forms of music like reggae."[7] Even secular and Rastafarian performers are paying respectful tributes to Jesus. One notable example is Dean Fraser, the veteran Rastafarian saxophonist whose work has enhanced countless reggae albums. He followed his tribute to Bob Marley with a collection dedicated to his Christian aunt called *Jesus Loves Me,* a beautiful album that includes such hymns as "A Mighty Fortress," "Amazing Grace," "Rock of Ages," and "The Old Rugged Cross."

Out of this rich mix, innovative Christian groups like Jamaica's stellar Lester Lewis and Singing Rose Ministry are even reaching back to the musical roots of the burra rhythms of West Indian slaves to celebrate the liberation of all captives accomplished by "The Lamb" that was slain. Count Ossie adopted burra rhythms in the 1950s to lay the basis for what would become today's reggae rhythms. To enlist such music to extol liberty in Jesus seems more than appropriate, since reggae music from its inception was developed by members of the Rastafarian movement as a reaction to the excesses of possession-oriented revivalism. Rastafarians insisted on one sovereign deity, not a pantheon. Where the message of adherents and global reggae superstars such as Bob Marley, his bandmates the Wailers, and some of his colleagues erred was in confusing Haile Selassie I, the emperor of Ethiopia, with the Jesus Christ that the emperor worshiped, as evidenced by T. "Ijahman Levi" Sutherland's beautiful yet cultic hymn "Jesus Selassie I Keepeth My Soul." Haile Selassie himself established a branch of the Ethiopian Orthodox Church in Jamaica to deflect worship from himself to Jesus, a message that Rastas, particularly of the Twelve Tribes persuasion, are increasingly coming to understand, hence the revolution in reggae. For

an intention of the music (as was true of island Christian music) was always to rescue people from the appeal of the orisha,[8] the many demanding deities of the Afro-Caribbean power religions that have pervaded global popular music.

In these religions, each of the gods in a pantheon is called into action by a different rhythm. In Haitian Vodun (Voodoo), for example, a god responds by striking a pole placed in the worship yard, traveling down the pole and along the ground, and coming up through the dancing feet of a worshiper, taking possession. Fans of the United States' David Byrne who enjoyed the Talking Heads' album *True Stories*, which accompanied Byrne's foray into major motion pictures, might not have realized that the song "Papa Legba," which closes the album, is an appeal through lyrics and rhythm to a member of the Vodun pantheon of gods to come and "ride the horse," the Vodun phrase for taking spiritual possession of an adherent. (One can find the same kind of terminology in more traditional religion-oriented Caribbean albums; for example, in the Haitian group Boukman Eksperyans' *Vodou Adjae* or in Jamaican Lord Sassa Frass's "Pocomania Jump," which is dedicated to "all Horseman.") Musicians from Lagos to Paris, Kingston to London, Rio de Janeiro to New York have adopted such rhythms and secularized them, just as North American musicians have secularized the music of the black church in rhythm and blues.

Carnaval not only is a world-famous tourist attraction but also includes a competition among city sections for prize money coveted for education and much needed neighborhood improvements. Similarly, in Brazil many of the rhythms employed by the neighborhood Carnaval bands are borrowed from Candomblé, Umbanda, Xangô, Catimbo, Caboclo, Casa das Minas, and Batuque—Brazil's power religions. Brazilian rhythms have been popular globally since the beginning of the twentieth century, particularly after the fascinating allegorical film *Black Orpheus* won the grand prize at the Cannes Film Festival in 1959. The film told the Greek mythological tale of Orpheus and Eurydice in a Candomblé-tinged Carnaval setting and, through its exquisitely beautiful soundtrack, introduced the world to what had been happening in samba. In addition to the use of rhythms, references to the gods pervade the lyrics of popular music in Brazil and in parts of Latin and South America. Famous samba performer Clara Nunes included references to Candomblé in her repertoire, just as the outstanding Margareth Menezes recently celebrated Oxala, the supreme deity, in her international hit "Elegibo."[9] Combining music and dance, the Bale Folclorico da Bahia brings to international audiences such pieces as "Dança de Origem," which tells how Oxala and his sons formed the universe in Candomblé mythology. In contemporary Cuban music, since Celina Gonzalez's celebration of "Santa Barbara/Que Viva Chango" openly united the Catholic saint with the Nigerian god Shango in the

1940s, open references to traditional religion became a movement that produced international stars like Tito Puente and Celia Cruz, who today pay regular homage to the religion Santeria. Trinidadian soca giant Nelson in "Down by the Riverside," on his album *Bring Back the Voodoo,* pays an overt tribute to the entire Nigerian orisha, the pantheon that lies behind Vodun, Santeria, Candomblé, Kumina, Trinidadian Shango, and the other Afro-Caribbean power religions.[10]

In the motherland of Africa, themes and drumbeats associated with gods so infuse popular music that when the great Nigerian drummer Babatunde Olatunji reintroduced the world to pan-African rhythms in his Drums of Passion collections in the late 1950s, he felt comfortable including both songs that celebrate Christ, such as the African Methodist Episcopal Church's "Bethlehemu," along with "Shango," a "chant to the God of thunder, the deified king of Old Oyo." One of our Nigerian students at the Caribbean Graduate School of Theology in Kingston, Jamaica, told us that a delegation of youth in Nigeria had petitioned church leaders to create a "Christian" drumbeat for their use, one that would be free of association with the lesser gods. Nigerian musical giant, Chief Commander Ebenezer Obey, a devout Christian supporter of the Evangelical Churches of West Africa and star of over a hundred best-selling albums, has done just that by creating the miliki rhythm, characterized by breathtaking guitar virtuosity and undulating polyrhythms.[11]

Still, the "Shango Message" (as the group Shango, produced by Afrika Bambaataa and Bernard Fowler, testifies) is one that has spread through the popular music of the globe. What is the message about God in power religion? The Supreme God has sent forth emanations that demand reverence and sacrifice from humanity. Unfortunately, these demands result in the bondage from which pagans rejoiced to have been freed when the once and for all sacrifice of Christ was first preached, eliminating the need to shed blood to propitiate deity. As Hebrews 10:12 puts it, "But this one [Jesus Christ] on behalf of sins produced an offering for all time" (my trans.). When we lose this beatific vision, a miserific vision of enslavement, blood sacrifice, and death follows.[12]

Satanist Images

The ultimate power religion, of course, is Satanism, around which groups like Slayer and even the Rolling Stones have flitted, nurturing a stance of rebellion chic. Sometimes groups identified with this tired anarchistic cesspool of sadomasochistic depravity and outmoded ritual ending in disappointment, despair, self-destruction, ultimate horror, and eternal misery have even reacted against it. Black Sabbath's "After For-

ever" on the album *Master of Reality,* for instance, asks if the listener has ever thought about whether one's soul can be saved. It asks whether God has become a part of the listener or if Christ is simply a name read in a schoolbook. The narrator proclaims he has seen the light and changed his ways, looking forward to final peace while rejecting listeners who will be "scared." The lyrics scoff at those who do not believe because of their friends' opinions, pointing out that they should realize that love comes only from God. The song chastises listeners who reject Christ, claiming they are weakly following the crowd and are no better than those who crucified Jesus. And to everyone who claims that God is "dead and gone" it lectures that only God can salvage them from "sin and hate."[13] The song is as forthright a testimony tract as anything on record. One sees a similar ambivalence in Alice Cooper, who has exploited the miserific vision as a stage antic.

More disturbing, however, is the theological vision of former attender of Christian schools Brian Warner (a.k.a. Marilyn Manson), the self-styled "AntiChrist Superstar." The band's concept album compares the growing up of a child in United States culture to the life cycle of a moth. Consistently pessimistic and nihilistic, the song cycle features self-loathing ("Wormboy," "Angel with the Scabbed Wings," "Tourniquet"), family loathing ("Kinderfeld," which refers to the toy trains a grandfather would run to cover moans of masturbation), and fan loathing ("Mister Superstar," "Dried Up, Tied and Dead to the World"). In this worldview, one's sole destiny is death ("Minute of Decay") with no salvation ("Man That You Fear," "Kinderfeld"). The reason for such a miserific vision is given in "The Reflecting God," where the narrator reports "seeing" God and finding himself simply "looking" at himself (the rock star as "Supergod," also in "Mister Superstar"). If failed humanity is the only God, then truly "everyone dies," as the song laments. And as in Flannery O'Connor's "A Good Man Is Hard to Find," in which authentic goodness is only achieved in the face of certain death, a reason for life is only found when death threatens.

Far from the Eastern view that one can bow to the "god" within another, in Marilyn Manson's perspective, one sees only an "AntiChrist," who is a "fake" star out for money, a "Moon" eclipsing the true "Sun." This antibeing (who does not "deserve" life) buries listeners' concepts of God in his spit ("Deformography"). Who is blamed for such despair? The fault is laid on "The Beautiful People" capitalism allows, whom fascism will eliminate, though fascism is also soon rejected ("1996"). Despite the press hype of Marilyn Manson's members as being paid up in the Church of Satan, "1996" declares the "AntiChrist" stance as also "AntiSatan."

The reason why Marilyn Manson rejects the idea of humanity as God is presented in "Irresponsible Hate Anthem," a scathing rejection of United States culture for "selling" suicides, abortions, and oppression. The song

alludes to the slaughter of the Amerindians (a slaughter which sent scores of people to God to "sort out") that has produced a culture of violence in which the "stick" is put in the hand of the victimizer. Marilyn Manson also attacks abortion in "Man That You Fear," a chant wherein the culture's surviving children are "poisoned" by television and grow up "inescapable" in their "sins" to prey on their parents with continuing violence.

This is a sick, sad worldview in which even the "watered down" slogan "Love everybody" and its antithesis "Hate" are unbearable in a world which is all humans have—both their heaven and their hell ("Wormboy").[14] In the *telos* of Marilyn Manson's work, the image of God most visible is that of erring humanity, and it is one that inspires disappointed loathing.

Neopagan and Eastern Images

A less nihilistic neopagan vision of God can be found in the music of self-avowed Wiccans like Stevie Nicks of the superlative Fleetwood Mac, especially in her "Rhiannon," which is about a Welsh witch and was still being recycled in the band's signature medley in the 1998 Grammy Awards ceremony. Sorcery positing gods as forces is sometimes evident in new folk music. Celtic folk music, for example, sometimes uses Druidic power images of divinity. One particularly skillful description of the "great dreams" that are "blown down" by "old forces" (as Celtic pagans viewed their nature deities), leaving behind the "white bones" of long dead adherents still in the sacrificial posture of offering "strange prayers in high places," has been captured by Thom Moore in the arresting song "Still Believing," powerfully rendered by Mary Black on her *Babes in the Wood* collection.[15] Against this lethal propensity to spill blood, South Africa's superstar singer Mahlathini, the Lion of Soweto, who sings call and response with the legendary Mahotella Queens to head the world's leading mbaqanga group, has issued a warning to all who would practice power religion in "Bhula Mngoma!" ("Find Out Witchdoctor!"). Give way to the Christians, he commands, for there stands truth.[16]

The appeal of neopagan power religion has always been the immanence of God, God's closeness to humanity. Eric Bazilian, a former member of the 1970s band the Hooters, captured this longing in a song he wrote for blues singer Joan Osborne, "One of Us," a song that wonders if God can feel humanity's loneliness, if God can really be that near to us.[17]

In the book *Hungry for Heaven* London-based musicologist Steve Turner details how the use of LSD confused popular musicians in the 1960s into thinking that "God is a force we are all a part of," as he quotes Paul Mac-Cartney.[18] The effect in the sixties was to turn formerly atheistic musicians

into pantheists. From the early sorcerers of the Shen Nung dynasty of China in 2737 B.C. to the Amerindian peyote cults in the United States today, users of hallucinogenic drugs have regularly experienced the drug-induced illusion of being in contact with deity.[19] One can find this journey delineated in the songs of George Harrison. "Soft-Hearted Hannah" describes how, after he "ate it," his eyes were opened. In "My Sweet Lord" he names the deity he has found; the backup singers alternate singing "hallelujah" with "hare Krishna," a technique Harrison expands in "Life Itself," in which he identifies "the One" as Christ, Vishnu, Buddha, Jehovah, our Lord, Govendam, Bismillah, Creator of All.[20]

Though the original Hinduism of the Guatama Buddha set forth moral principles to live by—an ethical lifestyle without an afterlife or supernatural transcendence—people needed a spiritual experience of knowing God; thus later "enlightened" teachers posited visitations of God in what are called avatars—incarnations in human form. Today's popular Eastern religion mixes pantheism, in which everyone is a part of God, with the appearance of avatars. The twentieth century has been rife with these appearances, many of them celebrated in popular music. The Maharaj Ji released a rock collection by the Anand Band singing his praises on his own Divine Light Mission label. Pete Townshend of the Who built the rock opera *Tommy* from the teachings of Meher Baba. While Ravi Shankar introduced ragas to the West, "Mahavishnu" John McLaughlin and the spiritualized Carlos Santana tried to represent the Eastern message in their music, a message also well captured by Rasa in the title of their album *Everything You See Is Me.*

Of course, not every religious reference one sees in popular music is always accurate or even intended. Musicians are often right-brain dominated and notoriously hazy or inconsistent in their concepts, sometimes more in love with the sound of words than concerned about their meanings. *Namaste,* for example, is a Hindi term popular in neopaganism which means the "good or soul or god(ess) in me salutes the same in you." The United Kingdom's Beastie Boys adopted it for their interesting bluesy piece "Namaste" but ignored the meaning of the word. Their song concerns a self-realization that darkness is not the opposite but the absence of light, which is good scholastic Roman Catholicism.[21]

Other recent rap, however, consciously departs into Eastern views, as does the United States' KRS-One when he claims the concept of Jesus was "stolen" from the Zodiac, Jesus being the "sun" of God, astrologically speaking. In this vision, the disciples are the twelve months, the four Gospels the four seasons, and the feeding of the five thousand a sign of the coming of the age of Pisces. In his perspective, the image of God is an astrological sign.[22]

Other Images

Many other images of God have crowded into contemporary music. Cat Stevens, who once turned the gatefold cover of one of his albums into a lesson on Buddhist self-denial, featuring one song that celebrated reincarnation ("Oh So Very Young") and another that identified Buddha with Jesus ("Jesus"), left Eastern religion for traditional Islam.[23] While Seals and Crofts turned to Bahai, Islam's nonviolent offshoot, Public Enemy embraced Louis Farrakhan's version of the Nation of Islam.

The self-proclaimed messiah of the Branch Davidians, David Koresh, like Gabriel of Sedona today, was a rock musician who released to radio stations cassette singles like "Book of Daniel" and "Sheshonian" from his enormous self-adulatory repertoire. Gabriel has turned his output into a hymnody, available on CD. Even Jeremy Spencer expended his considerable talent on a Columbia Records project promoting David "Moses" Berg's Children of God. The songs (except for the profanity in "War Horse") sound like most other Jesus Movement offerings, quoting Scripture and claiming "I Believe in Jesus."[24]

Some musical movements such as the Church of Elvis and the Church of Kurt Cobain are tongue in cheek—for now. But while these and many other movements globally may not overtly demand with the shamanistic Jim Morrison that one "cancel" one's "subscription" to Christ's resurrection ("When the Music's Over"), the result is the same when something other than the true image of God is proffered for acceptance.

As in every other realm of life, the partial or the counterfeit or the blatantly opposed image is often set up against the real reflection of God that leads to true wholeness and salvific truth. The question is, What image of God is going to predominate through the potent and informative medium of music?

Christian Images

In contrast, Christians over the ages have presented true images of God through popular music. The great teacher Clement of Alexandria, who lived around A.D. 200, set up a Christian school to transmit orthodox doctrine about God as well as to teach his students to interact with secular culture. One way he did so was to compose a hit song with a youth-oriented Christian pop lyric that we still sing in our church a full eighteen hundred years later:

> Shepherd of eager youth,
> Guiding in love and truth,
> Through devious ways;

> Christ our triumphant King,
> We come Thy name to sing,
> Hither our children bring
> To shout Thy praise.[25]

A century later Aurelius C. Prudentius found musical immortality in another megahit by centering his lyric in the ever-fresh account of God come among us in Jesus Christ:

> Of the Father's love begotten,
> Ere the worlds began to be,
> He is Alpha and Omega,
> He the Source, the Ending He.[26]

The success of these lyrics endures because they center on the nature of God in Christ, using a kaleidoscopic battery of images that seize hearers and fix pictures and phrases in their minds: guiding shepherd, triumphant king, all-subduing Word, healer of strife, rescuer of humanity, high priest, host at the heavenly feast, child of divine love, our source and our destination. Similar success has greeted numerous songs that have followed this pattern, avoiding triteness in lyrics, melody, or even rhythm as the centuries marched with metronomic regularity from Martin Luther's reformational "A Mighty Fortress Is Our God" to Walter Smith's 1867 winner "Immortal, Invisible, God Only Wise," which more than a century later, in 1986, became a hit for Cynthia Clawson.[27]

Therefore, in the music of today's Christian musicians whose lyrics center on the nature of God, we hear the centuries-old echo from the temple walls of Israel: in Michael W. Smith's "Emmanuel," in Rich Mullins's treasure "Awesome God," in the summary of biblical imagery in Aaron Jeoffrey's "He Is," in the story of the life of Christ in the Christland Singers' "Let Me Tell You about Jesus Christ," and in the nature of Christ explored in Alex Bradford's "Jesus the Stranger" from Vinette Carroll's Broadway musical "Your Arms Too Short to Box with God."[28] Some artists find new depth in the biblical imagery, artists such as the United Kingdom's Graham Kendrick in "From Heaven You Came (The Servant King)" and Mike Starkey in his electronic-jungle ode to the Holy Spirit, "Mighty Wind." In the United States, songwriters have rediscovered the celestial imagery for Christ: as in Petra's "Morning Star," Leon Patillo's "Star of the Morning," and Chris Taylor's "Bright and Morning Star." And South Africa's Ladysmith Black Mambazo experiments with the old imagery of the hymn "Leaning on the Everlasting Arms," stretching those arms of God across oceans to beckon the children of slaves in the black diaspora back home to their lost motherland.[29]

Others experiment with new imagery. Terry Talbot depicts Jesus as a "Lamplighter." Other artists portray God as moving water: White Heart in "The River Will Flow," the United Kingdom's Dave Brilbough in "The Day of Streams Is Over (The Time of the River Is Here)," and Jamaica's Grace Thrillers in "Living Waters." Jamaica's Claudelle Clark, in her lovely "God Is a Mountain," depicts the deity as both a transcendent mountain hidden in the cloud of unknowing and as a swinging bridge that climbs to that mountain by way of a first step up to the cross.[30]

From the repertory of sounds God has created, Christians today sub-create music in a kaleidoscopic variety of modes with a plethora of created and redeemed beats, accurately portraying the image of God. Many Christians are specifically gifted by God to share God's truths through music. For these musicians, the musical marketplace is their Mars Hill.[31]

Since in the Bible we see how seriously God takes lyrics, self-revealing by word and image powerful truths about God's nature and desires for humanity, the church of Jesus Christ needs to be just as serious, continuing to train Christian musicians and support them in their efforts. The church should facilitate the fielding of a competitive musical message of God to reach the listening world. Churches active in this endeavor should be lauded and encouraged in their efforts.

The arts are not a marginal by-product of culture, they are the essence of it. Increasingly in our media-oriented contemporary cultures, music is used as a conduit to pour information into us. Today, we often feel we live and move and have our being in music. Therefore, the music we subcreate should reflect true information about the one who created us, the Great Producer, in whom we do indeed live and move and have our being.

Suggestions for Exploration

Here are at least two approaches to writing a song: Start with the words or start with the music.

Beginning with the words (or idea, theme, or scene), of course, means you first produce either a poem or the lyrics for a song. The next step, setting the words to music, employs a kind of synesthesia, that crossover sensory experience wherein a color evokes a smell or a sight suggests a sound. In this case, you start with the lyrics or a theme or a scene and ask, What does this suggest to me musically? You decide whether major or minor chords are more appropriate to express the words or the idea and whether lilting or somber notes seem best. Then you see if a melody or rhythm suggests itself in response to these choices. In this way you attempt to develop

an original melodic setting that expresses or enhances the meaning of the words and seems worth playing for others.

How can you be certain your song will please God? Celebrate something about God or God's truth in it. Whether your words are upbeat praise lyrics to God, downbeat laments about the tragedy of a world disobeying God's rules, sketches of poignant human dramas, or calls for justice, they will please God. All truth is God's truth.[32]

If you choose to begin with the music and later find words to match or express it, you can take your first step in one of two ways: by keying off a feeling or by jamming on an instrument.

The first method is going to sound like hocus-pocus to some, but to others the creative urge is an historical and personal reality. The ancient Greeks believed the "muse" came upon poets and produced lyric or epic poetry. Christian artists today prefer to think of this experience as a filling of the Holy Spirit. But for Christians and non-Christians alike this kicking-in of the brain's aesthetic creative impulse produces a feeling that gives birth to a song, a poem, or a story. We call it inspiration. For Christians the Holy Spirit can stir this creative impulse, present in all, or guide it and enhance it as we shape its outflow to please God and celebrate God's world. Through subcreating we draw near to God and experience God drawing near to us.

The second more mundane but more explicable manner involves working with an instrument or singing, humming, or tapping. Jamming with an instrument means playing variations on existing music to see if a new song riff or hook emerges, then following where each note seems to lead, sometimes logically, sometimes in a surprising melodic or rhythmic variation, until you have created original music for a song.

One warning, though, about jamming on existing songs. Do not rip off the riffs or hooks or melodies of others. There's a word for that: plagiarism.[33] If God is the source of all creativity, God can lead you to something new in the nearly infinite realm of possible musical combinations. Do the best you can and keep trying until you achieve your own original contribution. Do not settle for second best. And remember to have your Christian perspective orient everything you write. Even if you are not a "Christian song" writer, you are a Christian writing songs—*all* the songs you write.

All of these methods suggest great trial and error, crafting and polishing until you have produced a piece of musical art. Though sometimes it comes easily or is done entirely in your head, usually creating a song is hard work. Often you will run into a lot of dead ends before you get an original lyric and a melody worth remembering.

As an example of how a song might come together, here is the process I followed in writing a praise song requested by our church for the offertory of a Thanksgiving service.

I pulled out *The Zondervan Topical Bible,* which collects all the passages on a given topic, and began reading verses on the theme of thanksgiving to see if any of the words suggested a melody. When I hit Deuteronomy 26:10, "And now, behold, I have brought the first-fruits of the land, which thou, O LORD, hast given me" (KJV), the passage sounded singable. I picked up my guitar, chose a C major chord for thanksgiving, and with a favorite variation on a bossa nova finger-picking style, I sang, "Lord, I bring the first-fruits of the earth," going up on the last note to an F chord to set up whatever might follow.

But what? The next part of the verse says, "And thou shalt set it before the LORD thy God." I decided a descending set of notes, depicting the motion of setting something down, might work well. A descending minor chord sounds beautiful, so I tried an A minor. That sounded so good that I repeated the musical phrase and expanded the lyric to include one's house, picking up the idea from verse 13.

Where to next? The minor chords sounded good, so I put in an E to A minor progression, then jumped to G major to depict the action of submission producing praise. Now a major chord progression of F to C to G to C to F, ending in an exultantly strummed C-G-C connected by F in sets made a lovely, triumphant emergence from the minor. The combination produced a setting for praise. The result was a lilting song of gratitude that is easy enough for anyone to play. I recommended repeating the ending until thankful, the exuberant feeling of the major chords enabling our sentiments of gratitude.

God in the Music Box Mirror

Words and Music by
William D. Spencer

Lord, I bring the first-fruits of the earth and set them be-fore your right - eous-ness.

Lord, I bring the first-fruits of my house and set them be-fore your ho - li-ness.

Lord, I re - joice in you, and as my heart swells I will

sing, al - le - lu, al - le - lu - ya.

Thank you, Lord, for all you've giv - en me.

Thank you, Lord, for all you've giv - en me.

4 Looking Comes First
A Personal Artistic Journey

Bruce Whitney Herman

> But the door into life generally opens behind us, and a hand is put forth which draws us in backwards. The sole wisdom for man or boy who is haunted with the hovering of unseen wings, with the scent of unseen roses . . . is work.
>
> George MacDonald

I am what many people call a dreamer. I can identify with the quotation from George MacDonald that speaks of boys "haunted with the hovering of unseen wings. . . ."[1] I am aware also that I was born to use my eyes and hands to express what I encounter in the world of dreams, visions, and the imagination. Let me qualify what I mean. I am not interested in simply recording mere subconscious ramblings. What I mean by dreams is the stuff of which reality is made.

Have you ever sat on a rocky ledge on the edge of a wood and imagined a faraway land not bounded by the rules of gravity and time? Have you dreamily looked out the window on what my wife, Meg, calls a "Cape Cod day" (a rainy, windswept summer afternoon) and sensed the nearness of an alternative world where things are not as they seem? In which, for example, you discover in a familiar old house a hitherto unnoticed stairwell that leads to the roof, where you find stretching before your feet the ocean! This is a place where inner weather is as important as outer, where justice ultimately wins out despite serious setbacks, and where you might find a mouse who is king or a house cat whose consummate wisdom aids you in some perilous adventure. I suspect, if we were to unrust our memories, we would all have a world or two to share—our own Narnias, as it were.[2] Or have we forgotten so soon?

You see, I think our imaginary lands are an echo of that country for which we were made, where dreams really do

come true. That country to which the writer of Hebrews refers: "But as it is, they desire a better country, that is, a heavenly one" (11:16 NRSV).

Early Days

When I was little the world around me was filled with a beauty that caused me to feel what might be called an exquisite longing—that is, an almost painful response to the loveliness of the visual world. I believe all children have a natural curiosity about the way things look and feel and taste, and yet some are made in such a way that they never tire of looking and tasting and seem to have an inordinate hunger for beauty and visual meaning. I was afflicted with this hunger.

I was also often ill with respiratory problems as a child. Though I had inherited my father's athletic frame and aptitudes, I had also inherited my maternal grandfather's allergies.

I mention these two things at the start because I believe my childhood experience of illness and weakness marked my nature and predisposed me to spend long periods of time looking—not passively staring or idly gazing, but hungrily searching the visual world for "clues," for evidence of meaning and worth. I think staying home from school and spending long days alone gave me time to develop this hunger.

This desire manifested itself early on as a need to draw. As far back as I can remember, I drew incessantly. Perhaps you have known someone like this or may in fact be this way yourself. As others report a strong physical desire for playing basketball, running, or simply eating and sleeping, I experienced an overmastering need to draw and to look at things. As you may know, drawing requires a great deal of time to produce any result. Three hours spent looking at a rose could be the proverbial drop in the bucket, a mere fraction of the necessary time to make a fine drawing of it. In one sense it takes God weeks to make a flower, yet few people are willing to look at one for fifteen minutes, let alone fifteen hours, a day, or two weeks. Yet painters must cultivate this kind of looking and desire.

"Looking comes first," said the artist in C. S. Lewis's imaginative story *The Great Divorce*.[3] He was speaking as a citizen of heaven to a visitor from hell, a former colleague on earth. The visitor had just demanded his brushes and paints in order to record his impressions of the landscape of heaven. He was too quick to respond, to express his subjective reaction to the trees, fields, and river before him. He needed to look longer and to allow the subject, in this case heaven, to unfold its wonders before his eyes. His haste to record his personal response preempted a deeper insight into and appreciation of God's creation. In the story, the visitor from hell ended up prefer-

ring his hell of subjective, ego-bound artistic expression over the humbling requirement of simply looking. After his visit to heaven he got back on the bus and returned to hell.

By using this example from Lewis's story I do not mean to imply that all seeing is a purely physical act and that all artists must paint or draw or sculpt what they see with the physical eye. For some artists who "see through, and not merely with the eye," to quote William Blake,[4] looking *through* the inner world of dreams, visions, and the imagination is as important as looking at the beauty of the physical world. It was this realm that captured my attention most forcibly: the world of creative possibility and the use of the imagination.

First Influences

The doodling of my mother and the animations of Walt Disney are my first conscious inspirations aside from the beauty of the physical world. The magic of creating an imaginary character on a blank page—whether a cartoon character or a simple face or figure like those my mother sketched as she talked on the phone—this magic held a powerful fascination for me.

The idea that by taking up pencil one could create something that had never existed before—at least not in exactly the same way—this idea drove me to practice drawing unceasingly. I was seized by a desire to "create"—that is, to imagine things new and surprising and bring into the world something unique and beautiful. I believe this urge is an echo of God's own creative urge, the evidence of which is revealed in the restless and everchanging shapes in moving water, in cloud and seashore formations, in the unchartable differences in the visual growth patterns of tree boughs and branches, in the intoxicating variety of colors and textures seen in wildflowers and animal life.

God's character, revealed in what has been made, seems to me to be wild and unpredictable at times. In fact, God reveals in his answer to Job[5] that the divine mind is ultimately unsearchable and incomprehensible by human intellect and will, that God's prerogatives are vast and wildly mysterious, lying outside our narrow definitions and limited understanding.

And this aspect of God's creation is what has motivated me most as an artist: God's mysterious creative will, which appears childlike in its restless inventiveness and majestic in its awesome power and scope.

Disney's Magic

The feature-length animated film *Fantasia*, produced by Walt Disney Studios in 1940, was already a classic by the time I was born in 1953. In

the film, several musical masterpieces are illustrated by animated cartoons. Works by Mussorgsky, Tchaikovsky, and Stravinsky, and classic fairy tales are revisited for a modern audience. Though the film was secreted away in archives by the time I was old enough to care, bits and pieces of it survived on television in the early 1960s, when I was just beginning to take my drawing seriously at ages seven and eight. One particular passage gripped my imagination: the segment illustrating Paul Dukas's symphonic poem *The Sorcerer's Apprentice,* itself an illustration of an ancient tale of magic and the havoc produced by a disobedient novice's opening a forbidden magical book.

This is a fitting piece with which to begin the narration of my artistic development for several reasons. *The Sorcerer's Apprentice* held a fascination for me both as art and as story. In the fable, a young fellow working for an aged and wise magician makes his first foray into the forbidden realm of the occult, unleashing powers and forces beyond his control. He opens the infamous book in his master's absence and pronounces the incantations at random, knowing nothing of their importance or order. A maelstrom of mischief ensues, and the boy is saved from certain ruin only by the timely return of the wizard. The moral of the story is obvious.

What is perhaps less obvious is how such a story, reinvented in colorful, mesmerizing form by Disney, might affect a young artist seeking a means to triumph over his limitations and circumstances to achieve artistic greatness. The idea of a forbidden, magical book that holds the secret of power and the ability to transform things—using mind over matter—this idea appealed at the deepest levels to me as a young creative artist. I have come to believe that it also appealed to an incipient corruption in my heart.

The desire for power and influence over events and people can begin early in a person's life—witness the mob mentality of many children ganging up on a weakling, or the ringleader phenomenon among young people. The Disney film appealed both to my urge to create and to my desire for supernatural powers. The latter may seem innocuous enough in a child, but I believe it may also indicate a genuinely dark pattern—the immemorial tendency in humankind to attempt to usurp the place of God.

In retrospect I view my attraction to the supernatural themes in Disney films and other popular entertainment venues as a corruption of the creative will, and I believe this corruption began with me at the first signs of creativity in my young life. The more innocent motives of a child's imagination and creative will are fairly obvious to most observers, and I was no different: I loved color, textures, shapes, lines, and their vivid and extravagant use in drawing and painting. In fact, the love of visual form seems to me a completely guileless preoccupation. Thus the phenomenon in our century of artists making paintings or sculptures that are nothing more than explorations of color, shape relationships, textural differences, and so

forth—in other words, pure abstraction—appears to me now as possibly the safest approach to art-making for the Christian.

But the desire to explore pure visual form, as distinct from expressing the emotional, psychological, and spiritual longings of humanity, was never enough to occupy me for long. I desired more than anything else to attain mastery over my materials and technique in order to express those perennial themes of human experience: death, life, conflict, peace, love, joy, sadness, power, and the aching for heaven and eternity. I also wanted attention for myself, admiration for my accomplishments and artistic prowess—not only for my technical excellence, but because of my insights into human nature and our predicament here on earth.

In short, I was striving to create as God creates. If this were all it was, fine and good; every child should aspire to be like mommy and daddy. But my desire to create carried with it the desire for glory—for fame and name—and this is the spiritual downfall faced by every artist. It leads to greed, resentment, unhealthy competitiveness, and ultimately to egomania. (See James 3:13–18.)

I do not mean to suggest that the Disney films had nothing but a corrosive effect on me as a developing artist—quite the contrary. The beautiful and often surprising backgrounds, the emotionally powerful and gripping presentation of human virtues and the evils of human error were important goods I derived from these movies. The heroism of Mickey Mouse, the beauty and sincerity of Snow White, the kindness and wisdom of Geppetto and the vagaries of his wayward puppet-boy Pinocchio, the humor and self-sacrifice of the seven dwarfs—all of these and many others were characters that moved me to seek the good and refuse the evil around me. What I am trying to suggest is that mixed in with these laudable themes were temptations to spiritual power beyond what is good and holy.

The theme of artistic temptation is much older than Walt Disney. In fact, the desire for fame and influence is as old as the Tower of Babel story in the Bible. You may recall that the people gathered and said, "Come, let us build ourselves a city, and a tower with its top in the heavens, and let us make a name for ourselves" (Gen. 11:1–9 NRSV). Building for self and for a glorious name is a fundamental corruption of the creative urge in humanity. From the beginning it has resulted in trouble, as with the architects of Babel, whose ability to create and communicate was destroyed by their own vanity. Where once had been free speech in a universal language now came confusion, deterioration of society, and the practice of a private language, each one speaking only to himself.

My gradual developing into a self-centered artist began, I believe, at an early age but truly manifested itself later in my early adulthood. So I turn now to a later chapter in my life—my first years away from home, my spiritual seeking in India, my marriage, and my eventual entry into art school, where I was exposed to the styles and artistic philosophy of this century.

The Eastern Path

In 1970 at the age of seventeen I left home in search of my identity as
a pilgrim and an artist. I had already become deeply enmeshed in Eastern
philosophy and religion during my high school years and had experimented
with hallucinogenic drugs, as had many of my generation in the late 1960s.
My family life had fallen on hard times after our fourth major geographic
move (from Richmond to Rochester to Buffalo to Atlanta), and my broth-
ers and parents had begun to recede in my mind as important people. I
now sought the company of artists and spiritual aspirants who, like me,
were leaving behind the world of their fathers and mothers. The 1960s
were, as many have documented, a time of tremendous unrest and change.
My own path lay through India and the religious mysticism of Hinduism.
My nominal Christian roots, though important to me, seemed to recede as
well, and I found myself becoming a follower of a guru from Ahmedna-
gar, India.

Meher Baba, which means "compassionate father," became my spiri-
tual master in 1970, one year after his "dropping the body," as his follow-
ers refer to his death. The dissolution of my formerly comfortable world of
childhood had resulted in a sudden wreckage. My feelings of security and
freedom from fear while under the protection of my parents fell away as I
saw my parents for what they were: confused grown-up children whose
American Dream had turned into a nightmare. Meher Baba was a fault-
less parent who had all the answers. He not only promised security and
certainty in a fearsome open-ended universe, but he also offered spiritual
authority and, ultimately, those magical powers I had longed for as a child.

The Hindu path is complex. Nevertheless, I will attempt a brief distilla-
tion of it for the purpose of explaining my sojourn.

All religious systems provide answers to theological questions such as,
Who are we? Where do we come from? Where are we going? Hinduism
states, in its essence, that we are God, we came from God, and we are going
to God, in the sense that we are going to *become* God. Nothing exists but
God; all else is *maya*, the cosmic illusion. All Hindu practices aim ultimately
at *moksha*, the final enlightenment that frees humanity from the illusion
of separateness from God. All religious ideas in Hinduism derive from this
central belief.

The physical universe is not exactly bad; it is merely a mirage. And to
overcome this mirage, to penetrate to the truth, one must see through
maya, through the mental illusion that things other than God exist. I bought
this worldview hook, line, and sinker. I read every book I could find—the
Bhagavad Gita, the Ramayana, the various meditation technique manu-
als, all of Baba's discourses, and the biographical works about him and his

work. I met Baba's intimate disciples, many of whom were more than sixty years old. And I sought every means possible of drawing close to his vision of oneness with the deity.

Baba's path is said to be the path of love and devotion, not of odd costumes and chanting. Baba-followers are encouraged to continue as they are, even to keep their birth-religion but avoiding the religious trappings. His disciples are to practice the deepest essence of their own religions. Baba said that all religions are ultimately the same one religion of love for God and love for one's fellow humans. Baba proclaimed he would spiritually enable his followers to practice this kernel of true religion—not by more teaching and words but by spiritual power, that same power Jesus wielded when he walked the earth.

I was spellbound by Baba's charisma. Though he had "dropped the body," he was very much alive spiritually, and I was visited by powerful visions of his presence that were accompanied by strong emotions. He seemed to be just who he said he was: the eternal Christ. I was drawn by increments into one of the circles surrounding this sage from the East. Among his more famous followers have been Mahatma Gandhi, Jawaharlal Nehru (former prime minister of India), a vice president of the Standard Oil Corporation, Marlene Dietrich, and many artists, writers, and musicians, including famous rock composer Peter Townshend of the Who.

While at the Meher Baba Spiritual Center in Myrtle Beach, South Carolina, I met many of Baba's American devotees. Among them were artists, poets, filmmakers, and composers. I felt I had found my true family: the household of spiritual artists. At the Baba Center I met Lyn and Phyllis Ott, artists from New York City who had sold everything—including their renovated church-home–art studio, which had been written up in *Life Magazine*—and had moved to Myrtle Beach to set up shop as Baba's American apostle-artists.

I was deeply influenced by these two dynamic individuals, who had banked so much on Baba's divinity, giving up budding careers in the New York art world to become nearly anonymous in the woods of South Carolina. When I first saw the large, expressionistic paintings that Lyn Ott had made of Meher Baba, I was both devastated and inspired. Devastated because I was overwhelmed by the spiritual power that seemed to emanate from Lyn's paintings and inspired because I had finally found someone who was doing precisely what I wanted to be doing: painting images of a living God.

I began to emulate Lyn's style of painting, trying to capture a similar sense of "Baba's presence" in my art, believing as I did that Baba was God. Thus I found myself investing a great deal of desire and hope in the prospect of expressing the divine reality directly through my paintings, believing and hoping that if I could find the right inner attitude and the right style, my art could somehow become a vessel of God's real presence. In retro-

spect I believe there is a certain validity and truth in this desire: the desire to incarnate God through our work of service to the world and to the body of Christ, the church. Yet this desire was perverted in me by the double idolatry of worshiping Baba, instead of God, and wanting this power, the power I felt in Lyn's art, for myself.

Perhaps you can see in these details of my late teens and early twenties the evidence of the corrupted creativity I mentioned earlier. During my childhood I had been given intimations of the dangers of the occult—that twisted desire to control events and people rather than to learn to love and give. And Baba was the consummate wizard of sorts; he deprecated the low-level exercise of spiritual power in witchcraft, not because it was wrong, but because it led down a sidetrack from the spiritual path to God-consciousness. In effect he seemed to say, "Occultism is a mere mudpuddle. Come with me to the ocean of spiritual power. I will give you godhood, not mere magic tricks!"

This promise, and belonging to a secret circle of enlightened artists, appealed to my desire for artistic and spiritual authority. But all the while I was progressing on my spiritual odyssey with Baba, I was haunted by doubts. Was Baba real? Did he truly have God's authority to grant enlightenment and liberation? What about Jesus, the Christ I had known as a child? Were Baba's claims compatible with his? What if Baba were actually evil and merely a wolf in sheep's clothing?

Baba had said to practice one's religion authentically, avoiding empty formulas and dry doctrines. So I began to read the Bible for the first time in any organized way. I read it with growing apprehensiveness as I encountered one statement after another that seemed to contradict Baba's claims:

> "I am the way, and the truth, and the life. No one comes to the Father except through me."
>
> John 14:6 NRSV

> "Very truly, I tell you, I am the gate for the sheep. All who came before me are thieves and bandits; but the sheep did not listen to them."
>
> John 10:7–8 NRSV

> "Beware that no one leads you astray. Many will come in my name and say, 'I am he!' and they will lead many astray."
>
> Mark 13:5–6 NRSV

> "And if anyone says to you at that time, 'Look! Here is the Messiah!' or 'Look! There he is!'—do not believe it. False messiahs and false prophets will appear

78

and produce signs and omens, to lead astray, if possible, the elect. But be alert; I have already told you everything."

<div align="right">Mark 13:21–23 NRSV</div>

My desire to know the truth was beginning to win out against the equally strong desire to continue to follow Baba and acquire the spiritual enlightenment he promised. A genuine love for Baba and his devotees had steadily grown in me, and I was finding it nearly impossible to disentangle truth from falsehood in both Baba's statements and those made by his disciples.

Simultaneously, my artistic pilgrimage was reaching an impasse. I tried sharing my doubts with Phyllis and Lyn. They too had had doubts about Baba but chalked them up to spiritual ignorance and mere intellectual qualms (which count for little in the Baba community, particularly as these qualms might apply to Baba and his claims and statements). Lyn told me my art was immature and the only way I could progress was to go to art school to "see if you can survive!"

Marriage and Art School

In 1972 I moved to Boston in search of art training. I had taken a college-level painting class at the University of South Carolina, but it was unhelpful and lacked any coherent connection with the great traditions of draughtsmanship and painting from the human form. I looked into the Boston schools: Massachusetts College of Art; the School of the Museum of Fine Arts, Boston; Art Institute of Boston; and others. Asking around, I discovered there was nearly a consensus among art students that Boston University was definitely *not* the school to attend, being mired as it was in traditional techniques. I thought to myself, Ah . . . they reject traditional art, but their own work shows a conspicuous lack of knowledge and technical merit. Perhaps their disdain is really veiled envy.

I looked into the school of fine arts at Boston University, saw the high quality of the student artwork there, and decided to apply despite the criticism I had heard. I would learn how to draw and paint in the grand tradition even though I might not ever use that tradition. Though the school was difficult to get into, with high standards of technical talent, I managed to get accepted and planned to enroll in the fall of 1973, a year later.

In September 1972 I had moved north of Boston to Gloucester, a seaside town teeming with scenic artists plying the tourist trade. I had no interest in this end of the art world, but I did meet a few artists there. One of them was David Bastien, an inventive sculptor who had studied in Boston and later in the North Shore area near Gloucester. David introduced me to the work and

<div align="center">79</div>

ideas of many modern artists as well as the philosophy of Martin Buber, whose writings later were to have a decisive influence over my thinking. He also introduced me to several other art students, among whom was Meg Matthews.

Meg was an outwardly carefree person who was attending a local art school but was fairly aimless in her pursuit of art. We became good friends over the fall and winter, finding music an additional common interest, and began to seek each other's company often, sometimes working on a Broadway tune at the piano, other times just chatting or playing guitars. Her mother's impending death from cancer, and my loneliness and masked despair from spiritual doubting, created a strong need in us to be together.

We found we could trust each other in a way that made us quite close. Our friendship deepened, and in November 1973, a few months after my return from a pilgrimage to India,[6] we were married. Immature and needy (she was nineteen and I was twenty) and both reeling from what seemed to be the self-destruction of our families in the late 1960s and early 1970s, we found solace and hope building a life together despite our limitations.

In September 1974, during Meg's first pregnancy, which began four months after we were married, I enrolled in Boston University School for the Arts—a year later than I'd planned and by anyone's reckoning a risky path to take for a newly wed, budding father twenty-one years of age. Risk, however, was in my nature. Not only did I enter the school, but I also threw aside any commercial art courses and pursued the fine arts with a vengeance. My belief since early childhood was that my art was reserved for the glory of God, and I held unswervingly to this belief, even though I was, at the time, duped into believing that Meher Baba is God. I was uncertain how this was to be worked out—how to bring my artwork under the guidance and authority of God—but I knew instinctively that I would eventually find the sacred thread running through all of God's creation and incorporate it into my work.

Meg encouraged me, not doubting my talent and drive but probably harboring private fears for our financial security. My parents were supportive of my decision to enter art school and even sent us a small regular stipend to help with food and rent. Meg worked at a laundromat, and I held various jobs, including stints as a cook for a short-order diner, as a house painter, as a taxi driver, and as a handyman.

My single-minded pursuit of painting as an all-or-nothing proposition must have given my father-in-law the vapors. Yet when he visited our shabby little apartments (we lived in no less than six different places in our Boston years), he was always impressed by and appreciative of my renovation skills, my mechanical abilities, and my devotion to Meg and the family.

My son, Ben, was born during my first year at art school. The school secretary ran into my first painting class one day and announced that Meg had gone into labor and that I needed to rush home! The class cheered as I ran out of the studio, covered with oil paint.

Formative Influences

The next two years of art school were formative in terms of my technique and basic knowledge. Learning the classics, developing old-master painting methods, grinding my own oil paints—this was the tenor of my training at Boston University. But an undercurrent ran through the school, one nourished by a deep commitment to the eastern European tradition of figurative expressionism—a twentieth century movement exemplified by the work of artists such as Oscar Kokoschka, Chaim Soutine, Emil Nolde, and German artists such as Ernst Kirchner and Max Beckmann.

Seldom were students encouraged to borrow from these modernist painters. We were kept to the strict order of verisimilitude—realism and faithfulness to nature. Yet these masters of expressionist painting were held in the highest esteem by all the twentieth century artists. Therefore, not surprisingly, many of the students who left Boston University and went on to develop their work beyond the academy ended up moving toward the expressionist idiom.

The expressionists are among the few artists of our time to continue the tradition of human narrative. When most others were abandoning the figure wholesale and plunging into complete abstraction (exemplified by groups such as the Cubists or the followers of Piet Mondrian or Wassily Kandinsky, who believed in the spiritual perfectibility of humankind through art), the expressionists were digging into the rich past for meaningful themes that address the perennial human condition.

In fact, this century has seen an erosion of commitment to the grand tradition of western European figurative art. The virtual elimination of human narrative and the human form from art has been the unstated (and possibly unconscious) agenda of the various modernisms. This tendency has been partially counterbalanced in the late twentieth century in the so-called postmodern era. Images of the human body now abound once again. But more often than not, the body is disconnected from any explicit story or reference to the tradition of religious or psychological narrative. My own training, with its insistence on careful observation of the human form and attention to the traditional masters and their inheritance of great Christian art, was atypical for the 1970s.

I found the work of one of the figurative expressionists, Max Beckmann (1884–1950), a German painter who belonged to a group called the Neu Sachlichkeit ("New Objectivity"), a stimulating influence. At the time that I was feeling this influence, I was in graduate school (still at Boston University) under the tutelage of Philip Guston, an important American painter and himself a figurative expressionist.[7]

In figure 1 you see *Departure*, one of Beckmann's famous triptychs.[8] Beckmann's adaptation of this religious art form to uniquely modern concerns

81

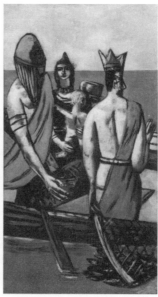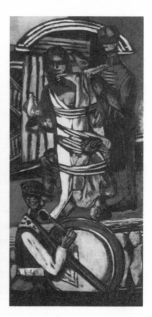

Fig. 1: Max Beckmann, *Departure* (1932–33, oil on canvas, triptych, center panel, 7′ 3/4″ x 45 3/8″ [215.3 x 115.2 cm]; side panels each 7′ 3/4″ x 39 1/4″ [215.3 x 99.7 cm]). The Museum of Modern Art, New York. Given anonymously (by exchange). Photograph © 1998 The Museum of Modern Art, New York.

was a stroke of genius, creating a scale of importance and significance that would clue in his viewers to his intentions.

In *Departure,* which Beckmann painted just after he was deported by the Nazis for being a "degenerate" artist, is an image of hope and release in the midst of barbarism and madness. The central panel contains a "holy family" of sorts (mother, child, and bearded father) on some journey—perhaps an escape from a modern Slaughter of the Innocents (Herod's infamous purge of male children). Beckmann includes a masked oarsman and a guide, probably as an allusion to a tradition exemplified in Dante's *Inferno.* In this tradition pilgrims to heaven are first ferried across the River Styx and led through Hades to higher climes as a form of purification and preparation for eternity.

The outer panels of *Departure* show scenes of torture, dismemberment, and terrorism—all effects of brutal war and societal disintegration, an accurate spiritual portrayal of Germany in the early 1930s leading up to the Nazi rallies. Beckmann hid in Amsterdam for a time and later emigrated to the United States, where he taught at Washington University in St. Louis and created some of his finest masterpieces. He died in New York in 1950.

Beckmann's impact upon my work should be obvious to anyone looking closely. (See figs. 2A and B.) I deliberately allowed his bold use of expressive color and exaggerated form to creep into my otherwise careful realist paintings. The reason for this is quite simple: Realism had grown stale for me, and every attempt I made at conveying in my work the gravity and power of God's presence seemed lame when I used the realist approach. Realist images of God are a contradiction in terms. Since we have no experience of God's face in

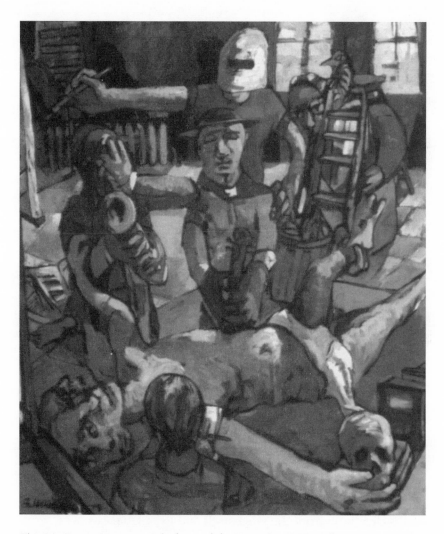

Fig. 2A: Bruce Herman, *Caiaphas and the Hypocrites* (1979, oil on canvas, 70" x 48"). Photograph by Bruce Herman.

83

Fig. 2B: Herman, *Portrait of Bill Harsh* (1981, oil on canvas, 72" x 72"). Photograph by Herman.

any direct sense and since Scripture expressly states that no one has ever seen God except the Son of God, then to paint "realistic" images of God is patently a false enterprise. I kept these considerations in the back of my mind, repressing them because of my loyalty to Baba.

Another artist whose work had a strong impact on my formative years is Georges Rouault (1871–1958), a French expressionistic painter. Rouault was a committed Roman Catholic Christian. His desire to serve God with his art is clear both from the work itself and from what has been written about him.[9] His depictions of Jesus' Passion and his use of an even bolder approach to color and form moved me deeply.

84

Rouault seemed to be driven by some deep longing for truth in art—something that I found lacking in the contemporary art scene. My experience of the art of our time is that a lot of it smacks of irony and cynicism. Here was a painter after my own heart—he was sincere, honest, and direct in his adoration of Christ, his master. At the same time, my doubts about Baba were resurfacing, and I was even beginning to plot my "defection" back to Jesus.

Jesus: There was a name that spelled truth and goodness and beauty. Why had Protestantism failed to yield a robust tradition of art dedicated to his glory? I had grown up in an Episcopal family, nominally religious, and had inherited some of the expected ethos. The beautiful music and the stained glass were inspiring, but all available pictures of Christ were sentimental and postcard pretty, resembling Breck-girl commercials more than portraits of a rugged Jewish carpenter. On the other hand, I found no lack of beautiful paintings of Jesus in Catholicism. And the Byzantine icon tradition of Orthodoxy is a strong and vital stream. Rouault obviously had drunk deeply from both these streams.

Where was I going artistically and spiritually? My path of art was also my spiritual path. I had always known that my art gift was God given. How was I to use it to his glory? As I continued to read my Bible and feel the pangs of doubt and growing despair over the conflict between Baba's and Jesus' claims, I continued to try to "work out my salvation," as it were, through my art.

From Realism to Expressionism

I read widely at this time (the late 1970s) in philosophy and poetry—two passions of mine outside of art. The writings of Jewish philosopher Martin Buber in particular affected me strongly. I carried *I and Thou*, his seminal work, around in my hip pocket for months, along with T. S. Eliot's *Four Quartets*, reading them over and over, imbibing the truth and the challenge to understand and live the religious impulse. Buber's thought embraces a dialogic approach to all of life. That is, at the core of reality is dialogue—reciprocity. He threads this truth through nearly all of his writings, clarifying it even as he celebrates its essential mystery.

In essence this principle may be expressed by comparing all of the cosmos to a love story. God creates and falls in love with the creation, and that love—that reciprocal response of feeling, thought, and action—that love is the glue that holds all things together. The universe rings with this song of songs. I was powerfully moved by this vision of a God who creates others—real others—and imbues them with true free will: the will to accept or refuse God's love and care. This doctrine of complete and true dialogue, give and take,

85

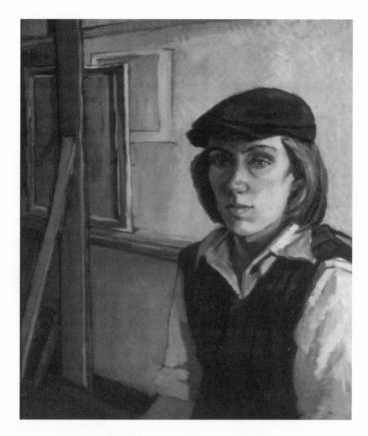

Fig. 3A: Herman, *Self-Portrait* (1974, oil on canvas, 28" x 20").
Photograph by Herman.

seemed to me to refute the Hindu metaphysic that God alone is real, that all of the universe is merely an illusion of being separate from God's being.

Buber's vision is derived almost entirely from the biblical worldview, and he refers to the Torah constantly in his work. I found that my interest in Buber corresponded in every way to my gradual pulling back from Meher Baba and Eastern religion. Ironically, perhaps, this pulling back was timed perfectly with my pulling away from realism as a stylistic approach to my art. As you can see from my self-portraits in figures 3A, B, and C, I was experiencing a gradual development away from realism. The first self-portrait, done my first year in art school, is naturalistic, showing my desire to acquire classical technique. The second is taken from my first year in the graduate program at Boston University. It is obviously indebted to the expressionists for its loose handling of paint; nevertheless, the residue of realist drawing is evident from the correct

86

Fig. 3C: Herman, *Self-Portrait* (1978, encaustic on panel, 12" x 16"). Photograph by Herman.

Fig. 3B: Herman, *Self-Portrait* (1977, oil on canvas, 38" x 24"). Photograph by Herman.

Fig. 4A: Herman, *Flight* (1978, encaustic on panel, 12" x 14"). Photograph by Herman.

proportion and natural color. (Sadly, the reproduction in this book is black and white.) The third self-portrait is from my last year in graduate school and reflects my final jumping off from realist technique. The color is exaggerated—strong reds and yellows—and the light and texture are theatrical and highly emotional. These are the hallmarks of expressionism: heightened color and exaggerated form. The goal is to distance the viewer from the familiar and so provide clues as to the story or emotional content of the piece.

When people express extreme joy or utter grief—any strong emotion—they exaggerate by spreading their arms wide, using superlatives (or expletives), and they often raise their voice or distort its normal accent for effect. In the same way, the expressionist idiom is all about expression, and what I wanted was a means of getting at truth—truth that cuts through the hackneyed and predictable response to life.

Figures 4A, B, and C are a series of images from the same period as the last self-portrait, all of them done in the encaustic method—that is, painting with beeswax instead of oil. The colored pigments are ground on a griddle in puddles of molten wax and painted directly on a canvas or panel. A torch or heat lamp is then passed close to the surface of the artwork so the layers of waxy

Fig. 4C: Herman, *Jazz* (1978, encaustic on panel, 12" x 14"). Photo-graph by Herman.

Fig. 4B: Herman, *Dreamer* (1978, encaustic on wood panel, 12" x 14"). Photograph by Herman.

paint can fuse, making a continuous painted surface in which transitions from one color to another blend subtly. The characteristic surface that results is a pleasingly built-up texture like that of candle drippings, though much more intentional and varied. This technique produces vivid colors and strong impasto (paint thickness), which appealed to my aesthetic sense in those days. These qualities also seemed fitting for the emotional and spiritual messages I was trying to send through my paintings. Titles like *Flight* (as in fleeing), *The Dreamer, Jazz,* and *Sorcerer's Apprentice* abounded in those days as I searched for a means of expressing my tumultuous inner life. The very act of my titling pieces was new and came with my switching from realism to expressionism. I was finally beginning to get at what I had hoped to find in painting: a means of exploring and expressing a deep philosophical and religious yearning—and some of George MacDonald's "unseen roses."

Crisis

Meanwhile, I was struggling with my desire to turn my life over to Christ but simultaneously feeling afraid of doing so. I felt as though I were being drawn "in backwards," as MacDonald says, as though the "door to life" were indeed behind me in the arms of Christ, my childhood religious master. I had gradually come to believe that Baba was a representative of a dark spiritual force that could entrap me or my family or possibly cause the suffering or death of my children or my wife. I was becoming terrified and feeling cornered spiritually. Several years passed, and all the while the doubt and dread continued unexpressed.

In March of 1979 my daughter, Sarah, was born, and we moved to Italy. When we returned to the States, I began my first teaching job at a prep school in the Boston area and in 1983 had my first solo exhibition in Boston.

During the last part of 1982, the intensity of my inner spiritual turmoil stepped up, and I found myself growing truly desperate, entering a crisis-like state of mind. I mentioned to Meg that I was considering leaving Baba to return to Jesus Christ, the Lord I had acknowledged as a young boy in the Episcopal Church. Meg's reaction was immediate and strong: "If you ever become a Christian, I'll divorce you. I am not interested in being married to a Bible thumper!"

Behind Meg's words was a great deal of wounding. She had seen me twisted into a superstitious, spiritually obsessed person while following Meher Baba. She was not about to be party to another idol, and for all she knew, following Jesus would bring more of the same.

Despite Meg's threat, just after Christmas 1982 I left Baba and begged Jesus' forgiveness, asking him to accept me back. When Meg found out, she

saw a lawyer, following through on her threat. In the year that followed she acted as though we were already divorced, meanwhile biding her time and being cautious lest I seek a court case to battle for custody of our children. I was devastated and tried over and over to talk her out of her decision. She was merely waiting until she could find the perfect moment to break away.

During this time, I was forced to continue painting, though I had lost any desire or motivation for it. I was obligated by prior agreement to follow through on my solo exhibition with the Chapel Gallery in Boston and to continue selling my work through Gallery NAGA, also in Boston. Both galleries were housed in converted church buildings that no longer had any religious purpose!

The work I did during that time was a mixture of introspection and self-revelation. Figures 5A, B, and C show the paintings *Night Studio, Garden,* and

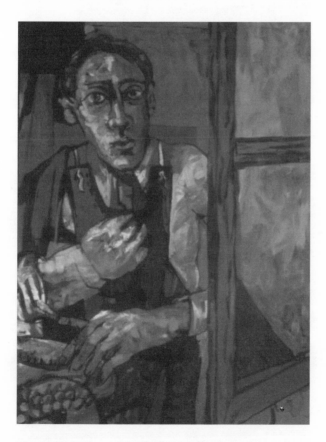

Fig. 5A: Herman, *Night Studio* (1982, oil on canvas, 70"x 48"). Photograph by Herman.

91

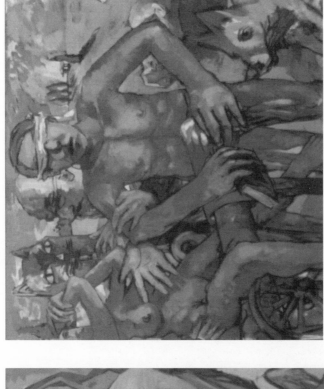

Fig. 5C: Herman, *Temptation: The World, the Flesh, and the Devil* (1981, oil on canvas, 48" x 72"). Photograph by Herman.

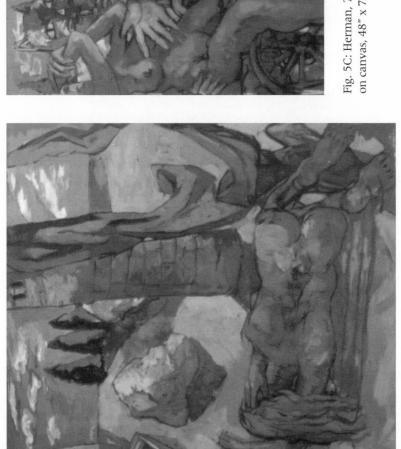

Fig. 5B: Herman, *The Garden* (1982, oil on canvas, 72" x 48"). Photograph by Herman.

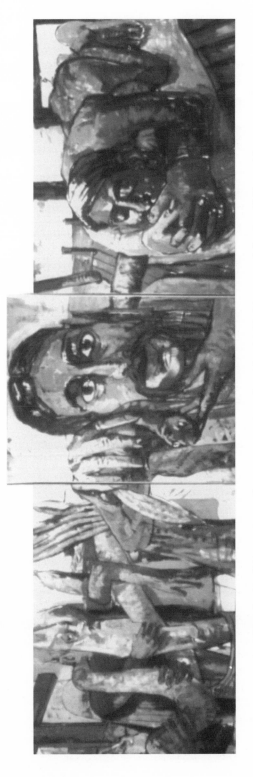

Fig. 6: Herman, *The Triumph of Suffering* (1983, oil on canvas, triptych, 72" x 216"). Photograph by David Herwaldt.

Temptation (the World, the Flesh, and the Devil). These works record the state of my soul just prior to and during my conversion. They reflect my dissolving marriage, inner conflict, and attempts to get at biblical themes. In figure 6 is my first real attempt to express my renewed faith in Christ and the gravity of my conflict now resolved through my conversion. The title is *The Triumph of Suffering.* In the right-hand panel is a prostrate supplicant; in the center panel, a Byzantine head of Christ. A gigantic snake, whose body coils and extends through all three panels, bites the forefinger of Christ. In the left panel is the tortured soul of my former self—wearing a devil mask, standing in a pail of waste, surrounded by poisonous plants—and a giant wooden cross, partly obscured, in the background. The symbols here are fairly straight-forward; they all allude to my pilgrimage to Christ for redemption. The snake stands for the devil and his spiritual attacks on the supplicant and the Christ, and the mask and junglelike poison plants are the worldly and spiritual temptations faced by an artist in this age. The piece is eighteen feet long and took up one whole wall in the gallery. I am not sure the gallery people who invited me to exhibit were counting on such an overt (and huge) statement of Christian faith on their secular, post-Christian walls. The show was reviewed in the *Boston Globe,* and the critic opined that my art was more derived from Christian philosophy than any direct religious statement of faith. I found this interpretation made me a little uneasy.

In 1983 through a series of semimiraculous events, Meg came to know Christ and returned to our marriage. She now says that the change in my attitude and behavior over the year following my conversion was the deciding factor in her coming to accept the claims of Jesus. She also says that the night I promised not to contest the divorce or fight her in custody battles was the night she decided to come back into our relationship and leave off divorce proceedings. She said, "You have finally given me enough respect to let me make my own decisions!"

Since that time much has happened both in my family life and in my art. Both of my children have embraced Christian faith; I have been appointed chair of a budding art department in a Christian college; my work has been growing in its biblical content and has been exhibited all over the United States and twice overseas; and I have formed a multitude of lifelong friendships with other Christian artists—and some of these contacts have led to collaborations for the glory of God.[10] My dream has come true in large part: I am making art that directly expresses my love for God, and I am in a position to influence younger artists to do the same.

The last series of images, figures 7A, B, and C, shows the direction my work has taken of late. My book *Golgotha: The Passion in Word and Image* is a compilation of most of the paintings I have done to date on the theme of the Suffering Servant—Jesus, Messiah, and his payment for our sins. I am presently working on two new groups of works, one on the great figures of the Old

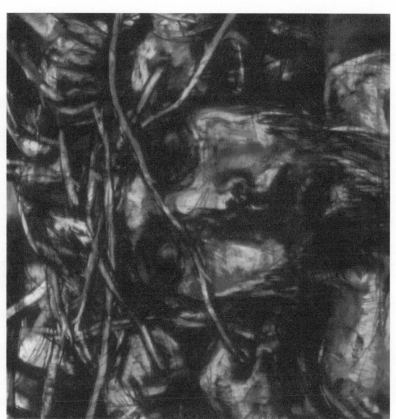

Fig. 7B: Herman, *The Crowning*, from *Golgotha* (1993, pastel, 38" x 45"). Photograph by Herman.

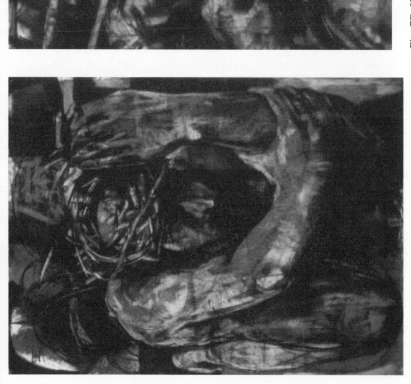

Fig. 7A: Herman, *The Flogging*, from *Golgotha* (1993, pastel, 50" x 30"). From the collection of Dr. Rodney Petersen. Photograph by Herman.

Fig. 7C: Herman, *The Nailing,* from *Golgotha* (1991, pastel, 22″ x 30″). Photograph by Herman.

Testament (Patriarchs, Judges, Prophets and Prophetesses) and the other on spiritual warfare, titled *War in Heaven.*

I thank God for allowing me to continue to paint and teach others. I live day to day with deepest gratitude for his healing of my marriage and the salvation of my family. I live also with a daily sense of hope and excitement to see the continued building of a strong Christian voice in popular and artistic culture and pray that I will be useful to the Lord and his church in helping that voice claim excellence and purity for Christ's name.

Suggestions for Exploration

1. Using a conventional pencil and good quality paper, sit down in a comfortable spot and simply look at some small piece of God's creation (example: a flower, a pine cone, an acorn). Try recording what you see very slowly,

drawing initially from the edge of the object and progressing to its center. Use care to engage in close observation; do not worry over your exercise's "art" quality, whether you are talented or seem to lack any capacity for drawing. You are making a response to God's beauty, not making a work of art. If your sketch looks clumsy, you need not worry. You have joined the ranks of most people who have never taken a formal art lesson in their lives.

We need to slow down to look, and looking always comes first. This exercise will be successful only if you have taken the time to look carefully. The results of the activity of drawing are unimportant. You may want to throw the drawing away. That is fine. Just remember: No one ever became a baseball player after the first throwing of a ball; it takes years of practice and perseverance.

2. Take a camera (any camera—an expensive one or a cheap one—it does not matter) and go for a long walk near your home. Don't worry about whether it is an inner city or a country lane, so long as it is where you *live*. Spend at least three rolls of film on shots of street corners or places in the woods—not the ones you would expect to see on a postcard, but random ones that catch your interest for other than obvious reasons. For example, a peeling billboard could have interesting textures that a close-up photo might capitalize on; a dilapidated barn or rotting tree might reveal some beautiful visual treat unexpectedly; a forsaken or rusting automobile or truck or piece of farm machinery might evoke strong feelings if framed in the camera lens properly.

The aspects of our environment that we most take for granted may hold surprising visual interest for us and our viewers if we take the time to look closely. In photography, as in drawing, looking comes first. And when we go through our lives never suspecting that our backyard may hold mysteries and miracles, we are less likely to find them. Even Jesus could not perform much by way of miracles in his home town due to the people's lack of trust and interest. When we look carefully around us, waiting and taking time to become sensitive, we will discover the miraculous in the mundane.

God's constant provision for our aesthetic as well as physical and spiritual needs is out there waiting to be harvested.

5 Postcards from the Past
Depicting God through the Visual Arts
Gwenfair M. Walters

From gentle, mystical shepherd to terrifying imperial figure or bloodstained suffering servant, pictorial depictions of Christ throughout the centuries have covered a wide variety of biblical types. And from advocating the veneration of images of Christ to insisting that Christ should never be depicted in art in any way, Christians throughout the ages have disagreed on the appropriateness of depicting the Savior. By taking a brief look at the history of depictions of Christ in art and at the controversy surrounding the making and using of images of Christ and the saints, we can better understand the issues involved in the question of whether God or Christ should be depicted through the visual arts. Then, armed with that understanding, we can examine what Scripture teaches on the subject and look at whether it might be possible to use art to know God better.

Depictions throughout History

We will focus briefly on depictions of Christ in four key periods: pre-Constantine, Byzantine, late Medieval, and post-Reformation. The different styles of the depictions reflect the particular emphasis of the spirituality of Christians in each period.

Pre-Constantine Depictions

Until the conversion of Emperor Constantine to Christianity in the fourth century, the early Christians experienced

99

waves of persecution. Not wanting to draw hostile attention to themselves by presenting in their art obviously Christian themes, such as the passion narrative (which, because it depicted the humiliation of the Lord, also may have brought disparagement upon the faith), Christians depicted Christ mystically and metaphorically. They used pagan figures to represent Christ in ways that disguised his identity from their persecutors. And rather than depicting him as he was in the historical past, they chose to emphasize, using Old Testament images that foreshadowed his life, the comforting accessibility of his presence to them in the present.[1]

One image that used both of these strategies was that of Christ as the Orpheus–Good Shepherd. This image protected the Christians by using a pagan mythological figure so that a nonbeliever would not know the painting was a Christian symbol. Nonbelievers also would not recognize the shepherd motif—it was used both of Christ in the Old Testament (Isa. 40:11) and by him to describe himself (John 10:11, 14), but Christ was never actually a shepherd! Thus the image was one not rooted in a particular time and place but rather in a timeless motif. By depicting Christ as a shepherd, one of the most popular early themes, Christians emphasized Christ's immanence, his eternal presence with them, an assurance they needed in the midst of persecution and the difficulties of being a Christian in the Roman Empire.[2]

Byzantine Depictions

After the conversion of Constantine, the persecutions ended and Christianity became first a tolerated religion and then the state religion. No longer did Christians need to hide; thus their depictions of Christ became bolder, and even opulent as the state funded the building of majestic basilicas with domes occupied by enormous mosaics of Christ. They presented him in splendor, using expensive materials and rich colors. The Christ-Pantocrator figure, a half-length figure of Christ with his right hand raised in blessing and his left hand holding a book or scroll, dominated the domes of many basilicas and depicted Christ as the allmighty, all-powerful Lord, surpassing the splendor and power of the emperors.

In the East in particular, highly specialized iconography developed for presenting images of Christ. The church monitored the theology expressed in the details of these icons and approved the depiction of Christ in images. The Quinisext Council of A.D. 692 declared:

In certain reproductions of venerable images, the Forerunner [John the Baptist] is pictured pointing to the Lamb with his finger. This representa-

100

tion was adopted as a symbol of grace. It was a hidden figure of that true Lamb who is Christ our God, shown to us according to the Law. Having thus welcomed these ancient figures and shadows as symbols of the truth transmitted to the Church, today we prefer grace and truth themselves, as a fulfillment of the Law. Therefore, in order to expose to the sight of all, at least with the help of painting, that which is perfect, we decree that henceforth Christ our God be represented in His human form and not in the ancient form of the lamb. We understand this to be the elevation of the humility of God the Word, and we are led to remembering His life in the flesh, His passion, His saving death and, thus, deliverance which took place for the world.[3]

This decree in effect eliminated symbolic portrayals of Christ, a prohibition that would have seemed strange to the early church. Now images of Christ were to portray his face directly, presenting both the human who lived in time and place and the God whose glory must be reflected in the painting.[4] While following these guidelines, iconographers developed a variety of icons for Christ, depicting him in the events of his life from the nativity to his ministry, death, and resurrection. These icons were meant to serve not merely as illustrations of Christ, as didactic tools, but rather as a focus for worship of Christ, for it was believed that veneration directed at an icon of Christ went directly to Christ himself.[5]

Late Medieval Depictions

By the late Middle Ages, Western depictions of Christ had come to emphasize his passion, for during this time, according to Emile Mâle, "the Passion became the chief concern of the Christian soul."[6] Stained-glass windows, murals, tapestries, altarpieces, and wooden, brass, ivory, and bejeweled sculptures depicted countless crucifixion scenes. In England, devotion to the wounds of Jesus was expressed in the woodprints of thousands of lay primers (devotional handbooks), which included the Arms of the Passion, the Five Wounds, the Image of Pity, and the Mass of St. Gregory.[7]

The Passion was not the only event commonly depicted. In thirteenth-century France, for example, the Nativity was more popular than the Passion as a visual theme, for, by including Christ's mother, it paid homage not only to Christ but to the Virgin, the most important saint of the Middle Ages.[8]

One frequent image of Christ and his mother was of Mary suckling the Christ child.[9] Earlier medieval depictions of this scene—for example, those during the Romanesque period—tended to portray both mother and child

staring straight ahead with expressionless faces, their clothing frozen in rigid lines. Later, Gothic statuary emphasized the intimate relationship between them: the child playing on his mother's lap; a loving expression on the mother's face. This emphasis on the tenderness and sweetness of the Madonna and Child in late medieval depictions of Christ reflects the shift during the Middle Ages from a scholastic to a more mystical and affective spirituality.

Post-Reformation Depictions

When the river of Christian art encountered the Reformation, it forked into at least two different streams. In the Roman Catholic stream—a Counter Reformational response—were artists such as Rubens, who depicted Christ in highly dramatic ways. Large-scale figures, bold colors, and voluminous drapery emphasized the divinity of Christ. In his early years, Rembrandt (1606–69) too emphasized this approach, but later, as he meditated on the Scriptures and came in line with many of the Reformation's ideals, he made a discovery, explained by art historian Visser 'T Hooft:

> [Rembrandt] now knew what was known to Luther [and] Calvin . . . that the Revelation is not a demonstration of God's power and glory which is at once evident to everybody, but a descent of God which is only intelligible to faith. . . . Since Rembrandt knew of this incognito of Christ, the Christ in his work no longer bears any resemblance to a figure from a heroic epic poem, or a model of touching humility. . . . Rembrandt is as realistic as the Gospels. . . . The novelty in the technique of this painter of the Bible consists in men discovering that this insignificant figure [Christ in the crucifixion scene], without beauty or power, is the one *on whom everything depends.*[10]

Rembrandt's depictions of Christ are thus in the Reformation stream: understated and quietly but deeply moving.

Attitudes toward Depicting Christ

Just as depictions of Christ have changed throughout the centuries, so have Christians' attitudes toward these depictions. The two most important episodes in the debate over whether Christ should be presented in art took place during the Iconoclastic Controversy and the sixteenth-century Reformation.

The First Great Debate

The first major period of debate over the use of images of Christ in worship, now referred to as the Iconoclastic Controversy, took place in the eighth and ninth centuries, primarily in the eastern part of the church. The stakes were high, and at times the conflict erupted in violence. Icons, altars, veils, and relics were destroyed, numerous monks and bishops were exiled, and riots, torture, and persecution resulted in injury and death.[11]

Iconodules (also known as iconophiles) argued in defense of the use of icons in worship; iconoclasts argued against them. Current knowledge of the argument comes primarily from the perspective of the iconodules, since they won the debate and their writings are the ones which have survived. The two most influential writers were John of Damascus (c. 675–c. 749) and Theodore the Studite (759–826). By the time Theodore was writing, the iconodule arguments were more fully developed, so we will draw primarily on his writings for a summary of the issues.

The issues were complex, ranging from topics such as the veneration of saints' images to the possibility that grace comes through icons; from the interplay of spirit and matter to the relationship of hearing and seeing. We will examine three groups of the iconodules' arguments related specifically to images of Christ.

Christology

The first group of arguments is christological. Many of these arguments revolved around the terms developed in the early councils in reaction to heresies. Thus, both sides of the debate used christological terminology to buttress their claims and to throw the other side into the heretic's box. The iconodules claimed that Christ is "circumscribed by the flesh, while remaining uncircumscribable in His divine nature" and therefore that the circumscription, "namely the image of Christ, is worthy of veneration."[12] In addition, icons represent and even prove the reality of the incarnation. Contrasting idols with icons, Theodore writes, "The one belongs to polytheism, but the other is the clearest evidence of the divine economy. . . ."[13] The divine economy refers to God's dealings with the world, particularly the plan of salvation through Christ. For Theodore, the denial of icons equals the denial of Christ's humanity and thus of our salvation.

The iconoclasts retorted that to portray Christ is a double blasphemy: "First of all, you attempt to represent the unrepresentable divinity. Second, if you try to represent the divine and human natures of Christ on the icon, you risk confusing them, which is monophysitism."[14] In addition, they accused the iconodules of Nestorianism, the heretical belief that the divine and human natures remained separate in the incarnate Christ. By

103

separating Christ's humanity and divinity and thus giving Christ's humanity a separate existence, the iconoclasts claimed, the iconodules introduced a fourth person into the Trinity.

Power of Prototype

The second group of the iconodules' arguments involved the relationship between the image and the Person whom it represents. Theodore describes the connection: "What we call 'circumscribed' is simply that which is a prototype. For that which is circumscribed can serve as a model for the image which is drawn as a copy. Therefore when you admit that Christ is circumscribed, you must grant, whether you like it or not, that He is the prototype of His image, as every man is of his own likeness."[15] Therefore, Theodore considers it appropriate to create images of Christ, for they correspond to Christ as their prototype.

One aspect of this correspondence is that the image has power only because of its connection to the prototype. St. John of Damascus writes, "Matter is endued with divine power through prayer made to those who are depicted in image. Purple by itself is simple, and so is silk, and the cloak which is made of both. But if the king puts it on, the cloak receives honour from the honour due to the wearer. So is it with matter. By itself it is of no account, but if the one portrayed in image be full of grace, men become partakers of his grace according to their faith."[16] The power of the prototype is extended to the worshiper through the image.

Levels of Veneration

The third set of arguments relates to levels of veneration. Should icons be placed higher on the walls of the church so that they are not venerated?[17] The iconodules answer no. Should the cross be venerated more than an icon? The iconodules say yes, if you are referring to the original cross.[18] Should the inscription on an icon be venerated? The iconodules say yes, for a name is "a sort of natural image of that to which it is applied."[19] Do different levels of veneration exist? The iconodules say yes, even though they have the "same outward form."[20] Is there a difference between honor and veneration, and between calling an object holy and calling it venerable? The iconodules say no, they are inextricably linked. The specificity of the questions demonstrates how detailed the arguments became and how focused they were on the outworkings of the veneration of images.

The Second Great Debate

The second major period of debate over the use of images in worship was the sixteenth-century Reformation. Unlike the first debate, the most

significant surviving writings from this debate are by those who were against images. And the thrust of this second debate was quite different, focusing on the centrality of Scripture and its impact on the use of images in worship. The parties in the debate shared a concern for the foundational nature of scriptural authority and a desire to see God's Word honored. They also opposed the veneration of images and were united in their concern over the abuse of images that had developed in the late Middle Ages. But they differed in their strategies and in their opinions regarding the prohibition of images. Among the many Reformers who wrote about the issue were Martin Luther (1483–1546) and John Calvin (1509–64).

Martin Luther

For Luther, whose posting of ninety-five theses in 1517 triggered the tidal wave of the Reformation, there are both appropriate and inappropriate uses of images in worship. The centrality of God's Word and the use of images are not necessarily opposed to each other. In fact, images can be used to emphasize the Word. He writes: "I do not think it wrong to paint such stories along with the verses on the walls of rooms and chambers so that one might have God's words and deeds constantly in view and thus encourage fear and faith toward God. And what harm would there be if someone were to illustrate the important stories of the entire Bible in their proper order for a small book which might become known as a layman's Bible? Indeed, one cannot bring God's words and deeds too often to the attention of the common man."[21]

For Luther, the idea of painting from God's Word is a natural one. Several times, he includes painting in lists of the ways in which God's Word can be effectively communicated. For example, in his commentary on Psalm 101:2, Luther writes about princes and kings who are adversaries of God's Word. He speaks of the situation in Germany in which God's Word is being presented powerfully and therefore they have no excuse: "For there is no shortage of great intelligence. God's Word is presented so powerfully, lucidly, and clearly in preaching, singing, speaking, writing, and painting that they must concede it is the true Word of God."[22] A similar list appears in his commentary on Psalm 147:19 in which he includes painting as one of the many ways in which God's Word can be praised: "Who can completely express the greatness of this gift? For who can exhaust all the virtue and power of God's Word? The Holy Scriptures, sermons, and all Christian books do nothing but praise God's Word, as we also do daily in our reading, writing, preaching, singing, poetizing, and painting."[23]

Further, in his commentary on Isaiah 30:8, Luther shows that painting can be an effective external sign to accentuate the teaching of the Word:

105

"This is customary procedure with the prophets: When the ungodly refuse to believe the bare Word, the prophets add an external sign. So Jeremiah, getting no results when he predicted the Babylonian captivity, wore a chain around his neck as an external sign (Jer. 27:2). So here the writing drawn on the tablet is a sign. Thus in our time the Word is read and taught by means of the tongue, the pen, songs, and paintings as a witness to the ungodly."[24]

In his early years as a reformer, Luther had reacted negatively to images. He believed that money given to beautify cathedrals could better be spent on taking care of the poor. And he was strongly opposed to images of saints used in shrines to which the laity would undertake arduous pilgrimages. He objected to the works-righteousness mentality deeply embedded in late medieval piety that required the laity, in order to avoid an extended stay in purgatory, to sacrifice money, time, and sometimes even health to the service of the saints.[25]

But as other reformers (particularly Andreas Bodenstein von Karlstadt, Luther's colleague at the University in Wittenberg) began iconoclastic attacks on churches, Luther offered a strong rebuttal in his only extended treatment on images, *Against the Heavenly Prophets in the Matter of Images and Sacraments*. In it, he takes two tacks. First, he objects to the iconoclasm because it was conducted in an improper manner. He speaks against the iconoclasts' rampages because they sidestepped the justice system and destroyed property without proper authority. If taken to their logical con-clusions, such actions could lead to widespread anarchy among the masses. Second, he charges, the iconoclasm was a violation of Christian freedom, which allows for individual Christians to follow their consciences in mat-ters of secondary importance. Instead of smashing images, the iconoclasts should be preaching the Word of God, allowing it gently to lead the peo-ple to destroy their own images, if necessary. What is more important is that images be removed from people's hearts rather than from before their eyes.[26]

Then, taking his second tack, Luther argues in favor of images. He dis-misses Moses' commandments as ceremonial laws relevant to Jews but not to Christians. Even if it were applicable, he argues, the command-ment about images applies only to worshiping images, not to making images that are not worshiped. Further, he claims that Paul, in 1 Co-rinthians 8:14, abrogated the commands against making images by declar-ing that the Corinthians were to have freedom in matters pertaining to idols.[27] While he does not condemn those who destroy images that are "divine and idolatrous," he says that "images for memorial and witness, such as crucifixes and images of saints, are to be tolerated."[28] He argues that the iconoclasts are reading his German Bible, which is filled with pictures, so why do they object to pictures on walls? "It is to be sure better

106

to paint pictures on walls of how God created the world, how Noah built the ark, and whatever other good stories there may be, than to paint shameless worldly things. Yes, would to God that I could persuade the rich and the mighty that they would permit the whole Bible to be painted on houses, on the inside and outside, so that all can see it. That would be a Christian work."[29] And finally, Luther points out that God commands Christians to meditate on Christ's passion and that this leads naturally to images formed in the imagination. Therefore, Luther concludes, "If it is not a sin but good to have the image of Christ in my heart, why should it be a sin to have it in my eyes?"[30]

John Calvin

Calvin, another renowned reformer, shared Luther's concern about the abuse of images in worship but went further in his prohibition of images. In *The Institutes of the Christian Religion,* Calvin focuses on idolatry. Giving a form to God, any form, is a corruption of God's glory: "Every statue man erects, or every image he paints to represent God, simply displeases God as something dishonorable to his majesty."[31] People everywhere have a need to create images of God that make him like themselves.[32] And once they create an image, they need to worship it: "Adoration promptly follows upon this sort of fancy: for when men thought they gazed upon God in images, they also worshiped him in them. . . . Men are so stupid that they fasten God wherever they fashion him."[33] Calvin objects to the Catholic view that differentiates between *latria* (worship) and *dulia* (veneration), stating that merely using a different word does not change the reality that they are in fact worshiping idols: "Let them show, I say, the real difference that makes them unlike the ancient idolaters. For just as an adulterer or a homicide cannot escape guilt by dubbing his crime with some other name, so it is absurd for them to be absolved by the subtle device of a name if they differ in no respect from idolaters whom they themselves are compelled to condemn."[34]

Calvin demonstrates an awareness of the arguments made in previous centuries and reacts in opposition to them. First, he opposes Pope Gregory's claim in the sixth century that "images are the books of the uneducated." If images of God are teachers, they are teaching falsehoods about God.[35] And if the church had been doing its job of the "preaching of his Word" and instructing in the "sacred mysteries," then there would have been no need for attempting to teach through images.[36] Calvin was also aware of the arguments of the Iconoclastic Controversy and the conclusion of the Seventh Ecumenical Council through the *Libri Carolini,* which had been compiled in the eighth century under Charlemagne's direction and of which an edition had been published in 1549 by Jean du Tillet. He lists a number

of arguments he considers a misuse of Scripture and refuses to follow the dictates of the council, saying, "Now let the promoters of images go and urge upon us the decree of that synod. As if those venerable fathers do not abrogate all trust in themselves either by treating Scripture so childishly or by rending it so impiously and foully!"[37] He points out that the anathema the council declared against those who do not venerate images of God would have condemned the prophets, apostles, and martyrs, who did not venerate images in their day.[38]

Although he condemns the veneration and worship of images of God, Calvin does not, however, prohibit all images: "I am not gripped by the superstition of thinking absolutely no images permissible. But because sculpture and painting are gifts of God, I seek a pure and legitimate use of each, lest those things which the Lord has conferred upon us for his glory and our good be not only polluted by perverse misuse but also turned to our destruction. . . . It remains that only those things are to be sculptured or painted which the eyes are capable of seeing: let not God's majesty, which is far above the perception of the eyes, be debased through unseemly representations."[39]

In his prohibition of images of God, Calvin includes those of Christ: "Scripture itself also not only carefully recounts to us the ascension of Christ, by which he withdrew the presence of his body from our sight and company, to shake from us all carnal thinking of him, but also, whenever it recalls him, bids our minds be raised up, and seek him in heaven, seated at the right hand of the Father."[40]

Thus, Calvin does not ban all images, but for him any worship or veneration of an image is idolatrous, and the creation of any image of God, even of the incarnate Christ, is sinful.[41]

The Biblical Commands

The issue of whether to make images of God is such a critical one that it makes the list of Ten Commandments. The second commandment, as stated both in Exodus 20:4 and Deuteronomy 5:8, is: "You shall not make for yourself an idol in the form of anything in heaven above or on the earth beneath or in the waters below. You shall not bow down to them or worship them; for I, the LORD your God, am a jealous God" (NIV).

This commandment played a critical role in the controversy throughout the centuries. To understand what the commandment refers to, we must look closely at the three levels of images mentioned. By referring to the heavens, the earth, and the waters, the Lord covers the gamut of possibilities for images. Given that God is consistent in all his commands and

instructions, if he had forbidden the mere making of representational images, then he would not have commanded the sculpting of them for the tabernacle. And yet, in his explicit instructions for the tabernacle, he includes images of cherubim (Exod. 37:7–9), almond flowers (Exod. 37:17–22), and pomegranates (Exod. 39:24). Representational art is included in the temple also.[42] Thus, God does not forbid the use of representational images and art in a place of worship. Instead, what seems more likely is that he forbids the worshiping of such images.

The second commandment prohibits the worshiping of any representational object. Another passage makes it clear that even if the object is meant to represent God himself rather than another god, it is still prohibited. In Deuteronomy 4:15–24, Moses, describing the day when God spoke to the Israelites out of the fire on Mount Horeb, reminds the Israelites that when they heard God's voice, they saw "no form of any kind." Therefore, Moses warns them not to make images "of any shape." "For the LORD your God is a consuming fire, a jealous God" (v. 24 NIV). This passage seems to imply that making an object to represent God makes him jealous, for it is not God that is being worshiped but an object. It also seems to imply that God does not choose to reveal himself in a visual form and therefore does not want humans attempting to depict him in a visible way either.

The prophet Isaiah reveals another aspect of God's objection to being presented in visual, finite form. God finds the comparison insulting:

> To whom then will you compare God?
> What image will you compare him to?
> As for an idol, a craftsman casts it,
> and a goldsmith overlays it with gold
> and fashions silver chains for it. . . .
> Do you not know?
> Have you not heard? . . .
> He sits enthroned above the circle of the earth,
> and its people are like grasshoppers. . . .
> He brings princes to naught
> and reduces the rulers of this world to nothing.
>
> Isaiah 40:18–19, 21–23 NIV

The New Testament confirms God's abhorrence of idols. Paul, when visiting Athens, is deeply disturbed by the city's idolatry. He teaches the people that the one true God cannot be confined to an idol: "The God who made the world and everything in it, he who is Lord of heaven and earth, does not live in shrines made by human hands, nor is he served by human hands, as though he needed anything, since he himself gives to all mortals life and breath and all things. . . . Since we are God's off-

spring, we ought not to think that the deity is like gold, or silver, or stone, an image formed by the art and imagination of mortals" (Acts 17:24–25, 29 NRSV).

God is the provider of our very life and breath; he does not need anything from us. Conversely, idols invite nurturing, even condescending, behavior; even images intended to be of the biblical God. For example, Margery Kempe, a fourteenth-century mystic, writes of her encounter with a woman on pilgrimage who had an image of Christ in her luggage: "The woman who had the image in the chest, when they came into fine cities, took the image out of her chest and set it in the laps of respectable wives. And they would dress it up in shirts and kiss it as though it had been God himself. And when [I] saw the worship and the reverence that they accorded the image, [I] was seized with sweet devotion and sweet meditations, so that [I] wept with great sobbing and loud crying."[43]

And Maxim Gorky describes his grandmother's treatment of icons: "To see her wipe the dust from the icons and clean the chasubles was both an interesting and a pleasant experience. The icons were very rich, with pearls, silver and coloured stones along their edges. She would nimbly pick an icon up, smile at it and say with great feeling: 'What a lovely little face!' Then she would cross herself and kiss the icon. Often, it seemed, she played at icons like my crippled cousin Katerina played with her dolls, seriously and with deep emotion."[44]

Paul's words indicate that God finds it offensive to be treated like a helpless object. Nor does God appreciate being modeled as a finite being. He is the creator of the universe. God made us; we should not think that we can make God. We are his offspring; how dare we think he is like any thing we can create with our own hands?

Paul reiterates this idea in Romans when he describes those who claim to be wise but who have become fools and "exchanged the glory of the immortal God for images made to look like mortal man and birds and animals and reptiles. . . . They exchanged the truth of God for a lie, and worshiped and served created things rather than the Creator—who is forever praised" (Rom. 1:21–25 NIV). Why would anyone exchange the most wonderful being in the universe for something small, malleable, predictable, controllable, and portable? Why exchange the glory of the immortal God for a wooden doll you can hold in your hand?

The Bible's teachings on images preclude the worshiping of any human-made object. When one worships such an object, even one that attempts to depict the God of the Bible, one worships something other than God, and this is idolatry. Idolatry not only insults God but is harmful to humanity, for it robs us of God's glory, power, and immensity. The God of the Israelites forbids us even to make representations of him, whether or not

we worship them.[45] Therefore, we should not create any art that attempts to portray God the Father as a visible, finite being.

The situation may be different, however, when we consider painting pictures of Christ. Unlike God the Father, Christ was not invisible when he was on earth. In fact, part of his function while on earth seems to have been to make the invisible God visible. Paul describes Christ as "the image of the invisible God, the firstborn of all creation" (Col. 1:15 NRSV; see also 2 Cor. 4:4). And Christ said, "Whoever has seen me has seen the Father" (John 14:9 NRSV).

Still, no Scripture passage speaks directly to this issue of whether to depict Christ in art. This is one of many points in the debate at which one's presuppositions of biblical interpretation come clearly into the decision. If one holds the regulative principle (whatever is not specifically prescribed in Scripture for worship is not allowed in worship, a principle held by certain segments of the Reformed community, for example), then the very absence of a directive on depictions of Christ is enough to prevent the use of such. However, if one holds that anything is permissible in Christian worship that is not specifically prohibited and is in accord with biblical principles in general (an approach held by Lutherans and by other segments of the Reformed community as well as other Protestants), then there may be room for the use of paintings or sculptures of Christ as long as they are not themselves worshiped. A third approach is that taken by the Roman Catholic Church and the Orthodox Church: to take both Scripture and Tradition (such factors as the church fathers, councils, papal dictates, and the liturgy) into account in making decisions about worship. Both the Orthodox and Catholic churches uphold the stance of the Seventh Ecumenical Council on the veneration of images of Christ.

Because in his human nature Christ was both finite and visible, perhaps the Scriptures do not preclude depicting him as such in paintings and sculptures representing him in his earthly life. If such works of art are produced, however, they must not be worshiped. They can be aids to worship, reminding one of the life or characteristics of Christ, or giving fresh insights into theological truths relating to him, but they must not become the focus of worship itself.

Using Art to Know God Better

There are many ways in which we in the twentieth century can use art from the past to enhance our knowledge of God and his scriptural truth. When we seek to learn more about God by examining a painting or sculpture in light of Scripture, art can help us see a familiar passage in a fresh

111

way and bring us to a clearer understanding of God. Indeed, many people's lives have been changed by particular works of art. Henri Nouwen's life, for example, was profoundly affected by seeing Rembrandt's *The Prodigal Son* at the Hermitage Museum in Russia.[46]

Most of the popular arts used in Christian worship in the past to which we in the United States have access have been imported from Europe and are now, ironically, housed in museums of *fine* arts. The most effective way to experience a painting or a sculpture is, obviously, to see it firsthand, so whenever afforded the opportunity, visit a museum. Late Antique, Byzantine, Medieval, European, and Early American sections are the most likely to include paintings with Christian subject matter. But you can also learn much through high quality reproductions in museum catalogs and art history books or even on postcards and posters.

Throughout the process of seeking to know God better through paintings and sculptures, one should pray for the Holy Spirit's guidance, for help in discerning truth from error, for fresh insights into scriptural truth, and perhaps even for a life-changing encounter. The governing principle is to judge the theological content of a painting or sculpture in light of the Scriptures. The Bible must always be brought to bear, for there can be no new revelation. This entails knowing the Scriptures well, and in this sense, for those who are touched more easily by seeing than by hearing, the world of art can spur a deeper examination of the Scriptures. This interplay of Word and work of art, this juxtaposition of Text and canvas, this bringing to bear of Divine Authoritative Declaration on human artistic impression, is what makes it possible for us to know God through these postcards from the past.

Suggestions for Exploration

Visit a museum. Before going, familiarize yourself with the common types of depictions of Christ. The more you read in advance about the types of works you will see, the better you will be able to understand what the paintings intend to communicate. And the more you know about artists' spiritual backgrounds, the better you know their presuppositional framework and can understand what the symbols they use mean.

Ask yourself the following questions when viewing a painting or sculpture of a biblical scene.

1. What Scripture passage does the scene depict? Often the title of the painting will indicate this clearly, but sometimes you are not provided with the title. In the latter case, study the central action of the scene and search your mind for stories that seem to match it. The better you know your

Bible, the better off you are. Are multiple scenes depicted? If so, are they in separate panels or merged within one frame?

2. Once you have ascertained which Scripture is illustrated, note what moment in the story the artist has chosen to emphasize. Is it the climactic moment? For example, Leonardo da Vinci's *Last Supper* illustrates the moment immediately after Christ said that someone would betray him, when the disciples are reacting with astonishment. Is the artist portraying a moment that is not actually mentioned in the Scriptures but is implied?

3. What emotions or actions are emphasized in the painting? Does the artist present the action in a highly dramatized fashion, as Baroque painters such as Rubens often did? Does the artist include many figures in each painting, using swirling drapery and bright colors to accentuate the excitement of the event? Or does the artist aim to capture the tender, intimate emotions of the participants, eliminating extraneous figures, focusing the light on the key person, choosing quiet but spiritually significant moments, as Rembrandt often did—particularly in later life. What mood is conveyed by the piece? Tranquility? Pathos? Anguish? Joy? Stillness? Violence?

4. How does the artist accomplish his or her goals? Note the brushwork. Is it thick and vigorous or soft and delicate? Note the colors. Are they muted and deep or bright and cheery? Note the lighting. Where is it coming from? Is it a heavenly light source, perhaps indicating divine approval of the central figure on which it shines as in a scene showing the descent of the dove at Jesus' baptism? Note the direction of lines or curves and the placement of bodies and objects. Where is the eye led? If the work is a sculpture, what kind of media is used? Wood, gold, silver, terra cotta? Is the sculpture three dimensional, or is it a scene in relief? Is the sculpture painted or polished or bejeweled? Is it roughly hewn or smoothly finished? How large is the scale of the work? Is it monumental or in miniature? Life sized, half sized, oversized? Note the condition of the painting or sculpture. Have the colors faded? Is anything missing? Has anything been added to the work since the death of the artist?

5. Who is the artist? What do you know about his or her religious convictions? Is he or she Protestant, Catholic, Orthodox? When was the painting made? And at what point during the spiritual pilgrimage of the artist? How does it compare with previous or later works by the same artist? If the artist is particularly prolific, as with Rembrandt, you can sometimes compare the work with other works by the same artist on the same theme and see the artist's spiritual journey reflected in his or her art. In what era in church history was the painting made? What can you learn about that era that has a bearing on the painting? Is the artist painting under threat of persecution by political or religious opponents? What is the occasion for

the painting? Where was it originally to be displayed? In a cathedral, parish church, home? Was it at the center of attention as part of the altarpiece? Was it hidden up in a ceiling vault or away in a small side chapel? Is it a work meant to stand on its own, is it part of a cycle, or is it one panel from a triptych? If the last, what is the complete set about? Was the work commissioned? If so, what do you know about the patron? Why was the painting made? Did the patrons contribute the painting to a church as a good work to shorten time in purgatory (as many did in the late medieval period)? Knowing who is involved in the work allows you to interpret its iconography more accurately. Similar objects in two different paintings may have different meanings depending on when and where and for what occasion they were painted.

6. Note the iconography of the painting. Hundreds of symbols have developed throughout church history, and knowing what they mean can contribute much to your understanding of a biblical scene. A book such as George Ferguson's *Signs and Symbols in Christian Art* can be an invaluable guide as you walk through a museum. Why is a skull at the foot of the cross? Why are rabbits often included in Nativity scenes? Or a peacock? What do the aspen, bulrush, clover, dandelion, elm, fern, grapes, hyacinth, iris, jasmine, and so on, stand for? Why do we see ten of this and seven of that? Why is Mary wearing blue, and why are halos gold? Knowing what these and other symbols mean can help you understand the central action of a biblical scene.[47]

7. Now that you have a fair idea of what the artist was trying to communicate through his or her painting, you can compare it with the biblical account to see whether what is communicated is true. You should take all of the above information into consideration. You should keep an eye out for paintings that tell lies unwittingly. For example, an ornate gold relief sculpture of the flagellation of Christ presents the event in such beautiful flowing lines, with the soldier holding Christ so gracefully, that the message that comes across is that the flagellation was an idyllic moment in time. On the other hand, sometimes an event not specified in the Scriptures can nevertheless trigger thinking along biblical and theological lines. For example, a terra-cotta relief in fresh greens and blues in the background with alabaster white figures of Christ and the Virgin with the Christ child reaching out to grasp three lilies and with three angels singing in the heavens can remind one that Mary probably had many tender moments with Christ, that Christ as a child was already destined to rise again (lilies symbolize resurrection), and that all Persons of the Trinity were involved in some capacity in the incarnation of Christ.

Whenever you run across a detail or an approach taken by a painting or sculpture that is unusual, look up the account in Scripture to see if any-

thing is contradictory. You should check the work of art against a wholistic understanding of Scripture, not merely prooftexting but rather measuring it against the totality of the scriptural message.

In this way, you can grow in your love of God and his Word while deepening your understanding of art from the past.

6 Movement: The Language of Dance

Celeste Snowber Schroeder

She could not contain her limbs after witnessing the most astounding event. Truly miracle and mystery were entwined in this moment of history, this moment of God-history. God had done the impossible. God had parted the Red Sea. Her joy and thankfulness could not be contained in the postures of stillness but had to leap off her body. So Miriam danced and danced with all the exhilaration she could muster and brought many other women with her, their arms and legs moving with the rhythms of their tambourines. Once again, theology became doxology as the human body danced the announcement of God's action and love (Exod. 15:20–21). redemption

Dance, as an art form, is taking movement—the language of dance—and shaping it in time and space. This art is centuries old, once central to the social and religious life of almost every culture. As Curt Sachs, the well-known dance historian, writes, "few danceless peoples" exist.[1]

Dance has taken shape through the nuances of each culture's body language, developing a diverse vocabulary of movement. The tapestry of dance is woven from the earthbound movements of Africa, the jigs of Scotland, the rhythms of flamenco, the vigorous jumps of Russian folk dance, the sways of Afro-American spirituals, the sweeping arabesque of the ballet dancer, the contraction of the modern dancer, the circle dances of the Hebrew people. In the latter part of the twentieth century, dance takes many forms—jazz, ballet, modern, and non-Western expressions—and reflects the dimensions of human experience.

What makes dance distinct as an art form is that it awakens our kinesthetic sense in a moment of time. Kinesthetic sense could be called our internal muscle sense, but it is more than that. It is our capacity to feel within our bodies, even if we are still. It is the dancer's inner body-awareness of movement, particularly in relation to space, energy, and size of movement. Therefore, even as we watch dance, we experience it kinesthetically, for movement is perceived not only intellectually

117

but physically. Dance has the capacity to touch us physically and emotionally at our roots, provoking the deepest emotions, from love to fear to joy to abandon. And as a time art, dance captures us in immediacy. Said well by dancer and writer Judith Rock, "In its brief incarnation, a successful dance creates a momentary relationship with us by drawing us into the temporal and physical reality that it is and presents."[2]

Dance draws us in through our bodies. Because we are bodily beings, dance has the potential to be an extremely accessible art. Unlike a musician or a painter, who must acquire a saxophone or a paintbrush, I do not have to purchase a body. I am a body. That is how God made me. Dance affirms the ever-present biblical truth that we are made as humans: body and spirit. Dance speaks to us body to body, body to spirit.

Dance and the Christian Faith

Our creative God has given us as many ways to move as verbal languages to speak. Yet among Christians, dance is perhaps the least familiar and the most misunderstood of the art forms. In my experience of teaching the arts in a Christian college, I have noted that most students have attended a music performance, but few have been to a dance performance. If they have, it is usually classical ballet, yet many other forms of dance exist, such as jazz, modern, modern-ballet, folk, performance art, or postmodern dance. Because the church predominantly has felt uncomfortable with the body, to encourage interest in dance as an art form and to establish a comfortable relationship between dance and the Christian faith has been difficult— despite a rich heritage of dance in church history.[3] The philosophical concept perhaps most responsible for a negative view of the body and dance among Christians—and, consequently, for the church's resistance to building a biblical framework for a theology of dance—is dualism.

Dualism *enemy*

Dualism is the notion that soul and body are disconnected; hierarchical dualism contends the soul (divine) is elevated over the body (earthly). Threads of dualism have woven their way through most expressions of Western philosophy and teachings of the church. Plato speaks of the body as the "prison" of the soul. Descartes says, "The soul, by which I am what I am, is entirely distinct from body."[4] Plotinus, the Neoplatonic philosopher, speaks of the soul being "deeply infected with the taint of the body."[5] Platonic and Neoplatonic dualisms formed the backdrop for continued dualisms through the Enlightenment and in the present age. Dualistic thinking was part of

118

the intellectual climate of the early church, since Greek philosophy was integrated in the training of church leaders. Scripture was read through what Brian Walsh calls "the dualistic world view glasses."[6] These attitudes have created an inhospitable climate for accepting our bodies as a gift from God, as something good and wholesome that can be used for God's glory.

But God has designed us as a whole: body and soul interconnected in a living, breathing organism. This is the Hebrew understanding of the body. The Old Testament scholar Johannes Pedersen says it well: "Soul and body are so intimately united that a distinction cannot be made between them. They are more than 'united': the body is the soul in its outward form."[7]

Creators of dance and the biblical writers avow this truth: the body and soul are connected. Dancers announce it through the aesthetics of bodily language; the biblical writers announce it through the nuances of the verbal text.

Body and Soul in the Old Testament

The Old Testament writers express the Hebrew perspective in their use of words for body, soul, heart, and mind. The connection between body and soul is demonstrated in narrative and poetry in which the body and parts of the body express emotion, and the soul and the emotions take on physical attributes. The bowels writhe in pain (Jer. 4:19 KJV), the belly grieves (Ps. 31:9 KJV), the liver churns (Lam. 2:11 KJV), the bones shake (Jer. 23:9), the soul thirsts (Ps. 63:1), and the flesh sings (Ps. 84:2). The depths of human emotion are referred to as parts of the body, and the body rejoices, laments, proclaims, and dances the longings of the human being. In the text of the Old Testament, the gestures of the body disclose an internal reality. So too with dance: the inward reality is expressed through the outward reality; this is the capacity of dance to function as symbol, as one thing pointing toward another. As Paul Klee, the twentieth-century visual artist, so aptly says, "Art does not reproduce the visible; rather, it makes visible."[8]

The Old Testament further shows the relationship between body and heart in the way the people of Israel prayed, worshiped, and proclaimed. Grief, anger, jubilation, reverence, adoration, confession, supplication, lament, and praise are all expressed in the context of the body. The Israelites prayed bodily: kneeling, swaying, lifting hands, lying prostrate, sitting, jumping, walking, leaping, and dancing.[9] The art of performance dance, too, literally fleshes out the relationship between body and heart, as the torso becomes a fine-tuned extension of an internal reality. In fact, if the dancer does not allow movement to originate from the center of his or her being, dance is simply relegated to a series of steps. José Limón, a dancer and choreographer in the twentieth century, writes: "The basic and all-important principle is never forgotten, that movement, in order to have power and eloquence and beauty

must spring from the organic center of the body. It must have its source and impulse from the breathing of the lungs and the beating of the heart. It must be intensely and completely human, or it will be gymnastics, and be mechanical and empty."[10] Even though the postures of a modern dancer are vastly different from those of the Old Testament worshiper in bodily prayer, the principle is the same: body becomes expression of heart and mind.

Nowhere is this principle more evident in the Old Testament than in the role of dance.[11] Dance was a response to God, one of thanksgiving and joy for how God had been faithful in the Israelites' lives. Unlike the people of neighboring cultures, for the Israelites dance was not a means to an end, a way to get God's attention, help crops grow, or create union with the deity.[12] Dance for devout Israelites was a way of saying yes to God. Yes with their fingers, yes with their toes, yes with their whole bodies. It was not a rehearsed step-by-step dance, but a dance that swept thanksgiving into their bodies. So when God parted the Red Sea, a sizeable miracle, appropriately the sister of Moses, Miriam, broke forth in dance and song (Exod. 15:20–21).

The emotion most readily expressed in the dance of the Israelites is joy. Some passages even use dance as a metaphor for joy: "You turned my wailing into dancing; you removed my sackcloth and clothed me with joy" (Ps. 30:11–12 NIV). Joy could not be contained in the discourse of the mind but had to ripple forth through the cells of the body.

The Israelites give us a spirituality that is embedded in physicality, where body and soul meet. Professional dancers, too, find this is their experience, particularly if they understand the dimension of the Spirit of God intersecting with the work of art, with the work of movement. The faith of the people of the Old Testament was written by their bodies through the dance and gives us hope and courage to live out our faith in a perceptible fashion.

Creation, Incarnation, Redemption

In opposition to dualism—a notion still central to the way Western culture views the body—the biblical worldview loudly proclaims that God created the body, that God came to us in a body, and that the body participates in redemption. These three concepts originate in the essential beliefs of the historic Christian faith: creation, incarnation, and redemption—theological principles which provide a framework for appreciating the art of dance.[13]

The Dance of Creation

God has created us as moving beings. Movement is fundamental to being human and is integral to God's design. Ted Shawn, a pioneer in modern dance,

attests to this truth. "We know that body movement is life itself—our movement begins in the womb before our birth and the new-born infant's need for movement is imperative and continuous. When we sleep there is constant movement, our hearts beat, our intestines work; in fact as long as there is life there is movement, and to move is hence to satisfy a basic and eternal need."[14]

One of the first signs of life is movement, the dance of creation. This is so beautifully portrayed by Elizabeth's baby leaping in her womb at the greeting of Mary. John the Baptist responds to the coming Messiah with the fullness of his little body. In the language of movement, leaping and kicking form this baby's first sentence.

The stages of childhood development are marked by movement: crawling, sitting, walking, falling, jumping, running, turning, skipping, dancing. Children delight in movement as they explore gravity and levity: swinging at the playground, skipping on the beach, jumping at hopscotch, running into a parent's arms. Even Jesus, when describing his generation, cites children's natural inclination to dance (Matt. 11:16–17; Luke 7:31–32). Unfortunately, as adults we become more sedentary and easily forget that we too once danced to the rhythm of our hearts. Children are permitted to dance, but as adults we constrain ourselves to postures of gravity. But even our mundane activities—typing at the computer, driving a car, cutting up carrots, rocking a child, singing a hymn—require movement. And we adults have a body language all our own, standing revealed as we move, as Doris Humphrey, a famous modern dancer, would say. "Nothing so clearly and inevitably reveals the inner [person] than movement and gesture. It is quite possible, if one chooses, to conceal and dissimulate behind words or paintings or statues or other forms of human expression, but the moment you move you stand revealed, for good or ill, for what you are."[15] Nonverbal language makes up the substance of our expressions: the glance, the posture, the grimace or frown, the elation in our eyes. Martha Graham, well-known pioneer in modern dance, says, "Movement never lies. It is a barometer telling the state of the soul's weather to all who can read it."[16]

Few of us are trained dancers, yet movement—the language of dance—is crucial for life, breath, work, play, and even prayer.

The Dance of Incarnation

God meets us through the person of Jesus Christ in the incarnation. The Word became flesh and dwelt among us, says the Gospel of John (1:14), living, breathing, eating, working, walking, and healing. The love of Jesus was made manifest through the physicality of his body, which touched those he healed, embraced the children, pounded nails, and washed the disciples' feet. His hands became a vital extension of the heart of God. Jesus met the

world through his body in the ultimate bodily sacrifice of giving his life. We in turn have been ushered into the kingdom of God through his body.

The incarnation affirms that God uses human flesh and delights in doing so. It affirms the body not as something separate in and of itself but as part of God's design. C. S. Lewis articulates this well: "Christianity is almost the only one of the great religions which thoroughly approves of the body—which believes that matter is good, that God himself once took on a human body, that some kind of body is going to be given to us even in Heaven and is going to be an essential part of our happiness, our beauty, and our energy."[17]

The dancer's paintbrush is the human body: the expressive use of muscles, bones, ligaments, arms, legs, and torsos in motion. The incarnation encourages the dancer faced with the church's uneasiness about dance to know that the physicality of the body is something that is honored by God. Saint John of Damascus, writing in defense of images during the Iconoclastic Controversy, speaks to us today about the importance of the physical nature of art: "In former times God, who is without form or body, could never be depicted. But now when God is seen in the flesh conversing with men, I make an image of the God whom I see. I do not worship matter; I worship the Creator of matter who became matter for my sake, who willed to take His abode in matter; who worked out my salvation through matter. Never will I cease honoring the matter which wrought my salvation! I honor it, but not as God."[18] The dancer must honor matter, not as an end in itself but as something God can use.

This stipulation, however, does not mean that a dance must blatantly express God to honor God. There is no formula for "Christian dance" just as there is no formula for "Christian art." Just because a dance has a religious theme—which is a common occurrence in the art of dance—does not make it Christian.[19] In fact, *Christian* is a problematic adjective for art or an aesthetic standard. "Liturgical dance" or "sacred dance" are more accurate terms. Liturgical dance is the art of dance or movement offered within the liturgy or worship service in the context of proclamation, worship, prayer, praise, or lament. One can sense the Spirit of God participating in such a dance. However, the Spirit of God participates with the Christian dancer regardless of whether he or she is performing a liturgical piece or a secular piece.[20] If we use what God has given us and are faithful in that use, we participate in the calling to tend and love the earth and to serve God.

The incarnation, because it is a story of divinity working through limitations, also encourages us to accept the limitations of our bodies. We are not perfect, and neither are our bodies. We live between the already and the not yet. Of all the arts, dance reminds us all too soon of the body's physical limitations. The dancer must find the balance between pushing the limitations of his or her body and accepting those limitations. The professional dancer, the one who has dedicated his or her life to this vocation, must

daily keep the body in shape. This is the task of all artists: to keep their tools in good condition. Good technique comes out of the daily practice of strengthening, stretching, and fine-tuning the movement of the body. And if one is a choreographer, one must cultivate improvisation skills and nurture the creative process to discover new movement.

In my own experience as a dancer, I have found that I have to dance continually within my limitations. As I grow older, I do not have the same endurance or flexibility. I also have a varying number of responsibilities, including rearing three boys. These limitations do not allow me to dance six hours a day. I have come to believe art comes from the essence of life, not just from being in the studio. God uses the artist's immersion in the dailiness of life as inspiration to create works of depth and meaning. My body's limitations become a place where grace is poured out, divinity meeting humanity.[21]

The Dance of Redemption

Our hymnology and theology are so frequented by language that speaks of the salvation of the soul that we might think the rest of us were somehow left out. However, this is not a New Testament concept. God came to bring redemption to the whole person: body, soul, mind, and heart. The word used for salvation in the New Testament, *sōzō*, is sometimes rendered as "healing." It is used sixteen times in the synoptic Gospels to describe the healings of Jesus. This use is not necessarily intended to equate healing with salvation, but it does reveal that God is concerned with the physical dimension of life as well as the spiritual.[22] Redemption affects the whole person. Jesus came to bring not only life to us but abundant life, and part of that life is to experience being the complete human beings God made us to be, physically and spiritually.

How appropriate that when the prodigal son finally returns home, the celebration is marked by music and dancing (Luke 15:11–32). In this parable, one of the few times dancing is mentioned in the New Testament, dance is a means of celebration. Returning home—returning to family, returning to God—*is* cause for dancing. One purpose of our ongoing salvation is to bring us to wholeness, a wholeness that cannot be contained in the mind but floods our entire being. In the art form of dance we can tangibly affirm that our physical and spiritual natures are intertwined.

Improvisation and the Life of Faith

In the theological realities of creation, incarnation, and redemption, I am given an ongoing invitation to create, mold, form, and eventually birth new movements—the making of a piece. But in the throes of the creative process,

one realizes that much of it is plain hard work. Going to the studio to create can sometimes be as romantic as mowing the lawn. Sometimes one must simply keep working. Madeleine L'Engle writes, "Inspiration far more often comes during the work than before it, because the largest part of the job of the artist is to listen to the work, and to go where it tells him [or her] to go."[23]

We create only out of what God has first given us. I could not choreograph if God had not given me the miracle of movement in my fingers, toes, pelvis, and neck. And what I do will be only a dim reflection of the indescribable beauty of the creation. Vincent van Gogh, a painter famous in the twentieth century, knew this reality deeply: "Christ alone . . . lived serenely as a greater artist than all other artists, despising marble and clay as well as color, working in living flesh. That is to say, this matchless artist, hardly to be conceived of by the obtuse instrument of our modern, nervous, stupefied brains, made neither statues nor pictures nor books; he loudly proclaimed that he made . . . living men [and women], immortals."[24]

The creation of who we are is a miracle. Van Gogh, who was once a preacher, knew only God could create the wonder of the human body. God, the original choreographer, has given the dancer the ability to create. Martha Graham writes: "The next time you look into the mirror, just look at the way the ears rest next to the head; look at the way the hairline grows, think of all the little bones in your wrist. It is a miracle. And the dance is celebration of that miracle."[25]

Risk and the Creative Process

If the creation reminds the dancer of who gave us the miracle of movement, the incarnation propels the dancer to risk in the work of the creative process.[26] The incarnation beckons us to risk because it is the reality of divinity coming through humanity. As God risked to become manifested in human form, the choreographer risks to form and re-form the language of the body into expressive art. At times, creating takes incredible courage. Courage is needed, first of all, because making art and making dances are seldom moneymaking endeavors, and second, because art-making and dance-making are invitations to surprise. One does not always know which movement will make sense. An artist must play with movement, play with paint, or play with notes until coming to a point of satisfaction, usually after hours and hours of hard work.

In dance, improvisation is playing with movement. It is a way of finding that which we know and that which we do not know. The word *improvisation* comes from the Latin *improvisus,* which means "unforeseen." Here is the element of surprise, when the artist plays until that which is not seen becomes seen. Improvisation is the act of instantaneously finding fresh

movement. It serves as a tool for exploring movement. One plays with elements such as rhythm, design, space, shape, tempo, directionality, repetition, emotive content, and focus—the seeds that produce the flower of dance.

Improvisation does not excuse poor technique or lack of practice. One cannot have freedom without form, but while improvising, one cannot have form unless one has amply experimented with the creative process. Cynthia Winton-Henry, a dancer and minister, captures the essence of the aliveness of improvisation: "Creation is the playground. Improvisation is the play. Creativity is what happens when they come together. Together God's people discover their power to imagine and to create real worlds never before seen. In this kin-dom, we play 'follow the leader' with the Spirit and 'tag' with the Holy."[27] In the act of improvisation the dancer can invite God into the process of exploring movement and bringing the new from the old.

The reality that God is with us in the creative process is an invitation to experience the presence of God day to day. David knew this experience of "withness" in his act of improvisation when he danced in procession with the ark. The Hebrew verbs used in 2 Samuel 6 tell us that David skipped, danced in the ordinary sense, playfully danced, whirled continually, and rotated with all his might.[28] David was highly criticized by his wife, Michal, for this dance, but he justified himself, saying it was before God that he danced. David had the exhilaration of knowing in his body that God was with him, just as God was with Moses, Joshua, Naomi, and Ruth.

The Life of Faith

Risks and leaps into the unknown are central both to improvisation and to the life of faith. The improvising dancer does not know exactly how the fall from a particular leap will change the piece, or how placing limits on one part of the body will affect the nuance of gesture, or how a certain set design will modify his or her moves. Improvisation with others is an act of even greater vulnerability and presents more possibilities for expression, design, tensions, and movements, ultimately forcing the dancer to think on his or her feet and move with the heart.

The act of improvisation incarnates the life of faith—the unpredictable, rich, and full orb of God's hand in our lives. Our lives can never be predictable, whether it is in the ordinary acts of living, leaping in midair, or landing on the ground. We never quite know how or where we will fall. Winton-Henry, describing the physicality of a leap, captures this reality: "In the leap of the present, we look back and realize that in that leap we fully were, humanity flailing its arms through the air. In amazement it dawns on us that both the arms and the leap are God's."[29] In a fall, in a leap, in gravity becoming levity, movement is transformed into meaning. But meaning

often is found only after pushing beyond the limits of what the dancer thinks he or she can do, or after executing a phrase of dance over a hundred times until it is done with ease and the physics of the movement are worked out. Only after pushing and practicing can the art of dance be abandoned to God, form and freedom playing together in the arena of art.

The life of faith is not much different. In the practice of dance, in the improvisation of dance, God works with us to form art. In a similar fashion, in the practice of life, in the improvisation of life, God forms faith in us. In turn, our faith informs our lives. Our lives are God's artwork, the Spirit becoming the master improvisor. We work together with God and in community with others, risks and all, to create and re-create lives yielded and transformed by the Spirit.

The Language of Dance

In the language of dance is a vast vocabulary of movement. One hundred pages can give barely a glimpse of the elements of dance. One can convey only an idea of an art that must be experienced bodily. Dance is a sensual art, not in a sexual sense but in the true root of the word: We experience dance with our senses—visual, auditory, and kinesthetic.

There are many aspects of a dance: stage presence (or projection), timing, costuming, spatial relationships, the relationship between form and content, composition, development of motifs, and technique, to name a few. All of these are woven into a whole that we experience sensually and aesthetically. What really makes a dance work is a complex matter. However, as one has the opportunity to attend performances and experience more of the language of the body, one receives a growing sense of what works for the audience.

What is most important is that the foundation of the Christian faith—the principles of creation, incarnation, and redemption—brings us to a deep appreciation for the language of the body. We can come anew to this art form and say, as the Hebrews did, yes, dance is a place where the glory of God can come through. It is a place where we can come knowing in our bodies that we were designed by an incredible Choreographer. The dance is a celebration of that miracle.

Suggestions for Exploration

1. *Kinetic reading.* Take a few lines from a psalm and interpret them only in the language of your body: gestures, postures, or creative movement. Notice how this allows you to understand the passage in a fresh way.

126

2. *Bodily prayer.* A variety of postures accompany prayer and worship in the biblical text. Play with these, allowing yourself to magnify the way you normally pray: bowing, kneeling, raising hands, lying prostrate, lifting hands, walking, or all of the above.[30]

3. *Movement language.* Movement is all around us: the wind, the nonverbal language of our friends and family, the crowd's nonverbal applause at a football game or a children's play. Choose a movement and shape it in a variety of ways by making it smaller or bigger, repeating it, or executing it with only one part of your body. Use this exercise as a tool for discovering movement.

4. *Design.* Find a group of about six people (with their permission) whom you can shape in a sculpture that communicates an emotion or concept. The Beatitudes are a good place to start, or the passage on the fruit of the Spirit. The sculptor shapes the people (the clay) in one connecting image that represents the idea. Notice the spaces between the people (negative space) as well as the people themselves (positive space) and how each of these elements communicates.

5. *Kinesthetic sense.* There are not many places where we can move with exhilaration or joy. Find an open space, perhaps a field, beach, or park where you can give yourself permission to skip. Skip freely, childlike, taking big steps or small, but allow your whole body to breathe with each skip, and enjoy the pure delight of swinging your body in space.

6. *Movement as metaphor.* The life of faith does not go in a straight line but turns, falls, sinks, pulls, pushes, releases, clings, pauses, leaps, and dances. These are all movement metaphors for where we may be in our Christian journey. Explore ways to illustrate these metaphors by moving different parts of your body, physically experiencing what it is like to push, release, leap, or sink.

7. *Interacting with dance.* If you have the opportunity, go to a dance performance. If you cannot attend a performance, you may be able to watch one on public television or on videos from your local library. Observe the relationship of the artistic form to the content, and how the dancers use space. Afterward, reflect on the performance and write down what grabs you about the piece. What does not? Why?[31]

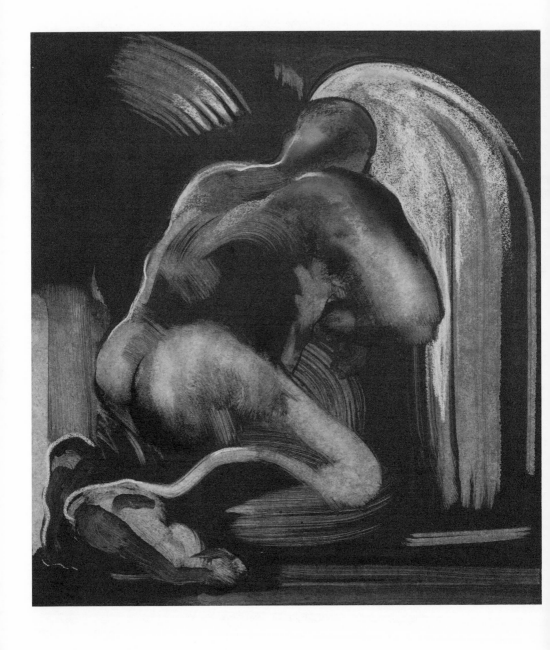

7 The Dramatic Arts and the Image of God

Norman M. Jones

When I arrived at graduate school, Dr. Saul Elkin, chair of the department and renowned theater scholar and artist, invited me into his office. He asked me to sit down and then said quite abruptly, "Where have you been?"

"Excuse me?" I said. I was not at all certain what he meant.

"You Christians. Where have you been? I have never understood what happened to you."

Because I had spent five years as an assistant pastor prior to graduate school, word had quickly spread that "one of those born-again Christians is in the program." Apparently, this was a first. Dr. Elkin and I had a stimulating conversation about Christian involvement in the arts in the twentieth century. We discussed some of the origins of theater within the church. Well documented, of course, is how the church in the Middle Ages led a resurgence of drama. For the first time since ancient Greece, drama had taken on a form in which people were challenged to examine themselves and to look beyond themselves. Dr. Elkin wondered why the church no longer saw itself on the forefront of the dramatic arts. "It seems like such a perfectly natural avenue of expression for the church," he stated. I found myself in full agreement with him and was astounded by the passion this Jewish scholar had for the issue. The conversation has, in many ways, haunted me ever since.

I entered graduate school expecting I would have to defend my faith constantly and endure ridicule for actually thinking I could be a legitimate theater artist and a Christian at the same time. I found the opposite to be the case. Theater artists and scholars were extremely interested in my perspective on plays. They valued my thoughts on scripts under consideration by the department for production. I was consistently asked to discuss my perspective on a play with an undergraduate theater class. Professors in the department would actually seek me out to hear what I thought of a play like *Equus* by Peter Shaffer, a powerful play dealing with the rel-

evance of worship to our daily experience, or to hear my perspective on Arthur Miller's plays, which have at their core significant questions about human values. I was once asked what a thoughtful born-again Christian would think about *night, Mother*, a Pulitzer Prize–winning play dealing with despair and suicide.

I was simply amazed. Why would these dedicated and sophisticated artists value my opinion? As a first-year graduate student I certainly did not feel qualified to have an opinion worth valuing. Was it simply because of the novelty of my presence? Were they humoring me? Slowly, I came to see these inquiries as a reflection of something much deeper. I came to believe that there is, in fact, an inherent spirituality in the art form of theater that these people recognized, whether consciously or unconsciously, and that my presence as an admitted "spiritual person" became a release for them to explore ways in which theater is not an end in itself but is an expression of something beyond themselves.

Theater and Spirituality

Theater in Ancient Greece

In ancient Greece a sacred gathering for worship, called the City Dionysia, convened each spring. For an entire week, work was suspended so all citizens could gather as a community. The catalyst for this worship was the performance of plays. Each day, four new plays were performed, each one based on the stories, familiar to the audience, of human interaction with the gods. Great playwrights such as Sophocles and Euripides, the prophets and preachers of their day, wrote scores of plays intended to lead the audience to participate in an act of worship.

Aristotle, in his treatise *Poetics*, describes how the audience was expected to participate. In the performance of a tragic play, members of the audience identify with the condition of the hero. They recognize the hero's tragic flaw, as he interacts with the gods and with humans, and come to an understanding of it in their minds and souls. By seeing what happens to the hero, who chooses not to repent of the flaw, the audience members are then moved to a deep spiritual awakening and may be purged or cleansed of that same flaw in themselves. They can then escape the fate that befell the tragic hero. This cleansing process is called catharsis.

One might look at Aristotle's catharsis as a fascinating metaphor for salvation. Aristotle was an honest seeker after the truth, after the light that is given to all humanity. And in his description of catharsis, we have a portrait of a society seeking after salvation. During a tragic play, we in the audi-

130

ence recognize that we share the sin of another (the tragic flaw of the hero), have the opportunity to repent of that sin, and the vicarious experience of the cleansing or purging of the sin in our own lives (salvation).

This metaphor is significant, not because it might demonstrate that for ancient Greek society catharsis was simply a counterfeit salvation, but because it indicates that for Greek writers, scholars, and thinkers an inherent spirituality exists in the dramatic impulse.

The Transcendence of Theater

As in the days of ancient Greece, today the performance of a play is still in a sense a sacred act, though not presented as a worship experience. Very few theater artists would identify their work as an attempt to give expression to the image of God in themselves, but many non-Christian theater artists have identified the potential spiritual nature of the art form. For example, in his classic book *The Empty Space,* British theater director Peter Brook states, "I am calling it the Holy Theatre for short, but it could be called The Theatre of the Invisible Made Visible." Further in the essay, he writes, "The theatre is a vehicle, a means for self-study, self-exploration; a possibility of salvation."[1] Pulitzer Prize–winning playwright David Mamet writes, "The purpose of the play is to bring to the stage the life of the soul."[2] And three-time Pulitzer Prize–winner Robert Sherwood said, "The theatre is the spiritual home of one who is barred from the church by distaste for dogma but who still requires and demands expression of great faith."[3]

Ecclesiastes 3:11 states, "He has also set eternity in [people's hearts]; yet they cannot fathom what God has done from beginning to end" (NIV). Eternity in our hearts. This phrase expresses a fundamental truth about the origin of the dramatic impulse, the reason behind humanity's attempt to make sense of life through dramatic performance. Actors pretend to be someone else, telling a story in front of a participating body called an audience. Through the dramatic impulse, humanity attempts to fathom "what God has done from beginning to end." All participants in the performance, audience members and actors, attempt to comprehend the image of God placed within them by the Creator. Drama is a way to strive for a marriage of the natural and the supernatural.

Staging a play is like opening Pandora's box. The dramatic impulse emerges from a tension between our mortality and immortality, a tension which artists since the beginning of time have endeavored to express. Shakespeare's Hamlet both marvels at and struggles with the image of God placed within him: "What a piece of work is a man! How noble in reason! How infinite in faculty! In form and moving how express and admirable! In action how like an angel! In apprehension how like a god! The beauty

of the world! The paragon of animals! And yet, to me, what is this quintessence of dust? Man delights not me: no, nor woman neither."[4] Humans have both mortality and immortality, as Ecclesiastes teaches, but we cannot comprehend their relationship. We are made a little lower than the angels (Ps. 8:5), yet as the apostle Paul recognizes, we no longer have the power to do the good we want to do (Rom. 7:15). This is conflict, and conflict is the essence of drama. Few plays have ever been written about a day when everything went right!

This is where God enters—in the gap between our mortality and immortality. In the observable spaces that fill a play, the God in whom we live and move and have our being (Acts 17:28) comments on our lives with one another and with the divine. Like God, a play transcends yet participates in human interaction. A play enables us to step out of our limited perspectives and look down, up, and across at our lives—similar to the omniscient way God sees them. Interactive plays especially make us participate, as well as observe, just as God participates with us. And through our pretending in theater, we draw closer to understanding our relationship with God.

Theater and the Incarnation

Theater Is Good

Some Christians have serious moral and theological objections to drama, many of which arise from a bias against a scriptural understanding of creation. Genesis 1:31 states, "God saw all that he had made, and it was very good" (NIV). The world that God made did not cease to reflect his glory after the fall of humans any more than humans ceased to be made in the image of God. The psalms continually remind us that "the heavens are telling the glory of God; and the firmament proclaims his handiwork" (19:1 RSV). The creation speaks to us of God, and if Paul says that "it has been groaning in travail," he also states that "ever since the creation of the world, his invisible nature, namely, his eternal power and deity, has been clearly perceived in the things that have been made" (Rom. 8:22; 1:20 RSV).

In the incarnation God took human form upon himself, thereby reaffirming that the physical world is good and upholding its ultimate significance. We must remember that though the physical world was implicated in the fall, which caused the suffering that afflicts all of creation, the physical dimension of our existence is also involved in our salvation. Murray Watts writes:

132

Man is not a soul, trapped in an earthbound body like a violin shut up in a wooden case; he is a whole being, the violin, the violin case, the music; they are all one, ready to be redeemed as one. The relationship of our physical world, and ourselves, to the new creation may well be like the seed that dies in the ground, springing forth abundantly more glorious, but the clues to the new creation are found in the old. God has not left the world which he made, nor changed his mind that it is very good. He has not left us marooned on our planet, struggling to climb up some spiritual staircase to meet him in a remote heaven.[5]

God has revealed himself through the things he has made, and he has walked with us on this earth in a physical body. Above all, he has made the human heart his dwelling place. He has not only redeemed creation, he is restoring it to its former glory.

Therefore, all art forms, whether music, dance, painting, theater, or any other of the multitude of gifts he has given, are not doomed by being a part of this physical earth. They are good because they are part of God's creation and because they spring directly from the Creator's own image in humans. Granted, all art forms, because of the fallenness of humanity, are subject to abuse. And certainly abuses abound. Nevertheless, we cannot reject what God has made. Our call is not to withdraw from or to deny the physical world but to redeem it. Our call involves redeeming the arts for the Christian and baptizing the imagination for both artist and audience.

Theater Is Incarnational

Several years ago, I helped edit a video for Gordon College. A statement made on the tape by Marvin Wilson has stayed with me ever since. He explained that the words *work* and *worship* come from the same root word in Hebrew. So something sacred is present in our every act and in every moment of the day. Through that principle I have been able to approach the creation of a stage production as an incarnational act and as an act of worship.

When we prepare a play for performance, we work through a variety of acting techniques in an attempt to discover as much as possible about our characters—physical mannerisms, emotional conflicts, relationships to other people. We improvise scenes that might help us understand the array of experiences the characters have had outside the context of this play. Slowly, the characters begin to reveal themselves to us, asking us to bring them to life, to give them flesh. Thus theater is word made flesh, an incarnational act. And in that act, we are faithful to the characters and to the work of art as a whole. We are obedient to the work, to the incarnation. We attempt to discover the truth of the story by allowing the characters to tell it themselves.

When viewed in this way, theater becomes a profound worship experience for both audience and performer. It becomes a means of revealing the miraculous in the mundane. One of my favorite characteristics of theater is its ability to give a voice to the "common person." It is sometimes difficult to see the miraculous in the multitude of faces we see every day, to be able to see these people as eternal beings. Theater can help us recapture that ability.

We watch Willy Loman in Arthur Miller's *Death of a Salesman* as he struggles with the conflicts of his life. Silly Willy Low Man. The most common of common men. The kind of man no one pays attention to in "real life." But in the incarnation of the stage, the common man is given a voice. Willy says to his wife: "Oh, I'll knock 'em dead next week. I'll go to Hartford. I'm very well liked in Hartford. You know, the trouble is, Linda, people don't seem to talk to me. I know it when I walk in. They seem to laugh at me. I don't know the reason for it, but they just pass me by. I'm not noticed." But his wife knows there is no such thing as a common man. She says to her sons later in the play: "I don't say he's a great man. Willy Loman never made a lot of money. His name was never in the paper. He's not the finest character that ever lived. But he's a human being, and a terrible thing is happening to him. So attention must be paid. He's not to be allowed to fall into his grave like an old dog. Attention, attention must be finally paid to such a person."[6] We sit in the audience and we know she is right. She has revealed the miraculous in the mundane: a man made in the image of God.

Theater and the Church

Christians in Theater

It is critical that Christians be involved in the dramatic arts. Not since the Middle Ages have cultures afforded Christians such tremendous opportunities to have an impact on their society through theater as we have today.

Theater in the late twentieth century is asking serious questions about its function in society and its power to change lives. An article titled "Waning of Spirituality Perplexes Artists Today" in *American Theatre* asks the question, Has theater lost its soul? The article states: "In the beginning theatre and religion were one. For the Greeks, theatre was a form of worship through which audiences glimpsed the divine. But in our time, leading theatre artists are experiencing a crisis of faith. The spiritual dimension of theatre—its ability to heal the soul—seems less real today than armies of angels

dancing on a pinhead."[7] In a recent conversation about the controversy over the National Endowment for the Arts, playwright John Guare, well known for his plays of skepticism, stated: "Why has our society lost its trust in art? In all that furor, I wonder why people who think art must be kept out of the hands of our children because of its ability to undermine morals do not see the opposite viewpoint just as clearly. If art has such power, it can also renew life. But today we don't know what to do with art. The imagination is not an escape, it's the answer. Why do people see the power of art to destroy and not its power to heal?"[8]

The need for fresh voices to lead a resurgence of spirituality in the dramatic arts has been expressed by other respected theater artists. "I continue to search for a poetic language in the theatre that will restore the primacy of metaphor in a world choking on materialism," noted director Peter Sellars. "I need a moratorium on my theatrical activity to rethink the reasons for doing it. We must restore theatre to its roots as a communal function. It must become a public forum where communities can discuss their problems and aspirations. This will not happen until Americans stop thinking about theatre as entertainment. Theatre is a Nautilus machine for the soul."[9]

Director Andrei Serban, whose productions of *The King Stag* and *The Serpent Woman* are spiritual allegories of the need to transcend self, believes that "theatre must look for spiritual truth—but now formulas of sociology are offered up as panaceas. Today's theatre is trapped in a sewer. Characters sit around in the muck without looking up. Art must inspire faith. But in our time, trying to provide spiritual weapons is difficult. Audiences resist."[10]

Director Richard Foreman, revealing the inherent danger of art for art's sake, states: "The art that interests me most in the twentieth century, from abstract painting to experimental theatre, is a form of spirituality. But I have become increasingly ambivalent about art. I wonder if it isn't a trap— a way of talking about the changes that have to be made in the self, in the audience and in the world without really making them. I am profoundly disturbed by the implications of this strange activity of making pretend worlds we call theatre."[11]

The skepticism of these artists arises from a theater that has, in many ways, become an end in itself, thus leading to despair. Art for art's sake is a dead end in which audiences look at theater purely as entertainment and artists address ultimate questions they cannot answer. Christians in the dramatic arts can provide a window for spiritual understanding. The questions asked by a theater that is transcendent, that deals with holistic issues of the human experience, are of a more spiritual nature and thus are familiar territory for Christians. And plays written, produced, and performed by Christians have a spiritual context not available to most theater artists. Christians in theater have the ability to point plays beyond the incarnation

135

on the stage to the incarnation of Christ. As Christian artists, we must inspire all participants in the theater experience to look beyond the questions asked by the playwright to the answers that can be found in God.

Having said that, however, I must point out a danger Christians tend to fall into. Christians often expect the arts to do something they are not capable of doing. Many Christians, seeing the impact of the arts on audiences, attempt to use the arts as "a tool for the Lord." Unfortunately, this reveals an incomplete understanding of the arts. The arts are good at asking questions, but when used to provide straightforward answers, they are forced into the wrong mold. The arts tend to be good at planting seeds, but not at harvesting crops.

On the other hand, Christians in the dramatic arts must ask themselves, When does the language of a play or the evil situation portrayed in a play "go too far," making the play inappropriate for a Christian to perform? When are audiences pushed to a point that they no longer experience the truth of the human characters portrayed on the stage, either rejecting them (distancing) or being corrupted by them (imitating)?

The answers to these questions are not always easy. Good plays often ask searing questions of the audience, questions that are sometimes disturbing. The biblical gift of prophecy, I believe, is closely linked to the dramatic arts. The Christian artist ought always to be attempting to find the delicate line between "what is okay and what is not okay" to perform, to see, to speak. As a Christian in the dramatic arts, my desire is to express the life of a "controversial" play so that my performance is not an endorsement of the philosophy of the play—for instance, a play that implies life is without hope. With a twinkle in my eye, I perform as though to tell the audience, "I ask you this question because I want you to find the answer."

A Holy Theater

In the fall of 1990 the Gordon theater department presented a relatively informal reading of *Stories from the National Enquirer* by Jeanne Murray Walker, winner of the Washington Theatre Festival. I collected a group of students, and with the playwright in the audience, we read the play. Afterward, Dr. Walker commented on the joy she experienced in hearing the play read so well. She stated that the professional production at the festival two months before had been extremely polished, but it had lacked the inherent spirituality of the play, a spirituality the Gordon students brought to the reading. Because the students were spiritually responsive and sensitive, a crucial component of the play had been brought to life for the first time.

Christians in the dramatic arts need to be aware of the spiritual aspects of a play as well as its physical and emotional aspects while they are involved

in the incarnational act of creating human characters. It would not be too strong to say that the performance of a play by a Christian is a profession of faith. When an actor fully incarnates a character in body, mind, soul, and spirit, he or she is professing faith in the image of God placed in all of humanity and is celebrating our common humanity. Peter Brook, describing his theater of the Invisible Made Visible, points out that "religious teaching . . . asserts that this visible-invisible cannot be seen automatically—it can only be seen given certain conditions. The conditions can relate to certain states or to a certain understanding. In any event, to comprehend the visibility of the invisible is a life's work. Holy art is an aid to this, and so we arrive at a definition of a holy theatre. A holy theatre not only presents the invisible but also offers conditions that make its perception possible."[12] Performers must play a conscious role in providing the conditions for a holy theater. It cannot happen accidentally. The director and actors must grapple with those conditions that make perception of the invisible possible. An actor's training is based on the premise that the body is the actor's instrument. For Christian actors, the focus is on the soul as well. In this regard Brook points out the similarities between the actor and the priest: "The act of performance is an act of sacrifice, of sacrificing what most men prefer to hide—this sacrifice is his gift to the spectator. Here there is a similar relation between actor and audience to the one between priest and worshipper. . . . The actor invokes, lays bare what lies in every man—and what daily life covers up. This theatre is holy because its purpose is holy."[13]

Theater and Christian Colleges

As Christian artists we have allowed ourselves to be marginal players in our culture instead of central players. Perhaps we are unable to recognize theater as more than entertainment. Perhaps we have failed to understand the inherent spirituality of the dramatic form. Only if our theater is dealing with matters of spirit and transcendence will it have the ability to transform. Harold Etrensperger writes: "When the artist succeeds in segregating a small part of his life struggle into the compass of a climax situation, we have a play or drama. If this drama comes alive before a participating group as audience and gives that group motivation for action that sends it out to live effectively in spite of its human weakness, if it truly 'catches the conscience,' then the play is of religious consequence."[14]

Christian liberal arts colleges can be the perfect catalysts for a renaissance of artistic involvement of Christians in the dramatic arts. We must fill the spiritual vacuum in contemporary theater. We must provide apprenticeships within the liberal arts context for Christian students of theater. We must provide crucial scholarship, accountability, and encouragement

for the growing number of Christian artists professionally committed to the dramatic arts.

Already we have taken positive first steps. We are experiencing a resurgence of activity in theater in the church and of professional theaters run by Christians. The Lamb's Players in San Diego, A.D. Players in Houston, Taproot Theatre in Seattle, and The Lamb's Theatre in New York City are attempting to, in the words of Lamb's Players artistic director Robert Smyth, "not entertain the saints, but speak to a wider audience—to challenge the perspective and the values of modern culture."[15] Several years ago an organization called Christians in Theatre Arts was created to "give Christians a continent-wide support network of other believers who are also theatre artists."[16] In August 1991 I met with twenty other professors of theater from Christian colleges. This two-day meeting was the first of its kind. And I am currently a member of a task force to determine the feasibility of a national organization for professors of theater at Christian colleges.

These are exciting developments. But our task is only beginning if we truly expect to baptize the imagination of our culture. Alongside a theater of absurdity or despair we must provide a theater of joy discovered in the heart of pain and a theater of hope renewed after the loss of faith. Such a theater of healing, truthfully expressing the human experience within the context of grace, can give us a fresh glimpse within our fallen state of the Creator God's daily re-creating of us and our world. And it will renew for us a creative, "incarnational," spiritual expression with which we may portray and celebrate catharsis, redemption, and hope, making sense of our human experience as God reconciles the world.

Suggestions for Exploration

Doing theater means reinventing any play in which you perform—looking at it with new eyes. Particularly within our Western cultural context, we think of audiences as spectators. The puzzle before us is, How do we create the conditions in which an audience is enabled to participate in a play?

When I was staging Mark Stevick's scripting of my idea for an interactive play, *Cry Innocent: The People versus Bridget Bishop,* the problem before us was how to create conditions in which the audience could choose to be involved without being coerced. The giving of a choice is a fundamental characteristic of the nature of God. God does not coerce us into making the greatest choice given to humanity: choosing God's Son. Therefore, we who follow God should not coerce others. And in theater, we should not create conditions that coerce the audience.

138

In performances of *Cry Innocent,* the audience sits in the center of a hall, facing a courtroom scene. Characters enter and exit from all over the hall. The audience finds itself playing the role of a Puritan jury, as characters continually address the audience on issues being debated as if the members of the audience are Puritans themselves. From time to time a character cajoles, reprimands, or appeals to an audience member, as might happen in a courtroom. At the end the audience is called upon to render a verdict.

The goal of this technique is to get audience members to rethink their perspectives on the Puritans, a misunderstood people. Through their examination of the lives and dilemmas acted out in their presence, audience members are called on to respond as Puritans and not simply to give a late twentieth-century critique.

The technique works. After each performance an audible sense of community has been created. People leaving the theater remonstrate loudly with characters and debate the issues among themselves.

My hope is that the play produces a sense of healing in audience members' attitudes toward the Puritans, but I hope even more that the Puritans serve as a metaphor for all those people who are different from the members of the audience, making those people less "other" in the audience members' experience.

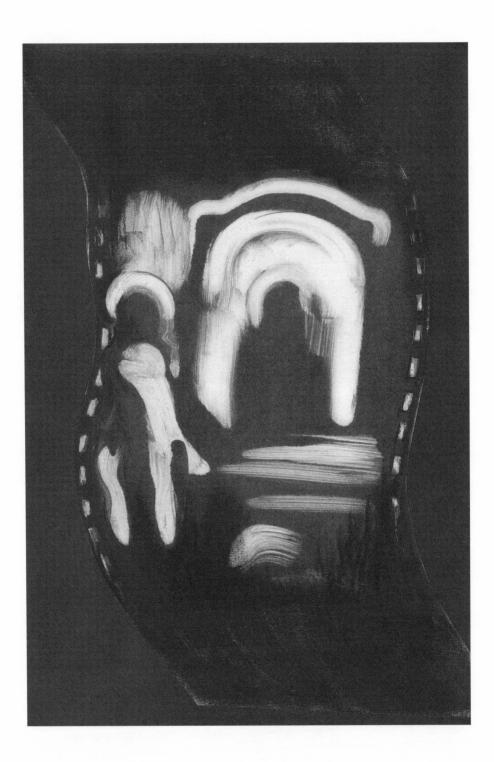

8 Eyes to See, Ears to Hear, and Minds to Understand
Movies and Other Media

Jasmin Sung with Richard Peace

Going to the movies is like taking a trip. Our tickets gain us a new universe for a couple of hours during which we experience things we would never experience in real life—things we hope will never happen to us, things we wish we could do.

When we watch a movie, we subject ourselves to virtual reality. Alan MacDonald, author of the book *Movies in Close-Up: Getting the Most from Film and Video,* suggests that movies can even surpass reality: "Film reaches us through a unique combination of story, sound and visual energy to provide a total experience that is brighter, louder and larger than life itself."[1] Seated in our padded seats, eating popcorn and sipping soda, we willingly suspend our disbelief and enter a new world. We turn off our brains, believing we cannot enjoy ourselves and think at the same time. After the credits roll, we exit the theater and leave everything behind. But have we really left *everything?*

The proverb "Seeing is believing" is based on the assumption that when we see something, we tend to believe it really happened. We go to the movies for entertainment, confident in our ability to distinguish between reality and fiction, but can

141

we really be sure we are unaffected by what we have seen? Images on the screen are bigger than life and often stay with us long after a film is over. According to the International Reading Association, the mind retains 10 percent of what is read, 20 percent of what is read and heard, 30 percent of what is seen, and 50 percent of what is seen and heard.[2] Even the emotions we feel while watching a film stay with us longer than we care to admit.

So when it comes to watching movies, seeing *should not* be believing. We must ask questions about what we see, what we hear, what we think, what we feel. Critical thinking skills are necessary when watching films, because film does not present reality. It can never do so. In fact, film is not so much about lying or telling the truth as it is about what we, the audience, and they, the filmmakers, perceive and present as truth. Essentially, what film presents is the director's view of reality. Every step in making a film involves the creation of illusion or image. The script limits the film to a slice of life. The choice of actors affects the rendering of the characters into people who evoke in audiences the responses the director wants. During the editing of the film, the editor's vision is imposed, creating a different statement. The music helps create the desired response in the audience. Through the shaping of all these influences, the resulting film often has little to do with the original situation. But in the minds of viewers (even sophisticated viewers), the film shows reality, and viewers lock onto that perception of reality.[3] "Film never can tell the complete truth; neither does it claim to tell the complete truth.

The Need for Media Literacy

A film by D. W. Griffith illustrates the danger of uncritically viewing a movie. His 1914 film *The Birth of a Nation*, based on a novel about the American Civil War by Thomas Dixon Jr., was the first in movie history to tell a cohesive story. Every film student in the United States probably has watched and discussed it to some extent. To this day it is considered an artistic masterpiece. Though many in its day watched the film as a form of entertainment, it nevertheless had an impact on race relations. Dixon and Griffith's point of view favored the Ku Klux Klan, and Griffith, using the photographic realism of newsreel, portrayed African-Americans as uncivilized and lazy good-for-nothings. Because Griffith was able to give Dixon's novel a sense of realism unattainable by the book, the film made a deep impression on the audience. What false assumptions about a particular race stayed in the minds of viewers? The effects of such a movie that deliberately confuses fact and fiction can be

142

devastating. This is just one of many examples of how we can easily base our knowledge purely on hearsay, fiction, and fantasy, on stereotypes and prejudices.

Because of the nature of film and other visual media, and because we are exposed daily to so many images and sound bites, we must learn to process discriminately what we see. We must become "media literate" in a world that has once again become image oriented. When we were growing up, we did not become literate merely by learning to decipher a string of letters or words. We had to learn how to read between the lines and to interpret a text carefully. In the same way, we need to develop critical-thinking skills to become media literate.

Becoming media literate involves learning to go beyond our first impressions or reactions. It involves asking questions and talking to others about what we see. We must learn to take a movie apart and examine its elements—identifying, appreciating, and responding to its components. By doing so, we can enjoy movies and glean from them the truths they can convey, while guarding against their not so obvious reductionistic tendencies.

And as we become media literate, movies begin to tell us more about our culture and who we are. Far from scorning popular culture, Christians ought to learn about it and consider why it is so influential. As a redeemed people, we have no choice but to take popular culture seriously. Not only is such an endeavor possible, but it can also be exciting. With a prayerful heart and an open mind, we can explore new ways of seeing and hearing that allow the redemptive story in our culture to unfold before our eyes and ears.

Learning from Movies

Throughout the Bible God tells the stories of his interaction with his people. In the Old Testament, even though most people did not have a physical encounter with God, they knew God through the stories of his activities among his people. The New Testament tells the story of God becoming a human being, living among his people and restoring them to himself. In essence, the stories in the Bible deal with issues of humanity and eternity.

So do our stories and movies deal with similar issues. Although movies are neither authoritative nor comprehensive, they do explore the human condition and, consequently, our alienation from God. Movies become richer in meaning when we examine them carefully and ask ourselves how God fits into the picture. As long as movies tell stories about people, they also tell about God. Part of being redeemed means taking the responsibility of fig-

uring out how God, the redeemer, is at work. Asking ourselves what might be redeeming in a movie is a good starting point for discovering truth in that movie, truth which otherwise might remain hidden.

In the Bible we see God's message traveling to reach large numbers of people through visions, dreams, prophecies, stone tablets, and letters; on boats; by messengers; at big gatherings; in synagogues, arenas, and amphitheaters; and through God incarnate, Jesus Christ. The messages Jesus brings to us are of faith, hope, love, forgiveness, grace, mercy, compassion, redemption, salvation, reconciliation, and sanctification. These messages are for everyone near and far. We are called to be "witnesses in Jerusalem, in all Judea and Samaria, and to the ends of the earth" (Acts 1:8 NRSV). Just as God used common means of communication during Bible times, he can use modern forms of communication to speak to us. The fruit ought to be the same: changed lives. So we should not be surprised that God can and does use cinema as a vehicle for the divine message.

With the limitations of film properly understood, we can see in movies powerful moments that lead to religious insight or portray religious truth or move us to a religious response. Films that show love, joy, peace, hope, and forgiveness in actual human situations can be the best films from a religious point of view. Preaching "Love one another" is one thing; showing love in action fleshes out those words before our eyes, motivating us to live out our calling.

Movies and Religion

Religious Themes and Characters

In the past, the portrayal of religious themes and characters in cinema usually has taken the form of serious biblical epics or sober depictions of the ministries of missionaries, priests, and nuns—people who don clerical robes and look religious. Though the lives of missionaries can be visually interesting because missionaries inhabit strange lands, monasteries generally are less appealing because of the code of silence and rigid disciplines of the nuns and monks. Like *Brother Orchid* did for a previous generation, *Sister Act* broke this stereotype with laughter and music. Whoopi Goldberg, playing a nightclub singer, introduces life and rhythm to a group of white nuns who do not know how to sing. By rearranging the choir, merging popular music with meaningful, religious lyrics, and entering the neighborhood from which the nuns had been estranged, she transforms the visually boring, cloistered life of nuns into a relevant,

exciting, and others-centered existence. But how many people would have attended the movie if it were marketed as a documentary about urban nuns struggling in a decaying neighborhood, sans Whoopi, gangsters, a chase through a casino, and renderings of golden oldies such as "I Will Follow Him"?

Contemporary religious figures have always found their way into film. Portrayals of clergy in World War II films are mostly positive. In the minds of a generation of viewers, Spencer Tracy will forever be the fighting Catholic priest. More recent portrayals of clergy are less positive, however, ranging from largely ineffective individuals, to other-worldly folk who are nice but naive, to charlatans such as Burt Lancaster's Elmer Gantry or Steve Martin's itinerant healer in *Leap of Faith*. Dead saints have fared better. The treatment of Francis and Clare in *Brother Sun/Sister Moon* authentically inspired many viewers.

Increasingly, religious experiences are finding their way into film. The tunnel of light and comforting figures awaiting the dying—images derived more from New Age sensibilities than from Christianity—are common fare now. But attempts at portraying religious experience accurately highlight an important weakness of film: its inability to show inner experience directly. As a result, scripts fall back on clichés: demonstrating what a bad guy a character is, showing his tears during a conversion experience, proving what a good guy he has become by the wonderful act of kindness he does for a former enemy.

In sum, religious themes and religious characters have taken quite a buffeting over the years as filmmakers have attempted to translate their largely invisible spiritual dimensions to the screen. Some moviegoers prefer their Christians tainted, irrelevant, or cuddly and approachable like Tom Bosley's successful transformation of Father Dowling. Distortion, misrepresentation, and reduction often have confronted Christians seeking to glimpse God at the movies.

But the church, which is in the reeducation and conviction business, should plow on with its sowing of true seeds. Just as filmmakers have destroyed caricatures of black people by making powerful movies such as James Clavell's *To Sir with Love* with Sidney Poitier and Spike Lee's *Malcolm X* with Denzel Washington, so should Christians struggle to represent on film more potently God and all Christian people.

Fictionalizing Jesus

When most people think of religious themes in film, they think of one director: Cecil B. DeMille. DeMille approached the Bible as if it were a novel

to be translated into cinema. His aim was to reduce to images a work of literature that many people had read and to interest them in buying tickets to see it. The goal was not to convey religious truth. It was to entertain. The result was an extravaganza—a tendency of films in that era. What the viewer saw was what Hollywood thought Bible lands and people *should* look like, not how they actually looked. The film images owed more to Busby Berkeley than to the Bible.

The problem with translating literary characters into film images is that by so doing you forever freeze those images in the minds of viewers. The characters will forever look like the actors in the films, thereby reducing much of the richness of our imaginations to the single film image. We also lose personal connections to the characters. When we read about a character, that character connects in significant ways to our world. But when that character is portrayed in film, our idea of what the character is like is limited specifically to someone else's idea. In the minds of a lot of folks, John the Baptist looks and acts just like Charlton Heston!

One further problem in trying to render the Gospels in cinema is that the Gospels are a genre of literature in which the intention is not to describe a historical situation fully but to present an abbreviated rendering of that situation to make a point with great power. The gospel pericopes describe real situations but do not portray in vivid detail what happened. When these pericopes are rendered in film, the result is often that they seem either "unreal" (as in the strict rendering of the Jesus film) or "imaginative" (as in a rendering by DeMille or Pasolini). Thus, some Christians believe that, though Jesus' message is filmable, his life is not.

Glimpses of God

We may catch glimpses of God not only in movies that directly explore religious themes or characters but also in movies that use images, ideas, and individuals in metaphoric ways. For example, many Christ figures are presented in film. Some of these are easily recognizable, as in the powerful and attractive portrayal of Eric Liddell in *Chariots of Fire*. Others are more oblique, as in *My Year of Living Dangerously*, in which Linda Hunt plays a man who gives himself for the sake of others.

We can glimpse God even in science fiction movies such as the *Star Wars* series, which, though it portrays God as the Force—clearly a sub-Christian rendering—misrepresenting the supernatural, at least argues for the existence of the supernatural. Indeed, the genre of science fiction uses the most advanced technology to speak about "God, humanity, war, sex, ethics, and the like. . . . It explores religious and philosophical issues in an intelligent

manner."[4] Thus, good science fiction, though often about intergalactic warfare, is not merely about such a conflict. The scriptwriter of *Star Trek,* Gene Roddenberry, for example, constantly wove an understanding of the Creator into his popular TV series. Even though Roddenberry insisted that he was a humanist and rejected Christianity, *Star Trek* nevertheless reveals truth about God. Some Christian Trekkies would even contend that it explores more spiritual themes than any other TV series and treats universal values in an edifying manner. And even where our view of God differs from that of Roddenberry, we can engage in stimulating dialogue about the points of contrast and comparison.

Hope in Hollywood

Although Hollywood hardly seems a place that would nurture Christian community, today more Christians in Hollywood are speaking up about their faith. And Hollywood, in turn, has begun recognizing and respecting the gifts of Christians. For example, Lee and Janet Scott Batchler, a successful husband-and-wife screenwriting team, have upheld high standards in their profession and attribute "their success . . . to hard work and their faith in God."[5] They live by the principle: Work at perfecting your craft, and your gift will make a place for you (see Prov. 22:29).

Ron Austin, a writer and producer in Hollywood, gives us hope for the movie industry and challenges our assumption that Hollywood is a wasteland: "I am not calling for Christian films. I don't think there is such a thing. I am calling for, hoping for, films that have Christian content—truth, hope, redemption. These often are films that make us uncomfortable, that aren't always nice as they attempt to create reality and reflect humanity."[6] In the same vein, the French artist and filmmaker Jean Cocteau contends that "Christ wants art with all its teeth."[7] Christians have every right to ask for movies that ask the right questions, the tough questions, the real questions of life. We have the responsibility both to deal with the underside of life and face problems honestly, not settling for less. We also have the responsibility to present Christ's hope and to portray the ultimate human failure or triumph resulting from different people's responses to that hope.

As Christians committed to spreading the Good News, we have a huge playing field, measuring the height and depth and width of the cross. Therefore, we can approach the world of films and other media with the confidence of those who have been given the keys of the kingdom. As Jo Kadlecek wisely counsels, "Let us restrain ourselves from imposing our faith and allow others to choose truth and in so doing find Christ."[8]

Suggestions for Exploration

1. One need not go to film school or consider a career change to explore using film or other media. Consider getting involved in public access cable television. In order to obtain permission to send programs to your television set via cable, cable operators are obligated by law to support broadcasts "in the public interest." Depending on the agreement, cable operators have to set up and pay for a cable access center. "Cable access," Sue Buske explains, "is one or more channels on a cable system dedicated to community-based programming. Access centers provide free or low-cost training and use of video production equipment and facilities."[9] Taking advantage of this free air time, you can actually put a show on the air at no cost outside of production. Churches, youth groups, special interest groups, and individuals—anybody—can get involved. All it takes is time and commitment to the community. Produce your own art show with artists in your community. How about an educational newscast? Have your own movie review. Bring the youth in your neighborhood together and produce a talk show. Produce a five-minute reflection of the day. Share how God has touched people.

2. If you want to experiment with a project without feeling the pressure of an audience, consider buying, renting, or borrowing a video camera. Many major cities have special groups, organizations, centers, networks, societies, or foundations that support amateur and professional filmmakers. Consider applying for grants or participating in a competition. The video camera user's magazine *Videomaker* publishes in every issue a list of user groups—groups of people interested in video who meet on a regular basis. Some groups even work together on projects. Some adult education centers offer special classes in production as well. Once you have met people in the field, you have begun networking.

3. Media literacy is not only about "finding the right answer, but about asking the right questions,"[10] questions that help us learn more about God and find God's message even in movies.

To learn about resources for developing media literacy, check out the following websites and related links:

http://movieguide.christcom.net
http://www.medialit.org/
http://www.ucc.org/ucnews/medlit/medlit.htm
http://www.nmmlp.org/

Or you can write or call the Center for Media Literacy:

Center for Media Literacy
4727 Wilshire Blvd.
Suite 403
Los Angeles, CA 90010
800-226-9494
email: cml@medialit.org

You can also call your local university or college to see if it offers conferences, seminars, or institutes on media literacy.

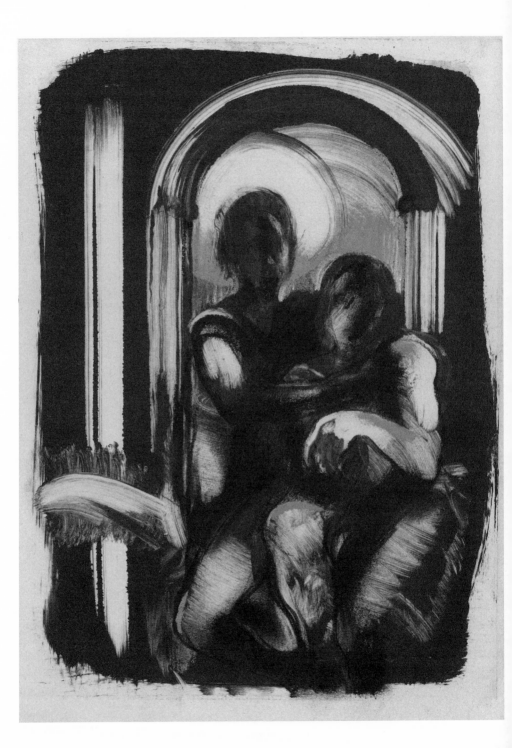

9 Ministry through the Arts

William David Spencer

"The heavens are telling the glory of God," sang David, strumming his harp for the piece we now identify as Psalm 19, "and the firmament proclaims his handiwork. Day to day pours forth speech, and night to night declares knowledge." But, he explains, "there is no speech, nor are there words; their voice is not heard; yet their voice goes out through all the earth, and their words to the end of the world" (NRSV). What a riddle! Here in this song of nature is constant communication about the creation. But how can a voice communicate if it is not heard? How are words known if they are not spoken? Paul the apostle will later counsel the church that people cannot respond to the gospel if they are sent no preacher, yet that same Paul will explain in Romans 1:18–20 that God is upset with the wicked because God's invisible "eternal power and divine nature" are clearly shown through the things that God has made. The silent proclamation of God's handiwork goes out over all the earth. The wind whispers in our ears of the brooding of the Spirit, the sky sweeps above us in daily displays of macrocosmic majesty, our inmost secret parts work with an order that confounds the intellect and humbles the learned. All God's handiwork declares the glory of God.

G. K. Chesterton once pointed out a similar truth with regard to humans and their products when he observed, "Every brick has as human a hieroglyph as if it were a grave brick of Babylon; every slate on the roof is as educational a document as if it were a slate covered with addition and subtraction sums."[1] Each artistic product a person makes is stamped with some imprint of that artist's personality. If the artist is God, then the handiwork proclaims majesty. But what does it proclaim if we are the artist? If we are true servants of Christ, it tells of our loyalty and our Christian worldview.

151

The Church and the Arts

Christian activity in the arts, then, should be regarded by Christians as a good thing. But historically there has been tension between the arts and Christian ministry. According to the commonly held view of the church, the arts have nearly uniformly needed redemption before they could be considered fit vehicles for ministry, and this suspicion has impeded the acceptance of the arts as qualified to minister through the centuries. This suspicion developed for very good reasons.

The Suspicion of the Church

When after severe persecution the church was finally granted an edict of tolerance by the Roman Empire in A.D. 311, it raised its battered head and looked around in horror at how the arts were being employed. In Rome's theaters in the name of entertainment, Christians had been brutally put to death. No wonder Christian leaders from John Chrysostom, the powerful preacher, on through the learned Augustine inveighed against the theater and its horrors. For sheer amusement, at the direction of political expediency, men had been slaughtered and women forced to prostitute themselves. When the Christian faith gained ascendancy, the theater was understandably shunned and went into decline. Like one expiring movie house in our changing neighborhood in Trenton, ancient theater sought to revitalize its sagging attendance with pornography. It died anyway.

From the ashes steamed a great cloud of suspicion, some of which still hovers over art in the church. Despite the great artistic and spiritual splendor of cathedrals in Europe and Great Britain, despite the towering sculpture of Christ the Redeemer that blesses Rio de Janeiro from Corcovado Peak, despite centuries of exquisite hymnody that produced Handel and the Bachs, so much art through the ages has not served to build up the church or anyone else. Instead, much art remains dedicated to celebrating pagan thoughts and immoral practices. From the apparently harmless but heterodox recurring Hollywood theme of dead people as angels who must do good to earn their wings, to the pernicious submerging of the cross in urine to make an artistic statement, art has not always served Christ.

On another level, some ancients felt that art substitutes for life, causing a false expenditure of emotion that hardens humankind to real suffering. Larry Norman echoes that complaint in his satire "The 6 O'clock News" on his classic rock album *So Long Ago the Garden*. In this criticism, art, like some afternoon soap operas, takes real human misery and disinfects it. With an organ-crescendo crisis before each commercial, critics charge, television's daytime dramas falsely evoke emotion in viewers, burning them out emotionally and

152

desensitizing them to real suffering. The case of Kitty Genovese, who was murdered while people watched from their houses, as lamented in Phil Ochs's '60s anthem "A Small Circle of Friends," is the *telos* of this malady. *Time* magazine in one advertisement tried to counteract this propensity in its readers by explaining that *Time* could "fly" them vicariously to the scenes of human suffering so that they could "care" and respond. Ideally, that is what all information sources would wish. But all too often, since the problems are distant and overwhelmingly complex, we simply watch them in our homes and become slowly inured. The end of that progression is the *I-Witness Video* syndrome that takes us back to the problem of ancient theater: Men killing one another and women prostituting themselves as entertainment.

Christian art is different. It is a gift from God that when exercised properly points back to the Giver. All good art tells us something about the God who creates all the beauty we see around us—flowers, stars, undersea panoramas, the wonders of nature that cry out in silent testimony.

What Chrysostom and Augustine were complaining about was art that was titillating and unedifying voyeurism. If our goal is to edify and move beholders toward the good by displaying beauty that points to God or by revealing how the world has fallen short, then we correctly use art. We wield a powerful sword capable of cutting deeply to expose the drudgery of sin in contrast to the excitement of goodness. This is Simone Weil's point about the need to present good as attractive and evil as repulsive. If we can do that, we fulfill God's intentions for our subcreating, and we reflect our Creator. Such art should be welcomed by all Christians.

The Contemporary Church

When we ask the question, How can we minister through the arts? we are presupposing that we *can* minister through artwork. But this presupposition may not be shared by everyone in the church at large or in your church in particular. That is why we have so few art galleries in Christian churches. Many believers would be mystified if they arrived one morning and found the fellowship hall festooned with participatory sculptures and the walls decorated with fifty-two abstract sketches of one woman's impressions while in prayer. Maybe a new print of that picture of Jesus rapping gently on the heart's door might be acceptable, but what is all this other stuff doing in church? Many of us have no categories in which to fit such works of art. We think, That's nice, but does it belong here—in the *sanctuary?* If it were not for banners, some of our worship places would look like the sacred equivalent of union halls.

But for some believers, the church is a womb that nurtures artistic expression. Some churches have become places where new praise music

is created, thought-provoking plays are performed, and poetry is read. When we attended the Presbyterian Church in Caparra Heights in San Juan during a sojourn in Puerto Rico, we were delighted to hear as part of the holiday worship services a new poem presented for each occasion by the church poet. Such artistically enriching churches have rediscovered the nurturing of the creative side of the human spirit.

Yet at the same time that artists applaud the church's use of the arts, sometimes the worst offenders in keeping the arts *out* of the church are artists themselves! Often, artists who understandably do not want to see the arts co-opted and polluted for utilitarian purposes are reluctant to see them employed by the church.

Philosopher Hans Rookmaaker in his manifesto, *Art Needs No Justification,* cautioned repeatedly that the primary purpose of art is not evangelism, that its existence is justifiable in itself. That message was necessary to hear. But the other side of that message for some was that art is irrelevant, a misinterpretation that would have appalled Rookmaaker.

In Newark we spent four fulfilling years working closely with Captains Lionel and Marilyn Chapman and the saints at the Newark Central Corps of the Salvation Army. The Army is a beacon in the toughest of city ministries. It was on the front lines in Newark. When we started attending services, we were shocked to learn that the Army neither baptizes nor gives communion. The Chapmans explained patiently to us baffled Presbyterians that, to the Salvation Army, neither is necessary for salvation. The Army is strictly in the business of seeing people get saved both from their sins and their circumstances.

Like the Salvation Army, evangelicals specialize. Evangelicals evangelize. That idea is built into our identity. We feel our primary task on earth is to proclaim the gospel message through preaching and verbal witnessing. If the arts can be hammered into fit vehicles to carry that message, then we can use them. But fifty-two abstract sketches on some woman's impressions during prayer? Who is going to get saved through that? This attitude may very well be the reason why the evangelical church has let the arts slip away. What arts we do allow are often so subverted they cease being artistic.

The tragedy of Christian novels is one glaring example. Believers often buy them to give them to nonbelievers, then go off and read in secret the same secular novels the nonbelievers are reading. When a good fantasy or gothic or children's story does manage to elbow its way through the ferocious manuscript screeners and editorial boards of Christian publishers, it explodes on the Christian scene like a well hit piñata and its contents are snapped up everywhere. Still, some believers feel, such a story has to have some overtly Christian content, since everything but witnessing is essentially a waste of the precious time entrusted to us.

154

Does art really have a legitimate place in evangelical Christianity? Will the Lord look at a life invested in the arts as talent buried in the ground? These questions hound artists in the church today.

But we have seen that the God who delights in creating a multitude of stars, beautiful varieties of tropical fish, and exquisite blooming shrubs deep in Amazon jungles where few or no humans will ever see them obviously thinks the arts are more than a conduit for packaged sermons. The proclamation poured out by God's artwork is wordless, yet it speaks with a power unapproached by lectures. Sermons may interpret God's handiwork, but they are only human commentary. As subcreators, then, created in the image of the Great Creator, how can we minister through our artistic subcreating in the example set by the Master Crafter?

Ministering through the Arts

The word *minister* comes from Middle English and Old French. It adopts the Latin word for servant or attendant, "one whose business is to carry out the wishes of another, an agent acting out a boss's orders or designs." Christians are servants or administrators or ministers of Jesus Christ. We act out the tasks Jesus set for us, helping with our gifts to bring in God's rule over all the earth. Those tasks fall into two categories: lighting the world and shepherding the flock. Christians are called to do both: light the world by revealing the truth about God to others, and shepherd Christ's flock by building up the church.

Many of us who consider ourselves conservative Christians tend to emphasize the first. But when our lives and churches are examined, we find we actually do a lot more caretaking than we think we do and a lot less evangelism than we ought to do. Those who consider themselves liberal Christians, on the other hand, tend to emphasize shepherding or caretaking of others, leaving the lighting of the world, if the literature is to be believed, to whatever religion happens to be in someone's background or ethnicity. But there too is misperception. Loyalty to Jesus still characterizes Christian lay people across the theological spectrum, and concern for physical needs, as every city minister knows, is not the sole contribution of any theological position.

Likewise, neither theological persuasion is ipso facto more interested in the arts, despite any emphases on ritual and worship. Nor, we should point out, is any political position. For example, the further left one goes politically, the more the arts are co-opted ideologically. The Communist Writers Collective, upon whose mailing list I unwittingly found myself during the early '70s, was as utilitarian in its use of art as any fundamentalist Sun-

day school handout—and a lot more lethal. The collective's reworking of the Cinderella myth had our heroine organizing the populace, defying Prince Charming, and ending on the scaffold damning God and royalty. Further, no political or theological position necessarily has built into it a full view of what God expects of us. The Scriptures are clear: To live just, merciful, and humble lives before God (Micah 6:8) and to enjoy the tasks God has given us (Eccles. 2:24). Christians are called to minister to others by introducing all to God and God's good desires for their lives. And once others have become Christians, then Christians should help bear their burdens and nurture them in the way of becoming more like Christ.

When our son was born, we did not shake his tiny hand in the delivery room and say, "Okay, kid, you're on your own." That is when our real work began: feeding and diapering and coping with night terrors and helping our little one grow in grace and wisdom. When the Holy Spirit uses us to introduce someone to salvation in Christ, do we lose interest in that person as soon as the commitment is made and move on to the next one? Of course not. An abandoned baby weakens and dies; so may an abandoned reborn person, as Jesus' parable of the sower points out (Luke 8:5–8). That is why our task in ministry is twofold: to assist birth and to nurture—to light the world and to shepherd the flock.

Now, how do the arts figure into this twofold calling? The arts, as communication of life and truth in arranged form and beauty, can minister powerfully. In lighting the world, they can stir responses to God. In shepherding the flock, they can display God's goodness and celebrate God.

Lighting the World

The Power of the Arts

One weekend while I was writing this chapter, the exciting new-folk-bluegrass stars Alison Krauss, Ron Block, and Union Station, along with that stalwart of southern gospel, the Cox Family, presented an exquisitely beautiful concert of gospel music that left a Harvard Yard crowd wreathed in what can only be described as beatific smiles. These consummate performers did what no evangelist currently can do: Present a clear and simple message of Jesus' grace to a sold-out house of hardened Bostonian academicians and Somerville sophisticates who paid over twenty dollars a head to hear of Jesus in four-part bell-like harmony set to rippling country picking.

The power of music for proclamation has been obvious to the church since Paul and Silas sang-prayed hymns *(proseuchomai humnos)* to a captive audience in the jail at Philippi. After God added an earth-quaking backbeat, they not only retained their inmate audience but also converted their jailer (Acts 16:25–34). Centuries later, the same thinking that had Martin

Luther beating the pubs for saloon songs he could rework into hymns like "A Mighty Fortress Is Our God" inspires the Christian music industry to do more than simply sell a product. Under the program Youth Leaders Only, for example, Word Records developed a nationwide ministry distributing records, written materials, and videos to ministers working with youth. As staff member Dan Hickling explained, "If we sit in Los Angeles or Waco, Tex., and just throw out records, we have no way of knowing if they're reaching teenagers. We now have a hand in accomplishing that ministry."[2] As gospel music now outsells jazz and classical music, its potential for proclamation in an age resisting the spoken word has become obvious to the culturally sensitive. Billy Ray Hearn, who developed Myrrh records for Word and his own Sparrow label, observed, "I saw in contemporary music the best vessel to reach young people with the gospel. They listen to the music that is current. That's their language."[3] Z Music Television, the Nashville-based worship network's music video program aimed at the MTV generation, is another Christian attempt to speak that language.[4]

Likewise, in film many people who would never accept an invitation to Sunday morning worship services not only happily handed over the price of admission, got a good seat, and broke down and cried during *Chariots of Fire, Romero,* or *The Mission,* they also either bought or rented these films on video.

No one is more aware of the national influence of cinema than politicians. Since the televised debates in which a well-made-up John F. Kennedy destroyed a sallow, sweaty Richard Nixon, politicians have exploited the power of the visual media. The impact crossed over to cinema when actors like Jane Fonda began to throw their weight behind political candidates. When an actor, Ronald Reagan, became president of the United States, the connection was complete. United States President Clinton's wooing of the Hollywood celebrity crowd and appearances on popular programs like *Saturday Night Live* underscored how mandatory that relationship has become. In a time when high-profile Christians like Billy Graham are limiting how much identification with politicians they want to broadcast, those politicians are filling the support gap with film and television stars. When asked what politicians found appealing about such alliances, Jane Fonda guessed maybe "because we have a lot of money [for donations]."[5]

But the answer runs far deeper than that. The power of film and television stars is the reflected glory of the power of their media. They are invested with a portion of the influence these penetrating visual images have on passively receptive viewers. They come into our lives as friend, foe, angel, hero or heroine—any role in which they are cast. And their identities in our minds remain permanently invested with whatever role they have acted before us. If people expect Angela Lansbury to be wiser than all of us and actually able to solve mysteries in real life, that is only

because we saw her do it week after week, year after year. The effects of these towering movie images and penetrating video or television images in shaping our opinions and understanding of ourselves are inestimable. Their power to light the world is as real as their ability to plunge it into an abyss of violence, despair, and self-centered nihilism. The potential for Christian filmmakers to light the world is staggering. Then why is this not done more? Why are we not stocking the local video store to its fluorescent lights with Christian films?

Moviemaker Ken Wales, producer of Billy Graham's film *The Prodigal,* explained to *Christianity Today* that Hollywood does not make large-scale films for what it considers to be "special audiences." Needing three times the return in revenue to cover a film's production costs and make money for investors, film companies look for actors and directors who have proven box office success and take advantage of "trendy topics," which together will place a film in the center of public interest. *Chariots of Fire* was made by non-Christians who were attracted by its dramatic potential. To them it was a sports story with an interesting twist. Two competitors served as foils for each other. One was driven by evangelical convictions that affected when he would perform; the second was struggling against the anti-Semitism that snaked beneath all his relationships. Fueled by these private motivations, they entered competition, and their varied audience identified with the characters' dilemmas, investing empathically in them. Because audiences embraced one or more characters, the film was a financial success, while for sheer craft it won Academy Awards. But other attempts to handle Christian material, such as the unfortunate *Last Temptation of Christ,* do not fare so well on either count. Neither mass of viewers nor critics embraced it.

Hollywood's hit-and-miss performance tells Christians that the church cannot wait around to see how accurately the world reflects our message. We have to be proactive in proclamation. Ken Wales counsels, "We need to develop writers and artists of the written word, of the screenplay, who can capture Christian reality and create a script that will have all the elements of any good film. We need desperately to develop fine Christian writers to do this, because the film screenplay is the foundation and key to an excellent motion picture."[6]

Wales's own superlative *Christy* attempted to achieve this excellence on broadcast television. The high expense of its top-flight production coupled with the supposedly unbalanced demographic response to it relegated the show to cable, but a standard definitely was set.

One television show that has succeeded on broadcast television is Martha Williamson's powerful *Touched by an Angel.* This initially flagging fantasy began under another producer by poking fun at God. Williamson, a committed Christian, took it over and garnered good ratings, netting thirty thousand calls asking for it to continue. What fueled its success? Empathy.

158

"Every difficult time I went through, every bad decision I made, every really dumb relationship I had has brought me to a point where I can write stories for 'Touched by an Angel' that are ringing true in a lot of hearts," Williamson explains. One common thread through each episode is that God loves us, and that love can work to right our lives and secure us through death. As Williamson notes, "If you can get that simple but absolute truth across every single week, you have changed television."[7] In 1995 *Touched by an Angel* extended its effect into real life. An episode, first aired on November 11, included three Panamanian children with cleft palates in a storyline featuring the condition. Through joint efforts of producer Williamson, her staff, and Operation Smile International, these children received corrective surgery.[8]

Christian broadcasters, too, are trying to show more about God and God's working in human lives through parabolic presentation than simply by broadcasting sermons. "If you have wall-to-wall preaching, you're going to lose the audience," counsels Jack Johnson, president of the Southern Baptist Convention's Radio and Television Commission.[9] As Christian Broadcasting Network pioneer and media guru Pat Robertson has explained: "Only a masochist would want to watch religious shows all day long."[10] The Family Channel's decision to delete preaching programs on its schedule and focus on talk shows and entertainment revealed the depth of Robertson's conviction.

Other innovative Christian cable experiments included *His Place* on Pittsburgh's WPCB TV 40. The program presented an eclectic mixture of fiction and reality as a diner hosts real people and imaginary characters spontaneously discussing current issues.

The effect of visual media for bad or good on viewing audiences cannot be minimized. One South Bronx observer, Ronin Ro, former editor of the rap music magazine the *Source*, told the *New York Times*, "Italian gangster films like 'Goodfellas' have been very influential to gangsters on the street. What you find is that there is a cause and effect, back and forth between the media and the street."[11]

Why should that cause and effect, back and forth flow be used for evil? Why cannot that flow occur between the "fine" screenplay and "excellent motion picture" Ken Wales solicits and the world? An effective commitment to providing good entertainment will go far to undergird and illustrate the proclamation of the church.

Evangelism and the Arts

In light of the power of the arts and of the Lord's charge to us to evangelize (Matt. 28:19–20), how explicitly Christian should works of art produced by Christians be? Do we draw pictures only about Jesus, or can our work be symbolic? How submerged in symbolism can our art be and still communicate something from the Christian worldview? Or does each of

our works of art, regardless of our intention for it, inevitably communicate something of the Christian worldview simply because we are Christians doing the artwork? Can Christians, therefore, make abstract works of art? One painter told me that when she was a little girl, an artist who was presenting a chalk talk at her church made her pledge never to paint abstract paintings, because they were a product of the devil. Now a senior citizen, she has felt too guilty ever to draw abstract art, though many times she has felt frustrated by that limitation on expressing emotions and convictions she feels deeply in her spirit. How do we address questions and dilemmas such as these? We begin by understanding the distinction between our Christian responsibility to evangelize and the task of art.

A "fine" use of words inspired by the Holy Spirit is ultimately the key to all evangelistic communication. Nobody comes to faith without some kind of articulation of the gospel. When Aída and I were college students in Inter-Varsity at Rutgers and Douglass during the 1960s, we lived by the slogan "The uninterpreted life means nothing." Today we might modify this all-or-none position to say *any* good a person does serves God's reign, but the slogan still contains a central undeniable truth about evangelism. Many Christians live a life of doing good deeds, hoping for that classic response from people they help: "Why do you do this for me?" Then, they plan to drive home the gospel message. But most of the time in this self-centered world, people just take a good deed for granted: "Yeah, Bill's a real nice guy. He's always doing stuff like that." We have to get explicit if we are going to help redeem the time and the lost. Light of the world ministry has to have some kind of verbal component.

But an explicit verbal component is *not* chiefly the task of any art form. Art stands in analogy to life. It comes at life obliquely through story, picture, gesture, performance. Therefore, the task of a Christian in the arts is not chiefly to be explicit in verbal content. The task of a Christian artist is to take part in the sanctification of the imagination, of all nature, of every human activity. The artist's sphere encompasses every human thought and action, and the Christian artist's reflection on this sphere flows out of the Christian worldview. Naturally, a Christian's art sometimes will be useful for evangelism, since evangelism is a central part of the Christian worldview, but a Christian artist's production is not limited to this single intention.

We in the church often expect too little from the arts with respect to creativity and scope, and too much from the arts with respect to proclamation. Artists make works of art because they have been created extremely right-brained. Explanation is a left-brained activity. Even the least degree of explanation is a problem for some artists. Few, if any, artists ever want to explain their work. If they wanted to write a textbook, they would have written one instead of painting a picture. "I leave my work open to consecutive interpretation" is the artist's great escape statement.

But works of art flowing from a Christian worldview, like God's wordless handiwork in nature, can *attract* people to the gospel by *showing* them the world through the vision of the creating-redeeming God. In that process a certain amount of cognitive information can be imparted.

The arts and evangelism meet when both are seeking to find fresh and creative ways to present the old, old story. When either attempts to tell or show that story in ways that are neither fresh nor creative, they fail.

Preaching today is against the wall. With video images and music bombarding us day and night, the task faced by a lone figure standing generally motionless before a seated audience for twenty minutes or more without overheads, dual-screen projections, interpretive dance movements, mimes, or backup chorus is daunting. Yet the renewed interest in storytellers at schools, stand-up comedians in clubs, one-actor plays in theaters, and motivational speakers in convention halls tells us the spoken word is far from dead. It is human, touching us in a way technology cannot. If preaching lacks power and impact, the reason is not because of the form. Preachers should tell the gospel story in ways that light it up with a new blaze for our generations. At the same time, they must be vigilant to ensure that the old, old story remains unchanged by the new media.[12]

So must the arts be freed to reflect the old, old story in new and creative ways. Sometimes we put such restrictions on our artists that they tell the old, old story in ways that are just old. I dub this in literature the Christian pornographic novel. As most boys discover in middle school, the classic pornographic novel follows a formula: A little nothing of a plot, followed by a sex scene, followed by a little more nothing, followed by a bit bigger sex scene, followed by a little less nothing, followed by a more extended sex scene, ending the nothing-plot in a veritable orgy. In the Christian bookstores I used to search in my youth, so many of the popular Christian novels began with a little nothing of a plot, followed by the first witnessing scene, followed by a bit more nothing of a plot, followed by a more explicit witnessing scene, followed by a bit more nothing of a plot, ending in a veritable orgy of witnessing, usually led by a pastor. Included was either somebody's death or, in some apocalyptic stories, the end of the world. In other tales that sought to break the stranglehold of this formula, the plot was still interrupted by a mandatory verbal witness, a lot like the mandatory bed scenes Hollywood tiresomely sticks into every PG and PG-13 movie not about children, whether or not the scenes fit the plot. The extra ingredient spoils the savory broth. We did it wrong for so many years one began to wonder if we could get it right.

Historic classics as well as successful modern efforts tell us, of course, we can. But we need to apply this practical rule: No Christian should expect art to take the place of evangelism. Art does not replace a verbal witness and will not fulfill the Lord's charge to us in Matthew 28:19–20. Christian artists who understand that fact are freed and have their art freed. Because Chris-

tian artists do not have to depend on their art forms for all their evangelism service, their art is freed to serve the Lord, others, and themselves in a variety of ways in and besides evangelism.

If we learn anything as artists from the Old Testament, we learn that God expects us to enjoy our work under the sun and, when the opportunity comes, to use that work for God's glory. God requires a person to act justly, love mercy, and walk humbly with God. When art reflects a life like this in all its varied aspects, it does a service. And when art is well crafted, it is good in matters of both craft and morality. Art becomes bad when either aspect is lessened. What usually makes art bad in the church, as we have seen, is when it is subverted to only one task, evangelism or didactic teaching or whatever that task might be.

When in *Out of the Silent Planet* C. S. Lewis tackled H. G. Wells's theories of human expansion and took them to their inevitable conclusion by positing what might happen when sinful humanity breaks free of living on earth, or when he explored this expansion further in *Perelandra* in a parallel to the temptation account of Genesis, he demonstrated just how powerful building a new story on the old, old story can be. His books still sell because they do not *use* stories, they *tell* stories. They do not insult the reader.

One summer the late great magazine *Eternity* inquired of leading Christian celebrities what they had earmarked for summer reading. Ruth Graham, for whose great wisdom I have the utmost respect, said without any pretense or feeling of obligation to impress readers that she was looking forward to reading *Watership Down*. Christians read well-written books that tell truths about life whether they are Christian in outlook or sub-Christian, as this delightful fantasy happens to be. Sub-Christian, after all, is not anti-Christian. *Chariots of Fire* delighted Christian audiences because it simply presented the joy of living in the Lord, not because it told the gospel story. *The Prodigal* stood out from other church-made films of its time because it presented real people in real dilemmas and did not tell us whether the characters' lives were mended but made viewers work to envision the resolution.

The arts can serve best in the light of the world task of ministry when, from a Christian worldview, they reflect the gospel, show a fresh perspective on or depiction of the attractiveness of the faith, and glorify those things true and honorable and just and pure and excellent and commendable that Paul counsels us to dwell upon in Philippians 4:8. Further, Christian artists can exercise and develop their craft, depicting truth and beauty as tabernacle artist Bezalel did against the day when, as he was, they will be called to a holy task. All of these options please God, for all such handiwork shows forth God's glory.

One option that does not please God, however, is approving anything in our art that is antithetical to the gospel. Christians do not recognize "art for

art's sake" as a value-free excuse for saying anything one wants to say through the arts. All art has a message—whether it is Christian, existentialist, nihilist, New Age, neopagan, whatever—because art flows from the worldview of the artist. Everyone has a worldview; no one is value free. Such a statement does not mean that a Christian cannot depict evil in artwork. No, by all means, go ahead and depict it ruthlessly in all its alluring beauty and moral squalor. But what it does mean is that a Christian cannot *approve* it; that is, make it unequivocally attractive, publicize it, and glorify it. One painting by a newly converted artist from Salem who formerly practiced witchcraft deeply troubles Christians who see it. The attraction of an angelic figure is so overpowering that it draws undue attention to itself and not to God, whom the angel supposedly represents. It seems to have become a figure to be worshiped. One ballet we saw in the Dominican Republic performed by a traveling troupe from the United States was so decadent in portraying aberrant sexual relations that we felt soiled watching it. One song we heard, built upon the imagery of the Beast glutting itself on the blood of the saints, was sung with such twisted anticipation that I tossed the entire record out—right next to the copy of *Naked Lunch,* which features images of ejaculation at the point of execution. Reveling in evil is anti-Christian. Christians cannot dabble in questionable presentations that are not using art for God. We always champion the good, the pure, the true, the loving, even when we are depicting evil or not intentionally making a theological or moral statement. We cannot approve of anything evil, and we cannot attract our audience to it without providing a counterweight.

We cannot sing smutty songs or draw risqué pictures; we also cannot make pornographically violent or scatological or racist films. Not all occupations in the arts are neutral. This is not to suggest that artists cannot paint nudes. The human body cannot of itself be evil. Down that road lurks madness and the pointing finger of the accuser from the time of Eden to today. But what we do with the body can be evil, and we must be careful how we depict it. In sculpture, for further example, we cannot carve attractive figures of demons without a hint of the evil that is there.

We are not always to blame if our artwork is misused, of course. One artist told me he made a beautiful picture of a young boy. Two men visited his gallery, and, as they admired the painting, he realized they were pedophiles. He refused to sell them the painting, despite their increasingly extravagant offers of money.

While we are not always so blessed as to be able to block misuse of our work, we can always aim to present to the world excellent art that depicts God and goodness as being attractive and evil as being repulsive in spite of its allure.

We should keep in mind that we never exist in a vacuum of art. Our faith leavens all of our life and informs all that we do. In that way we help light the world.

Shepherding the Flock

"Do you love me?" Jesus asked Peter in John 21:15–17. "Feed my lambs." And again, "Tend my sheep." And again, "Feed my sheep." Peter was hurt. He thought Jesus doubted the sincerity of his love. But Jesus doubted the sincerity of his commitment to the church, whether Peter would remain true and dedicate his life to building up the body of Christ. That is the same question Jesus asked in Luke 18:8 of people who were losing heart and neglecting to pray. He told the story of a persistent widow who, by not giving up, got what she wanted in the end: "When the Child of Humanity comes back to you, will he find any faith left upon the earth because you have been faithful in feeding my flock of believers?"(my paraphrase).

How do we feed Jesus' flock? How can we assure our Lord that he will find faith on earth when he returns? The nourishment of the church is the teaching of Scripture (Deut. 8:3; Matt. 4:4). Symbolized in our need to feed the body is our need to have our spirits fed by the life-sustaining words of God. Those concepts stand side by side in the prayer Jesus gave us to pray. In the Lord's Prayer we are taught to ask daily for our food—sustenance for the body—and daily for forgiveness of sins and succor from evil—sustenance for the spirit (Matt. 6:11–14).[13] Our task is to build up the church in its knowledge, in parallel to shoring up its physical well-being (Matt. 25:31–46). How we do this building up varies. Sometimes we do it didactically; sometimes indirectly, alternately telling and showing. The first method informs our disciples, while the second makes them work to discover the truth. Good teachers use both means. Not only do some disciples learn better in one way or the other but everyone needs a balance of approaches to make certain all points are lodged in the will and the emotions as well as in the intellect. How many times do we know what is the right thing to do and still go off and sin? Telling us is essential, but it is not the whole didactic task. Moving our will to assent is the key.

This is where the arts can be used powerfully to build up the church. Many factors shape the will. Allegiance is one—by a person being convinced that Christ's way is the best way. Choosing the way of denial in mystical prayer lets a person see beyond the things of the world to glimpse God, the great Giver. This choice must come from within when a person feels glutted by the things of earth; it must never be imposed. On the other hand, those who choose the way of affirmation find God within the gifts of earth. When Nigerian Christian youth sent the delegation to their church leaders demanding that a Christian drumbeat be created as a substitute for pagan drumbeats the church had taken away, their action was not frivolous or ancillary to the process of sanctification. As culturally sensitive Christians, they were seeking how to be in their world but not of it, fulfilling Jesus' prayer in John 17:6–19. To the rhythm of drums Nigeria's varied cultures pass through their

stages of life. What these youth were asking for was a redeeming of culture—the task of the church.

In so many ways the arts can redeem our lives by redeeming our vision. They can help us see not as the world sees but as God sees. Further, they exercise two powerfully active functions: to display God's goodness to others, which is people oriented, and to glorify God, which is worship or God oriented.

Displaying God's Goodness

Pictures can help us look at our world by forcing us to stop and examine something for a space of time. We run around in our jobs, meeting our goals, and often ignore the incredible beauty into which God has placed us. When we see a painting or sculpture, we are forced to stop and contemplate that beauty as it reflects the beauty of its Creator. In Franco Zeffirelli's beautiful ode to St. Francis, the film *Brother Sun, Sister Moon,* the real protagonist may be nature. Sequences of butterflies in flowing fields display God's goodness everywhere, the same kind of beauty that arrests us when we see ballet. Our bodies are not just functional; they are God's work of moving art that can glorify God in that movement. Dance reminds us of grace.

Our response to God's goodness is expressed powerfully through art; for example, hymns such as the psalms rise to praise God with no other intention than gratitude for the beauty of the earth and its goodness (Ps. 104). Nobody criticizes the psalms for not evangelizing. We need them for worship.

One role of the arts in the church is to build us up by reflecting the deeper truths of growth in God, reinforcing what is taught. So many ways exist to do this in a church that is seeking perfect love without fear.

The holy dance, for example, has existed in African-American Pentecostal and some Baptist churches for centuries. "Touching fire," as we have learned in our various city ministries, is a unique way to experience the loving presence of God's Spirit. Liturgical dance is a way to communicate that experience to others as well as to express our response to God.

Before he died, actor Vincent Price campaigned to put reproductions of great paintings on sale in food stores to enrich the lives of United States citizens. How many churches have a space for art displays that enrich the lives of believers? Look around at those walls in your church's hallways, at that back-room corner—you could create a resting, nurturing place of beautiful original artwork by artists sitting quietly, and perhaps unencouraged, in your congregation.

Glorifying God

Churches like Willow Creek Community Church have become famous for their use of plays to support the morning's message. Drama is a pow-

erful means the church has used for years in the Sunday school and in holiday productions. What about for adults too? Every other year our tiny church mounts a Christmas pageant presenting the medieval York Mystery Cycle. Our middle- and working-class congregation can identify with these twelfth- and thirteenth-century plays written by the clergy for the people and eventually taken over by the craft guilds and performed with great jollity. One year, family groups volunteered to perform one play apiece, and we were able to field the *Prologue,* the *Annunciation,* the *Shepherd's Play,* and the *Three Kings' Play* with Christmas carols and Scripture readings interspersed. Carpenters in the congregation built a life-sized manger. Tiny children dressed up like sheep, and the old English with its "lackadays" and "mayhaps" sprang alive across the centuries as families figured out a play's message and ignited it into a blaze of edifying fun once again.

The Jesus movement rose from California churches like Calvary Chapel that were not afraid to allow a new song for a new time to praise God. As the heavy-metal churches that have sprung up recently reveal, the spirit of spiritual adventure is still alive. Certainly some of these new songs can err. With truth, error always creeps in as Christ's enemy sows tares among the wheat. A tour through many hymnals will reveal some overripe ancient heresies. Consider the words of "Must Jesus Bear the Cross Alone?" The arts should be pruned, just as preaching and teaching should be pruned, to eliminate error and allow truth to grow. Used rightly, they can accomplish in ministry what nothing else can. They can make people stop, draw them in, overwhelm their senses with a powerful message, and make them work to resolve that message.

Conclusion

In the introduction to this book I listed a representative potpourri of art forms. These could be grouped into products (pots, plots, clockwork tots, etc.) and actions (act, tat, pirouette, etc.). Every well-made or well-done work of art flowing from a Christian perspective can serve the kingdom of Christ in positive or negative images showing some truth about God, the world, or God's activity in the world.

Discordant, chaotic music; wire sculpture; dark minors in oil paint; convoluted transformational blank verse in poetry; contortions in dance; and nonsense in drama can reflect the despair of a spirit bereft of God. Full majestic chords; shimmering colors; sweeping marble sculptures; high onomatopoeic or mythopoeic verse; mellow, filtered photographs or distinct ones; mellifluous movements in dance; and simple clay pot-

tery shaped cunningly for use can all mirror the joys of Eden, of heaven come to earth.

Jesus, the Master Crafter, continually used the arts in his ministry. Throughout his teaching, Jesus spun stories. Just before he was to enter his passion, Jesus gathered his disciples for a last meal and then led them in a song (Matt. 26:17–30).

On his triumphant procession into Jerusalem, Jesus was challenged about the accolades of his followers. "If they do not praise me," he replied, "the very stones would cry out" (Luke 19:40). Today in works of art like *Chariots of Fire,* the stones have cried out. If the church does not like the message of some of those "stones," like *The Last Temptation of Christ,* then it should take over the artistic crying out. The church should support those in its midst who have been gifted by God to cry out in art and help them apply their art as a healthy ministry.

And we *must* take care of our artists. Christians in professional ministry today are at great risk. Well publicized are the infidelities and drug problems of some of our musicians, writers, and preachers. The problems of secular performers are being duplicated in the church, in part because we have duplicated the conditions that set secular performers up for moral failure. The whole "pressure circuit" of performing is unhealthy. Christian artists who produce a product like a book or tapestry are less at risk here since they can stay at home with their families and use the familial center as a workbase. But performers travel, and that constant life in movement erodes the stability of relationships. If you leave your house plants unwatered for six months, they shrivel up and die. If you leave your spouse and children for six months, your relationships can shrivel up and die. "You pity this plant?" God asked Jonah in a parabolic lesson using real life entities (see Jonah 4:9–11). "What about people?"

We should take our cues from how Jesus ministered. Jesus' ministry was relaxed. He went to a place and stayed for a while, getting involved in the weddings, fish fries, and get-togethers as well as performing in the natural amphitheaters. As a rule, Jesus did no one-night stands. He established himself, performing a visible ministry for a time, then moved on. He could assure God in John 17:12 that he had saved all but the one who betrayed him. How many Christian performers can stand before God and present the wife or husband of their youth and all of their children as loving believers? The church is responsible for providing for their ministries a supportive climate in which no one is lost due to the combination of high demand and neglect.

Some are waking up. Noel Stookey, the great Christian folksinger of Peter, Paul, and Mary fame, talked about the group's re-formation in 1983 after the hectic pace of the 1960s. "We realized that this was fun, and—more than fun—it seemed to have a purpose. . . . It didn't have to be 'Families go hang,' and we could be together—until our teeth fall out."[14]

The Holy Spirit did a great job reconciling the world to God before we were born and will continue to do so after we are dead. Our job is to do our part, not all of the task. We should be faithful, relaxed, pleasant witnesses for Christ. We are called to brighten our corner, not the whole room. We should not act like prima donnas because we happen to have a gift in art. That is simply one gift of many. The fabled artistic temperament is simply immaturity that has no place in ministry and often covers up a lack of talent. If we relax and do what God has gifted us to do, neither the church nor the world can force us into a mold. Elders and deacons cannot throw away their families and lead; no leader can, according to 1 Timothy 3:1–13. Neither are we called to throw away our own physical or mental health, burning out for ministry. All gifts from God should be nurtured—not exploited, but respected, welcomed, supported. And we should equally support all other gifts, the didactic, administrative, and service gifts along with the high-profile and artistic gifts. If your church is not doing that, then change the church or change churches. Enough orthodox, faithful churches exist for us to find and share community.

Finally, the secret to all is discipline. Even critics of James Dobson applauded when he took time off to nurture his family by creating a film presentation and sending it out instead of making personal appearances. That physician healed himself. So should we all. Airlines, for a time, gave special rates to spouses to help keep business trips from fragmenting families. We should bring the whole family when we invite performers. Christianity is communal first and foremost—the body of Christ! We need to take care of every part. We need to encourage and care for one another, supporting all in our combined ministry.

Suggestions for Exploration

Go through the list of art forms in the introduction to this book and supplement it with any of your favorite art forms that are missing. Try to think of a way to apply every art form you can to some aspect of the life and ministry of your church. Some ideas: Quilt the names of missionaries your church supports on a great tapestry, or make a quilt from square patches decorated by each individual or family in the church. Produce a Reformation Day drama. Have classes paint a mural together on the wall of each Sunday school room, depicting some impression or scene from their favorite lesson of the year. Paint the murals out every four years and start again, keeping a photograph of each one. Conduct a special service of the arts periodically, featuring music and poetry. Perform a liturgical dance based on the parable of the pearl of great price. Tell the Good Samaritan tale in

mime for a harvest party. Display pottery vessels set aside for common and holy use. Create fifty-two abstract paintings of your experiences in prayer and hang them in the sanctuary.

Praise good artistic work and encourage one another in all uses of God's gifts. God bless you and your congregation with an infectious delight!

Notes

Preface

1. Claudia Frost, "Fine Arts Department," *Syllabus* (a publication of the Hamilton-Wenham Regional High School Community; 1 December 1995): 8.

2. President William Clinton at the Concert of the Americas at the Third Hemispheric Summit of the Americas (The John F. Kennedy Center for the Performing Arts, N.Y., 1994).

Chapter 1—*The Bible as Apologetic for Art*

1. Aristotle describes the poet as someone who aims to describe what "might happen," "what could and would happen either probably or inevitably," whereas the historian describes "what actually happened." The poet tends to give general truths, "the sort of thing that a certain type of person will do or say either probably or necessarily," rather than "particular facts" (*Poetics* IX). Moreover, the poet "represents life," "either things as they were or are; or things as they are said and seem to be; or things as they should be" (*Poetics* XXV). The difference between a craft or skill and art is that in a craft that is not also art, no general truth is communicated.

The art form itself should communicate a general truth about life. History can be sung, but the type of music chosen to communicate that history would convey a general truth, making it art.

Francis A. Schaeffer thinks art shows the artist's worldview. See *Art and the Bible: Two Essays* (Downers Grove, Ill.: InterVarsity, 1973), 37.

2. Noah Webster, *Webster's New Universal Unabridged Dictionary,* ed. Jean L. McKechnie, 2d ed. (New York: Simon and Schuster, 1983), 105.

3. Aristotle agrees: "From childhood humans have an instinct for representation, and in this respect differ from the other animals that they are far more imitative and learn their first lessons by representing things" (*Poetics* III.4).

4. See W. A. Crockett and J. G. Sigountas, eds., *Through No Fault of Their Own? The Fate of Those Who Have Never Heard* (Grand Rapids: Baker, 1991), 126–30.

5. Dancing is a response to joy in Isa. 30:29; Lam. 5:15; Ps. 30:11. See also A. Besançon Spencer, "Dancing," in *Dictionary of Biblical Imagery* (Downers Grove, Ill.: InterVarsity, 1998).

6. 1 Sam. 18:6–7; 10:5; Judg. 11:34; 2 Kings 3:15.

7. 1 Chron. 15:16–29; 16:4–7, 37, 41–42; 25:1–8; 2 Chron. 29:25.

8. See also 2 Sam. 6:5; Ps. 81:2–3; 149:3; 150:3–5. D. A. Foxvog and A. D. Kilmer, "Music," in *The International Standard Bible Encyclopedia* III, 2d ed. (Grand Rapids:

Eerdmans, 1986), 436–49. E. Werner, "Musical Instruments," in *The Interpreter's Dictionary of the Bible* III (Nashville: Abingdon, 1962), 469–76.

9. Col. 3:16; Eph. 5:18–19. Paul uses the same words for what Christians sing as were used of the Levites: "hymns," "songs" (Josephus, *Jewish Antiquities* XX.9.6 [216–17]).

10. *Webster's Dictionary*, 1052. See also Leland Ryken, *Words of Delight: A Literary Introduction to the Bible*, 2d ed. (Grand Rapids: Baker, 1992), and Aída Besançon Spencer, "Literary Criticism," in *New Testament Criticism and Interpretation*, eds. D. A. Black and D. S. Dockery (Grand Rapids: Zondervan, 1991), 227–51.

11. *Webster's Dictionary*, 1847.

12. This material is excerpted from Aída Besançon Spencer, "God as a Symbolizing God: A Symbolic Hermeneutic," *Journal of the Evangelical Theological Society* 24 (December 1981): 323–31.

13. See also Matt. 27:45–54; Mark 15:33–39.

14. Norval Geldenhuys, *Commentary on the Gospel of Luke*, New International Commentary on the New Testament (Grand Rapids: Eerdmans, 1951), 611.

15. Exod. 13:2, 13–15; 22:29–30; Num. 3:12–13, 40–51; 18:15–19.

16. F. F. Bruce, *Jesus and Christian Origins outside the New Testament* (Grand Rapids: Eerdmans, 1974), 30. Also see A. Plummer, *A Critical and Exegetical Commentary on the Gospel according to Saint Luke*, The International Critical Commentary, 5th ed. (Edinburgh: T. and T. Clark, 1922), 537.

17. G. Henton Davies, "Exodus," in *The Twentieth Century Bible Commentary*, 2d ed., eds. G. H. Davies, A. Richardson, and C. L. Wallis (New York: Harper, 1955), 133.

18. B. W. Anderson, *Understanding the Old Testament*, 2d ed. (Englewood Cliffs, N.J.: Prentice-Hall, 1966), 49.

19. William Neil, *Harper's Bible Commentary* (New York: Harper, 1962), 76.

20. Philip C. Johnson, "Exodus," in *The Wycliffe Bible Commentary*, eds. C. F. Pfeiffer and E. F. Harrison (Chicago: Moody, 1962), 60.

21. Susanne K. Langer, *Philosophy in a New Key: A Study in the Symbolism of Reason, Rite, and Art*, 3d ed. (Cambridge: Harvard University, 1957), 26.

22. See also H. R. Rookmaaker, *Art Needs No Justification* (Downers Grove, Ill.: InterVarsity, 1978). For other helpful studies on the Bible and the arts see Frank C. Gaebelein, *The Christian, the Arts, and Truth: Regaining the Vision of Greatness* (Portland, Ore.: Multnomah, 1985); Leland Ryken, *The Christian Imagination: Essays on Literature and the Arts* (Grand Rapids: Baker, 1981); Ryken, *The Liberated Imagination: Thinking Christianly about the Arts* (Wheaton: Harold Shaw, 1989); John Wilson, *One of the Richest Gifts: An Introductory Study of the Arts from a Christian World-view* (Edinburgh: Handsel, 1981). The bibliography has further references.

Chapter 2—*Fiction as a Looking Glass*

1. The core of the following answers to this question was developed with William David Spencer.

2. Isa. 5:1–7; Ps. 80:8–16; Luke 13:6–9; John 15:1–8.

3. Matt. 13:24–32; Mark 4:26–29; Luke 8:5–15.

4. Harriet Beecher Stowe, *Uncle Tom's Cabin* (New York: George Braziller, 1966), vii, 434; Stowe, *Uncle Tom's Cabin; or, Life among the Lowly,* ed. George Bullen (Boston: Houghton, Mifflin, 1887), xi, xiv, xxii, xxxii, xxxvi.

5. Robert L. Brawley, *Centering on God: Method and Message in Luke-Acts,* Literary Currents in Biblical Interpretation (Louisville: Westminster/John Knox, 1990), 29–32.

6. C. S. Lewis, *An Experiment in Criticism* (Cambridge: Cambridge University, 1961), 80.

7. Marion Zimmer Bradley, *The Mists of Avalon* (New York: Alfred A. Knopf, 1982), 23, 59, 128, 136, 172, 179.

8. C. S. Lewis, "On Stories," in *Essays Presented to Charles Williams,* ed. C. S. Lewis (Grand Rapids: Eerdmans, 1966), 96.

9. In 1991, 63.9 percent of murders were caused by an argument; 52.5 percent of rapes in the United States were committed inside one's own home, near home, or at a friend's, relative's, or neighbor's home. Bureau of the Census, *Statistical Abstract of the United States,* 113th ed. (Washington: U.S. Government, 1993), 195, 197.

10. Margaret Scherf, *Always Murder a Friend* (Garden City, N.Y.: Doubleday, 1948). For further study of her methods, see chap. 18 of William David Spencer, *Mysterium and Mystery: The Clerical Crime Novel* (Carbondale, Ill.: Southern Illinois University, 1989).

11. See W. D. Spencer, "The Promise," *The Wittenburg Door* 62 (August–September 1981): 13, 25.

12. David Lindsay, *A Voyage to Arcturus* (New York: Ballantine, 1963). See Gen. 1:1–21; 1 Tim. 4:3–5.

13. Lewis, *Essays,* 105.

14. G. K. Chesterton, *Manalive* (New York: John Lane, 1912), 2–3.

15. C. H. Dodd, "The Gospel Parables," *Bulletin of the John Rylands Library* 16 (1932), 403.

16. Umberto Eco, *Postscript to the Name of the Rose* (New York: Harcourt Brace Jovanovich, 1983), 59.

17. Madeleine L'Engle insightfully points out: "All children are artists, and it is an indictment of our culture that so many of them lose their creativity, their unfettered imaginations, as they grow older." *Walking on Water: Reflections on Faith and Art* (New York: Bantam, 1980), 51.

18. C. S. Lewis, *Perelandra: A Novel* (New York: Macmillan, 1958), 30.

19. Edgar Rice Burroughs, *Pirates of Venus* (Tarzana, Calif.: Edgar Rice Burroughs, 1934), 58–59.

20. Spitzer's philological circle is described by Aída Besançon Spencer, *Paul's Literary Style: A Stylistic and Historical Comparison of II Corinthians 11:16–12:13, Romans 8:9–39, and Philippians 3:2–4:13,* an Evangelical Theological Society Monograph (Winona Lake, Ind.: Eisenbrauns, 1984), 57–63. A new printing is available from University Press of America, Lanham, Md.

21. W. H. Auden, "Afterword," in *The Golden Key* (New York: Ariel, 1968), 84.

22. Lewis, *Experiment,* 35–36.

23. Margaret Parker, *Unlocking the Power of God's Word* (Downers Grove, Ill.: Inter-Varsity, 1991), 18, 21, 25, 28.

24. See Aída Besançon Spencer, "Literary Criticism," in *New Testament Criticism and Interpretation,* ed. D. A. Black and D. S. Dockery (Grand Rapids: Zondervan, 1991), 227–29.

25. Lewis, *Experiment,* 88.

26. Ibid., 82.

27. Noah Webster, *Webster's New Universal Unabridged Dictionary,* ed. Jean L. Mc-Kechnie, 2d ed. (New York: Dorset and Baber, 1983), 680.

28. Matthew Head, *The Congo Venus* (New York: Simon and Schuster, 1950), 207. For further discussion, see chap. 22 of Spencer, *Mysterium.*

29. Frances Lockridge and Richard Lockridge, *Dead as a Dinosaur* (Philadelphia: J. B. Lippincott, 1952), 87.

30. Lewis, *Essays,* 103, 98.

31. See also Lewis, *Experiment,* 35.

32. P. G. Wodehouse, "Jeeves and the Unbidden Guest," in *Carry On, Jeeves!* (New York: Pocket, 1927), 49.

33. Alice Walker, *The Color Purple* (New York: Harcourt Brace Jovanovich, 1982), 7.

34. W. Hamilton Fyfe, trans., Aristotle, *The Poetics,* The Loeb Classical Library (Cambridge: Harvard University, 1927), 17 n.b.

35. Pauline Bloom, "How to Achieve Story Structure," in *The Mystery Writer's Handbook: A Handbook on the Writing of Detective, Suspense, Mystery and Crime Stories,* ed. Herbert Brean (New York: Harper, 1956), 35. See also Leland Ryken, "The Bible as Literature," in *The Christian Imagination: Essays on Literature and the Arts* (Grand Rapids: Baker, 1981), 176.

36. L'Engle, *Walking on Water,* 153, 79.

37. Leland Ryken, *The Liberated Imagination: Thinking Christianly about the Arts* (Wheaton: Shaw, 1989), 179–80. See also pp. 179–217 for explanation and examples.

38. Simone Weil, "Morality and Literature," in *The Simone Weil Reader,* ed. George A. Panichas (Mt. Kisco, N.Y.: Moyer Bell, 1977), 290.

39. Auden, *Golden Key,* 86.

40. George MacDonald, *The Princess and Curdie* (New York: E. P. Dutton, 1949), 1–2.

41. For a helpful book on figurative terms, see Richard A. Lanham, *A Handlist of Rhetorical Terms,* 2d ed. (Berkeley: University of California, 1991). See also Spencer, appendix 2 of *Paul's Literary Style.* On style, see Lanham, *Style: An Anti-Textbook* (New Haven: Yale University, 1974).

42. MacDonald, *Princess,* 2–3.

43. Ibid., 3–4.

44. Ibid., 14.

45. Ibid., 203. When the grandmother seeks to heal Princess Irene's father, the king, she weeps over him as he lies in a purifying but painful fire and "from her hair the water of her weeping dropped like sunset rain in the light of the roses." Drops fall from her hair into the fire "in showers" and raise "as it were the sound of running brooks" (ibid., 218).

46. Ibid., 4.

47. The first appearance of the great-great-grandmother reverses the first narrative. Here a woman is described in inanimate metaphors: "a lady, 'beautiful exceedingly,' dressed in something pale *green*, like velvet, over which her hair fell in *cataracts* of a rich golden colour. It looked as if it were *pouring down* from her head . . . *like the water* . . . , vanishing in a golden *vapour* ere it reached the floor. It came flowing from under the edge of a coronet of *gold*, set with alternated pearls and emeralds. In front of the crown was a great *emerald*, which looked somehow as if out of it had come the *light* they had followed . . . her slippers, . . . were one mass of gleaming emeralds, of various shades of green, all mingling lovelily like the waving of *grass in the wind and sun*. She looked about five-and-twenty years old" (ibid., 44).

In another passage, the narrator moves from inanimate images to animate images and back: "The [green light] spread and melted away . . . and there were eyes— and a face—and a lovely form—and lo! the whole cavern blazing with lights innumerable" (48). Curdie describes her as "the mother of all the light that dwells in the stones of the earth" (50). Her tone "was precious like a jewel" (61).

48. See also Aída Besançon Spencer, "Romans 1: Finding God in Creation," chap. 10 in *Through No Fault of Their Own? The Fate of Those Who Have Never Heard*, ed. W. V. Crockett and J. G. Sigountos (Grand Rapids: Baker, 1991).

49. MacDonald, *Princess*, 45.

50. Greville MacDonald, *George MacDonald and His Wife* (London: George Allen and Unwin, 1924), 122.

51. Rolland Hein, *The Harmony Within: The Spiritual Vision of George MacDonald* (Grand Rapids: Christian University, 1982), 45.

52. L'Engle, *Walking on Water*, 119.

53. See Joan D. Berbrich, *Writing Creatively* (New York: Amsco School Publications, 1977), 401–7.

Chapter 3—*God in the Music Box Mirror*

1. Maria Newman, "And Still the Cubans Flee, with 1000 More Picked Up," *New York Times*, 31 August 1994, A10, cols. 3–4. Just how key music is to the self-image and motivation of a people became evident once again in September 1994 when Bosnia's culture minister, Enes Karic, with the backing of the governing Party of Democratic Action, ordered one of Sarajevo's leading radio deejay's to stop playing "aggressor music"—songs performed by Serbs. According to a special report to the *New York Times*, Mimo Sahinpasic, the popular radio host, recoiled. "I was outraged. There are Serbian singers—like Djordje Balasevic—whose antiwar songs have done more for Bosnia than 80 percent of our leaders. So I ignored the letter. I'm in Bosnia to fight for what's left of the Yugoslav idea, not to live in a one-party state" (quoted in Roger Cohen, "Bosnians Fear a Rising Islamic Authoritarianism," *New York Times*, 10 October 1994, A3, col. 1).

The Muslim authorities were right to be worried. Just how powerful music can be as a political stimulant was demonstrated when Jamaican superstar Bob Marley's anthem "Zimbabwe" became the rallying cry for rebels toppling the Rhodesian government. In desperate retaliation, the Rhodesian authorities arrested their own leading popular music performer, Thomas Mapfumo, forcing

him to play for rival political parties, blasting out his music from helicopters while attempting to lure people out of the bush about the time of the internal settlement. But Mapfumo coded the songs and in symbolic language sent the opposite message than the one authorities intended, further fueling the revolution despite government efforts at musical manipulation (see liner notes for Thomas Mapfumo, *The Chimurenga Singles 1976–1980,* Earthworks ELP 2004, 1984). For further reference see Dr. Alec J. C. Pongweni, *Songs That Won the Liberation War* (Harare, Zimbabwe: College Press, 1982), and Julie Friedrikse, *None but Ourselves: The Masses vs. the Media in the Making of Zimbabwe* (Johannesburg, South Africa: Raven Press, 1982).

Finally, that music is a lifeline even for Christian youth in the often frightening, constantly changing culture of the United States was poignantly articulated by Jennifer Whiddon, a twenty-one-year-old Alabaman college student who in responding to a *Christianity Today* article on "Generation X" pleaded, "The church must understand that music is our life. It helps us escape from the pain of divorce, abuse, and so on." As a Christian, she orients her prayers and directs her "work for Jesus" from the issue-oriented laments of what have come to be called grunge bands, those groups based on the pioneering Seattle sounds of Pearl Jam and the late Kurt Cobain and Nirvana (Letters to the Editor, *Christianity Today,* 14 November 1994, 8).

2. See, for example, the lovely hymn "This Is My Father's World," verse 1.

3. While rap music today is a wonderful outgrowth of Afro-Caribbean music giving voice to many honest concerns and used powerfully by DC Talk and others to celebrate God's good news, the subset of gangsta rap has become as great a concern to many today—particularly in the African-American community where it vies with the gospel and presents a violent solution for racism and poverty—as Lamech's violent musical solution was to the good people of his day. In February 1994 before a congressional hearing on music lyrics and interstate commerce, Dr. C. DeLores Tucker, a distinguished stateswoman who was Pennsylvania's first African-American secretary of state and a veteran of the Civil Rights movement, testified, "Dr. [Martin Luther] King would be marching and demonstrating against the glamorization of violence and its corrupting influence which has now become a part of our culture of freedom. [He] would be deeply saddened by those in our community who abuse and misuse the freedom of speech by dehumanizing, demeaning, degrading our own women."

Syndicated African-American talk show host Joseph E. Madison added that while he is certainly not opposed to rap, gangsta rap seduces the young and poses a threat to all and should be considered an outrage. He said, "My own 14 year old son . . . began fantasizing and hero-worshipping the images of thugs and criminals, even to the point of dressing like gangsta rappers he saw on music videos, and believed jail was a better alternative to his middle-class home and existence." (Tucker and Madison are quoted by Darius James in his review of the hearing, in which he supports gangsta rappers. See "Gangstaphobia," *Spin,* May 1994, 66.) Even among antiestablishment musicians the nihilistic threat of gangsta lyrics has become a concern. Gil Scott-Heron, the patriarch of black protest music, has warned about the misanthropic and genocidal dangers of gangsta rap's attitudes (see his "Message to the Messengers," *Spirits* [TVT: 4310-2, 1994]).

176

4. See study 2 in Stanley Gevirtz's monograph *Patterns in the Early Poetry of Israel* (Chicago: University of Chicago, 1963), 25ff.

5. For example, Ps. 118:22 in Acts 4:11; Ps. 139:1–2 in Rom. 8:27; Ps. 94:11 in 1 Cor. 3:20; Ps. 112:9 in 2 Cor. 9:9; Ps. 68:18 in Gal. 4:8; Ps. 2:8 in Heb. 1:2; Ps. 2:7 in Heb. 1:5; Ps. 45:6–7 in Heb. 1:8; Ps. 102:25 in Heb. 1:10; Ps. 110:1 in Heb. 1:13; Ps. 138:6 in James 4:6; and Ps. 118:22 in 1 Peter 2:7.

6. Henry George Liddell and Robert Scott, eds., *A Greek-English Lexicon,* 9th ed. (Oxford: Oxford University, 1940), 2018, 1849, 2030.

7. Reginald Allen, "No Change for Born-Again Tommy—Yes Indeed!" *Sunday Gleaner,* 10 May 1998, E1, cols. 1–4. Such a revival has not come about by magic but through solid preparation by a plethora of Christians and Christian organizations working together. Jamaica Theological Seminary/Caribbean Graduate School of Theology in Kingston, Jamaica, has educated thousands of pastors, counselors, and Bible school teachers across the Caribbean, working to build a solid evangelical infrastructure into Caribbean Christianity. For example, Professor Clinton Chisholm, a recognized evangelical Christian expert on Caribbean music, has consciously educated pastors to accept Caribbean rhythms as redeemable by Christ. The embracing of reggae and soca by United States gospel groups like the Winans and many others has also exerted a strong influence on Caribbean Christians to separate the music from its cultic appropriation, as has the steady incorporation of island rhythms by The Grace Thrillers, Love Singers, Change, Ernie Smith, Marcia Hamilton, Bunny Anderson, Birthright, and so many other wonderful Jamaican Christian bands. Therefore, the music, accepted as cultural rather than religious, has become part of the common ground between Christians and Afrocentric Rastafarians who had suspected that Caribbean Christians preferred North American gospel and country western music (both extremely popular in Jamaica) over their own cultural music. When some Rastas began to worship Jesus solely, many churches were ready to accept them, reggae, locks, African identity, and all. When, for example, Judy Mowatt switched allegiance from Haile Selassie and Jesus as God jointly to Jesus exclusively, she was discipled in Kingston's Christian Holiness Church, whose active health clinic, educational program, and cell group ministry are led by Dr. Samuel Vassel, who holds degrees from JTS, CGST, and the United Theological College. Likewise, Lieutenant Stitchie was baptized at Glad Tidings Open Bible Church under Rev. Cedric Lue and is also associated with New Testament Church of God. Papa San is discipled by Haven Hill Baptist. Junior Tucker is discipled at Swallowfield Chapel, a Charismatic Brethren Church, and also worships at The Church on the Rock under the Rev. David Keane, the same church discipling Carlene Davis and Tommy Cowan. Paul Blake of the Bloodfire Posse operates his Sold Out Ministries out of The Church on the Rock's Montego Bay sister church, pastored by David Keane's brother. The rise of such huge charismatic churches added to the steady ministry of Jamaica's equally burgeoning non-Charismatic sister churches has given Christianity a highly visible and appealing presence.

8. Those interested in my thorough thoughts on Rastafari and Christianity may find them in my forthcoming book from SPCK, London, *Dread Jesus,* and their synopsis in my commentary on a seminal work of Rastafari and a chapter on the impact of reggae music around the world in Nathaniel Samuel Murrell, William David Spencer,

and Adrian Anthony McFarlane, eds., *Chanting Down Babylon: The Rastafari Reader* (Philadelphia: Temple University, 1998). Ijahman Levi's piece is on his album *Africa* (RAS: 3203, 1987).

9. Margareth Menezes' "Elegibo" is the title cut of her breakthrough album (Mango: 539855-1, 1990). Talking Heads' *True Stories* is on Sire (2551-1, 1987). While various power religion rhythms have been recorded in obscure places like *The Authentic Sound of Haitian Voodoo* (Ansonia: 1543, 1976), Kumina drumming on the Jamaican Folk Singers' *Encore, Volume 3* (self produced, no information), or in Folkways collections (like *Drums of Defiance: Maroon Music from the Earliest Free Black Communities of Jamaica,* which includes Myal rhythms), Boukman Eksperyans is available commercially on Shanachie and Lord Sassa Frass on Black Scorpio.

Christians have often debated the appropriateness of employing drumbeats that have been used to call spirits. Some shun them entirely. Others, like the Rev. Clinton Chisholm, author of *A Matter of Principle* (Kingston: Autos, 1997), reference the work of anthropologist Sheila S. Walker in *Ceremonial Spirit Possession in Africa and Afro-America: Forms, Meanings, and Functional Significance for Individuals and Social Groups* (Leiden: Brill, 1972), observing that, to the uninitiated, beats are simply beats; however, any musicians previously involved in a possession cult, particularly those who have simply left without switching allegiance to the protection of Jesus, would be foolish to employ in their popular music a rhythm with which they have been conditioned to call a daemon (20). The definitive description of the terrifying possession experience of power religion has been done by Maya Deren, who did not live long after her experiments, in her *Divine Horsemen: The Living Gods of Haiti* (New York: McPherson, 1953).

On the other hand, to condemn all popular or rock rhythms as demonic, as some Christians have done in the past, is also ill advised, as it confuses matters of morality or theology with often provincialized matters of taste: "If I'm not used to it—or if I don't like it—there must be *something* wrong with it." Further, since many rhythms are African in origin, such prejudice on the part of Anglo listeners may well be racist and, as such, sub-Christian. Christ is more than able to redeem all things in life, including misappropriated rhythms. Beats as well as lyrics (among all other things) belong first to God. This may be a 1 Corinthians 8 issue.

10. *Bossa Magazine: Brazilian Jazz World Guide* regularly covers such topics as the tours of Bahia's Folklore Ballet and the Candomblé music to Iemanja, the Queen Mother of the Sea. Those interested in exploring Caribbean music might well notice the outstanding series of books currently being issued from Temple University Press (in conjunction with Ian Randle Publishers). Chris McGowan and Ricardo Pessanha's new edition of *The Brazilian Sound: Samba, Bossa Nova and the Popular Music of Brazil* (1998) is filled with informed and intelligent commentary on everything and almost everyone in Brazilian music and is loaded with photographs as well. Likewise Peter Manuel's *Caribbean Currents* gives an extremely helpful overview of the whole Caribbean musical scene, while Kevin O'Brien Chang and Wayne Chen's delightful *Reggae Routes* collects all the inside information, photographs—even gossip—of Jamaica's fascinating music. The explosion of lilting, world-class merengue and bachata from the Dominican Republic are examined in their fascinating social

and political contexts in Paul Austerlitz's *Merengue: Dominican Music and Dominican Identity* and Deborah Pacini Hernandez's *Bachata*. Also worth noting among many excellent music journals are *Reggae Report*, which specializes in reggae, and *Popular Music and Society* (a publication of the Popular Culture Association out of Bowling Green State University in Ohio). On global music, all issues of *The Beat: Reggae, African, Caribbean, World Music* are worth consulting. Special issues treat Brazil (vol. 10, no. 2, 1991), Carnaval, which includes an article on salsa and Santeria (vol. 13, no. 2, 1994), and Brazil–Celia Cruz (vol. 14, no. 6, 1995).

11. "Bethelehemu" is on *More Drums of Passion* (Columbia: 9307, n.d.) and "Shango (Chant to the God of Thunder)" is on *Drums of Passion* (Columbia: 8210, 1959). Ebenezer Obey's song "Miliki" can be found on *Je Ka Jo (Let Us Dance)* (Obey: 001, 1983). Some Western releases are *Miliki Plus* (Virgin: VM7:1983) and *JuJu Jubilee* (Shanachie: 43031, 1985). Among his Nigerian titles are *Adam and Eve* (Decca), *Celebration, My Vision, Patience, Peace, Providence, Victory,* and *Ose (Thank You)* (Obey).

12. For a fuller explanation, readers may consult my article "Christ's Sacrifice as Apologetic: An Application of Hebrews 10:1–18" in *The Journal of the Evangelical Theological Society* 40, no. 2 (June 1997), 189–97. To learn about the Supreme God, see chaps. 5–7 in Aída Besançon Spencer and William David Spencer, eds., *The Global God: Multicultural Evangelical Views of God* (Grand Rapids: Baker, 1998).

13. Tony Iommi, Bill Ward, John "Ozzy" Osbourne, and Geezer Butler's "After Forever" is on Black Sabbath's *Master of Reality* (Warner: 2562, 1971).

14. Marilyn Manson, *AntiChrist Superstar* (Nothing/Interscope: 90086, 1996).

15. "Rhiannon" first appeared on Fleetwood Mac's self-titled album (Warner: 0698, 1975). Mary Black's *Babes in the Wood* is from Gift Horse/Curb (D2-77528, 1991).

16. Mahlathini, *The Lion of Soweto* (Virgin Earthworks: 90867-1, 1987). Most of the combined work of Mahlathini and the Mahotella Queens can be found on Shanachie. Those who would like our extensive critique of neopaganism can find it in Aída Besançon Spencer, Donna F. G. Hailson, Catherine Clark Kroeger, William David Spencer, *The Goddess Revival* (Grand Rapids: Baker, 1995).

17. Joan Osborne's poignant version of Eric Bazilian's "One of Us" is on *Relish* (Mercury/Blue Gorilla: 314 526 699-2, 1995).

18. Steve Turner, *Hungry for Heaven: Rock 'n' Roll and the Search for Redemption* rev. ed. (Downers Grove, Ill.: InterVarsity, 1995), 55. This excellent, thoroughly researched survey is indispensable for anyone interested in assaying the theological state of rock. Also interesting from a secular stance is Tommy Udo and Stuart Baile's "I'll Get Me Cult," a fascinating checklist of religions and quasireligions and the bands that popularize them (*VOX*, June 1997) that lumps Jesus Christ in with Aleister Crowley, Buddhism, Joseph Campbell, Kurt Cobain, Temple of Psychick Youth, Unarius Society, Zoroastrianism, Herman Hesse, and so on.

19. Two excellent resources on the true effect of hallucinogenic drugs on the body are Mark Yoslow, *Drugs in the Body: Effects of Abuse* (New York: Franklin Watts, 1992), and Janice Keller Phelps, M.D., and Alan E. Nourse, M.D., *The Hidden Addiction and How to Get Free: Recognizing and Breaking the Habits That Control Your Life* (Boston: Little, Brown, 1986).

20. "Soft-Hearted Hannah" is on *George Harrison* (Dark Horse Records: 3255, 1979). "My Sweet Lord" is from the boxed set *All Things Must Pass* (Apple: 639, 1970) and "Life Itself" from *Somewhere in England* (Dark Horse: 3492, 1981). The Beatles' drug-related output from "Tomorrow Never Knows" on *Revolver* (covered by such performers as Danielle Dax, who revived it as a single in 1990), through "A Day in the Life" on *Sgt. Pepper's Lonely Heart's Club Band,* through "I Am the Walrus" on the *Magical Mystery Tour* album can be found scattered through their work.

21. "Namaste" is on Beastie Boys, *Check Your Head* (Capital/Grand Royal: 7 98938 2, 1992).

22. KRS-One, *I Got Next* (Jive: 01241-41601-1, 1997).

23. *Cat Stevens' Buddha and the Chocolate Box* (A&M: 3623, 1973).

24. *Jeremy Spencer and the Children* (Columbia: KC 31990, 1972). Christian music aficionados will remember Paul Stooky released a song called "Give a Damn" on his *Paul and* album that recalled the Spanky and Our Gang musical plea. This, of course, was all before the arrival of Bruce Cockburn.

25. Translation by Henry M. Dexter, 1846.

26. Translation by John M. Neale, 1854, and Henry W. Baker, 1859.

27. Claire Cloninger and John Rosasco have beautifully updated the hymn for the title track of Cynthia Clawson's *Immortal* (Dayspring: 7-01-41450-0, 1986).

28. Amy Grant's version of "Emmanuel" appeared in 1983 on *A Christmas Album* (Myrrh: MSB-6768, 1983) and also on her *The Collection* (Myrrh: 7-01-684306-8, 1986). Rich Mullins's "Awesome God," which first appeared in 1988, has just been rereleased on *Songs* (Reunion: 701 0116 725, 60234 16205 2, 1996). Aaron Jeoffrey's "He Is" is on Star Song (G2 7243 8 20027 27 SSD0027, 1994). The Christland Singers have their song collected on Spirit Feel's sampler *The Gospel Sound of Spirit Feel* (SF 1012, 1991), while William Hardy Jr. and the company's rendering is on the original Broadway cast version of *Your Arms Too Short to Box with God* (MCA: 37126, 1977). Of course, the best known of the gospel pop songs about the life of Christ is Johnny Pate and Curtis Mayfield's version of "Amen," which became a remarkably successful crossover hit for the Impressions. For those interested in classic gospel music, a treasure has just appeared in Willa Ward-Royster's *How I Got Over: Clara Ward and the World-Famous Ward Singers* (Philadelphia: Temple University, 1997). As sister to Clara Ward and a founding member of the definitive female gospel group, she shares candid insights in this memoir that break open the complex and ambiguous world of religious entertaining.

29. Graham Kendrick's "From Heaven You Came (The Servant King)" is from *Love Eternal*—Sue Rinaldi (KCM: 730, 1983). Mike Starkey's "Mighty Wind" is from *Grace* (Proost/Serious Music: 14, 1997). This privately pressed collection of rave worship songs currently in use in churches in London is available from 11 Junction Road, Oldfield Park, Bath, England BA2 3NQ. Petra's piece is from *Washes Whiter Than* (Star Song: R 8014, 1979); Leon Patillo's, originally appearing on *Don't Give In*, is collected on *Cornerstone: Leon Patillo's Best* (Word: 7-01-685206-7, 1987); Chris Taylor's has so far appeared at this writing on the delightfully packaged *Mindy's Revenge* sampler from Word (7019950604, 1997).

30. Readers can find "Lamplighter" on Terry Talbot, *A Song Shall Rise* (Birdwing: 2028, 1981). "The River Will Flow," originally released on *Freedom*, is now available

on White Heart's *Souvenirs* (Sparrow: 1250, 1990). Dave Bilbrough's song is on his *New Heart* (KMC: 922, 1995) and along with Graham Kendrick's piece can be found excerpted on Kingsway Music's twenty-seven-song compilation, *Stadium Praise* sampler, which is practically being given away at two pounds from this major United Kingdom company. The Grace Thrillers' "Living Waters" is available along with the rest of their marvelous catalog from 15860 NE 14th Court, North Miami Beach, FL 33162 (Showers of Blessing: GT0008, n.d.), while Claudelle Clarke's title track (GG Records Ltd: 0011, 1979) is from 5 Hope Road, Half-Way Tree, Kingston 10, JA, W.I.

31. Much exciting new material is appearing from Christian bands as diverse as Christafari (on Gotee), who have been included in Sunsplash, Jamaica's annual state-of-reggae all-star concert; Symbiotica (Graceland), with its superb mixing of techno, hip hop, rap, and jazz with a provocative vocal lyric; the Channel Surfers (Organic), who blend rock, rap, and reggae in a winning mix; fun ska rap band The Supertones (BEC); Caedmon's Call (Warner Alliance), with its superior acoustic work; the World Wide Message Cult (Warner Alliance), a Manchester, United Kingdom powerhouse; Okasa Lamptey (Olam), Accra's Christian Afro-reggae prince; and many others!

32. This is what Christians call "common grace" (John 1:9).

33. Obviously one cannot know *every* song that has been composed and some amount of duplication is inevitable, but one can certainly avoid going ahead with a song when duplication is demonstrated. And one certainly should not intentionally rip off popular songs just to catch an audience's ear through familiarity, Luther's success in lifting a bar tune for his hymn "A Mighty Fortress" notwithstanding. God is original enough to inspire lasting anthems. The church need not squander its God-given talent slinking around like a musical marauder pillaging the world rather than investing these talents in profitable creation. Let us both enjoy the multitude of great songs in our heritage and also sing a new song to God.

Chapter 4—*Looking Comes First: A Personal Artistic Journey*

1. George MacDonald, chap. 3 in *Alec Forbes,* vol. 1, as quoted by C. S. Lewis in *George MacDonald: An Anthology* (New York: Macmillan, 1947).

2. The mythical land of Narnia was created by C. S. Lewis and is explored in a series of seven volumes: Lewis, *The Chronicles of Narnia* (New York: Macmillan, 1950). In this imaginary country animals can speak, and they have a Creator-God-Lion named Aslan whose resemblance to Christ is unmistakable.

3. C. S. Lewis, *The Great Divorce* (New York: Macmillan, 1946), 80.

4. William Blake, "Auguries of Innocence," in *William Blake: A Selection of Poems and Letters*, ed. J. Bronowski (London: Penguin, 1958).

5. Job 38–41.

6. Pilgrimage to the Tomb of Meher Baba was expected of all his devotees. This journey, combined with an interview with his *mandali* (inner circle of close disciples), is often the highlight in the lives of Baba's disciples. My own pilgrimage there was fraught with terrible inner struggle and a sense of dread that issued from my doubts about Baba's claims. The letters and telegrams I received nearly every day from Meg were a lifeline and a source of great comfort to me. In spite of my struggles, I never

revealed my doubts to Meg or anyone but Baba's *mandali*. They were typically comforting but encouraged me to take these things in stride and stay with Baba.

7. Philip Guston, born in Canada, grew up in Los Angeles, California. He went to school with Jackson Pollock of abstract expressionist fame and painted murals during the Work Progress Administration under Roosevelt. Later, he joined the New York School, as it is called, and became a leading abstract painter there. At the end of his career, when I studied under him, he had abandoned abstraction to reinvestigate the power of narrative and the human figure in his late figurative expressionist paintings.

8. The triptych was the principal format of altarpieces throughout the Middle Ages and early Renaissance. A triptych typically consisted of a folding, three-way screen that displayed the crucifixion in the central panel with adoring saints in the outer panels. It could be turned around and on the reverse side could often be seen a Resurrection in the middle with the Last Judgment or scenes of heaven and hell on the sides.

9. For example, see Frank Getlein, *Georges Rouault's Miserere* (Milwaukee: Bruce, 1964).

10. These collaborations have included *Golgotha: The Passion in Word and Image* (Gordon College, 1993), coauthored by Bruce Herman and Patricia Hanlon, with help from George Wingate, a member of Christians in the Visual Arts (CIVA) whose prints grace the chapter endings and title page; and *The Florence Portfolio* (Normal, Ill.: Normal Editions Workshop, University of Illinois, 1995), a limited edition portfolio of twenty original etchings, the subject matter of which is taken from the Bible, with the theme of Sacrifice. Eight CIVA members collaborated on this piece.

Chapter 5—*Postcards from the Past: Depicting God through the Visual Arts*

1. Pierre Du-Bourguet, S.J., *Early Christian Painting* (London: Weidenfeld and Nicolson, 1965), 21.

2. Ibid., 15–16.

3. Leonid Ouspensky, *Theology of the Icon*, vol. 1, trans. Anthony Gythiel (Crestwood, N.Y.: St. Vladimir's Seminary, 1978), 92–93.

4. Ibid., 96, 100. This view was never formally adopted in the West, so symbolic representations remained a part of the Roman Catholic Church's iconography throughout the centuries.

5. See the text of the Seventh Ecumenical Council in Ouspensky, *Theology of the Icon*, 135.

6. Emile Mâle, *Religious Art in France: The Late Middle Ages* (Princeton: Princeton University, 1986), 83, quoted by Eamon Duffy, *The Stripping of the Altars* (New Haven: Yale University, 1992), 234.

7. Duffy, *Stripping of the Altars*, 234–48.

8. Emile Mâle, *The Gothic Image: Religious Art in France of the Thirteenth Century* (New York: Harper and Row, 1958), 183.

9. This image originally came from "a Coptic adaptation of Isis suckling the infant Horus." Peter Brown, *The World of Late Antiquity* (London: Thames and Hudson, 1971), 143.

10. W. A. Visser 'T Hooft, *Rembrandt and the Gospel* (London: SCM Press, 1957), 33–35.

11. For further details see Ambrosios Giakalis, *Images of the Divine: The Theology of Icons at the Seventh Ecumenical Council* (Leiden, Netherlands: E. J. Brill, 1994), 7, 10–11; and Ouspensky, *Theology of the Icon,* 109.

12. Theodore the Studite, *Refutations of the Iconoclasts,* 2.1–2.2 in *On the Holy Icons,* trans. Catharine P. Roth (Crestwood, N.Y.: St. Vladimir's Seminary, 1981), 44–45. Circumscription is defined to include many kinds: "inclusion, quantity, quality, position, places, times, shapes, bodies—all of which are denied in the case of God, for divinity has none of these. But Christ incarnate is revealed within these limitations" (*Refutations,* 3.13).

13. *Refutations,* 1.7 in *On the Holy Icons,* 27.

14. Abridgment of the iconoclastic *horos* by Ouspensky, *Theology of the Icon,* 124–25, using Héfélé, *Histoire des Conciles* (Paris, 1910), 697–703.

15. *Refutations,* 2.9.

16. John of Damascus, *The Veneration of Icons* (Willots, Calif.: Eastern Orthodox Books, n.d.), 7.

17. *Refutations,* 2.

18. *Refutations,* 1.15.

19. *Refutations,* 1.14.

20. *Refutations,* 1.19. The church officially differentiated between *dulia,* which was veneration to be directed at saints, and *latria,* which was worship directed at God.

21. Martin Luther, "Personal Prayer Book," in *Devotional Writings* II, ed. Gustav K. Wiencke, vol. 43 of *Luther's Works* (Philadelphia: Fortress Press, 1968), 43.

22. Martin Luther, *Selected Psalms* II, ed. Jaroslav Pelikan, vol. 13 of *Luther's Works* (St. Louis: Concordia, 1956), 168.

23. Martin Luther, *Selected Psalms* III, ed. Jaroslav Pelikan, vol. 14 of *Luther's Works* (St. Louis: Concordia, 1958), 131.

24. Martin Luther, *Lectures on Isaiah,* ed. Jaroslav Pelikan, vol. 16 of *Luther's Works* (St. Louis: Concordia, 1969), 255.

25. Carl C. Christensen, *Art and the Reformation in Germany* (Athens, Ohio: Ohio University, 1979), 43–47.

26. Martin Luther, "Against the Holy Prophets," in *Church and Ministry* II, ed. Conrad Bergendoff, vol. 40 of *Luther's Works* (Philadelphia: Muhlenberg Press, 1958), 81–90.

27. Ibid., 95.

28. Ibid., 91.

29. Ibid., 99.

30. Ibid., 100.

31. John Calvin, *Calvin: Institutes of the Christian Religion,* ed. John T. McNeill (Philadelphia: Westminster Press, 1960), I.xi.2.

32. Ibid., I.xi. 8.

33. Ibid., I.xi.9.

34. Ibid., I.xi.11.

35. Ibid., I.xi. 5.

36. Ibid., I.xi.7.

37. Ibid., I.xi.14–15.

38. Ibid., I.xi.16.

39. Ibid., I.xi.12.

40. Ibid., IV.xvii.36.

41. For further reading on Calvin's and other Reformation views of the worship of images of God, see Mary Beaty and Benjamin W. Farley, eds., *Calvin's Ecclesiastical Advice* (Louisville: Westminster/John Knox Press, 1991), 71–80; Charles Garside Jr., *Zwingli and the Arts* (New Haven: Yale University, 1966); Christensen, *Art and the Reformation in Germany;* John Phillips, *The Reformation of Images: Destruction of Art in England, 1535–1660* (Berkeley: University of California, 1973); and Clifford Davidson and Ann Eljenholm Nichols, *Iconoclasm versus Art and Drama* (Kalamazoo, Mich.: Medieval Institute Publications, 1988).

42. We are not told God's specific instructions for the temple, but we are told that Solomon is the one whom God chooses to build his house. And once the temple is built, the Lord chooses to fill it with his glory (1 Kings 8:10–11). Thus, it may be safe to assume that the temple was built without violating God's principles. Solomon includes cherubim (1 Kings 6:23), palm trees and open flowers (1 Kings 6:29), lilies (1 Kings 7:19), pomegranates (1 Kings 7:20), the sea and bulls (1 Kings 7:25), and lions (1 Kings 7:29).

43. Margery Kempe, *The Book of Margery Kempe,* trans. B. A. Windeatt (London: Penguin Books, 1995), 113.

44. Maxim Gorky, *My Childhood* (New York: Pelican Classics, 1966), 63–64, as quoted in John Baggley, *Doors of Perception: Icons and Their Spiritual Significance* (Oxford: A. R. Mowbray, 1987), 97.

45. This can be argued from Deut. 4:15 but not from the second commandment. And there are no representations of God in either the tabernacle or the temple.

46. See Henri J. M. Nouwen, *The Return of the Prodigal Son* (New York: Doubleday, 1992). Nouwen describes the role the painting played in his leaving his teaching position at Harvard University to serve at a L'Arche community.

47. See George Ferguson, *Signs and Symbols in Christian Art* (New York: Oxford University, 1954). Ferguson's iconography is based on Renaissance painting, when most of Christian iconography was fully developed and which has remained fairly constant ever since. It is particularly helpful for understanding art of the Western (i.e., Catholic and Protestant) church. To understand the iconography of Eastern (i.e., Orthodox) art, a book such as *The Meaning of Icons* by Leonid Ouspensky and Vladimir Lossky (Boston: Boston Book and Art Shop, 1969) is useful.

Chapter 6—*Movement: The Language of Dance*

1. Curt Sachs, *World History of the Dance,* trans. Bessie Schönberg (New York: W. W. Norton and Company, 1937), 11.

2. See Judith Rock and Norman Mealy, *Performer as Priest and Prophet: Restoring the Intuitive in Worship through Music and Dance* (San Francisco: Harper and Row, 1988), 1.

3. For a few good resources on dance in church history, see Ronald Gagne, Thomas Kane, and Robert VerEecke, *Introducing Dance in Christian Worship* (Washington: Pastoral Press, 1984); J. G. Davies, *Liturgical Dance: An Historical, Theological and Practical Handbook* (London: SCM, 1984); and Margaret Fisk Taylor, *A Time to Dance: Symbolic Movement in Worship,* 2d ed. (Austin: The Sharing Company, 1981).

4. Davies, *Liturgical Dance,* 87.

5. Ibid., 86.

6. Brian Walsh and Richard Middleton, *Transforming Vision: Shaping a Christian World View* (Downers Grove, Ill.: InterVarsity, 1984), 109. For a comprehensive understanding of the effect of dualism on the imagination in Western thinking, see Richard Kearney, *The Wake of Imagination: Toward a Postmodern Culture* (Minneapolis: University of Minnesota, 1988).

7. Johannes Pedersen, *Israel: Its Life and Culture,* vol. 1 (London: Oxford University, 1926), 99, 171.

8. Paul Klee, "Creative Credo," in *Theories of Modern Art: A Source Book by Artists and Critics,* ed. Herschel B. Chipp (Berkeley: University of California, 1968), 182.

9. See Schroeder, "Praying with the Bones I: Old Testament," in *Embodied Prayer: Harmonizing Body and Soul* (Liguori, Mo.: Triumph-Liguori, 1995), 63–73.

10. José Limón, "On Dance," in *The Vision of Modern Dance,* ed. Jean Morrison Brown (Princeton: Princeton Book Company, 1979), 103.

11. For a full view of the way dance is used in the Old Testament, see Exod. 15:20; 32:19; Judg. 11:34; 21:21–23; 1 Sam. 18:6–7; 21:11; 29:5; 2 Sam. 6:11–21; 1 Kings 18:26; 1 Chron. 15:29; Job 21:11; Pss. 30:11–12; 149:3; 150:4; Song of Sol. 6:13; Eccles. 3:4; Jer. 31:4, 13; Lam. 5:15.

12. An example of dance in a neighboring culture is found in 1 Kings 18:26 when the people danced around the altar to get the god Baal's attention. For a detailed description of sacred dance in the surrounding cultures in the Ancient Near East, see W. O. E. Oesterley, *The Sacred Dance: A Study in Comparative Folklore* (Cambridge: Cambridge University, 1923).

13. For a full discussion of the theological principles of creation, incarnation, and redemption in relationship to the body, see my book *Embodied Prayer.*

14. Ted Shawn, *Dance We Must* (New York: Haskell House, 1974), 3.

15. Rudolf Laban, "The Educational and Therapeutic Value of the Dance," in *The Dance Has Many Faces,* ed. Walter Sorell, 2d ed. (New York: Columbia University, 1966), 113.

16. Martha Graham, *Blood Memory* (New York: Doubleday, 1991), 4.

17. C. S. Lewis, *Mere Christianity* (New York: Macmillan, 1943), 91.

18. St. John of Damascus, *On the Divine Images: Three Apologies against Those Who Attack the Divine Images,* trans. David Anderson (Crestwood, N.Y.: St. Vladimir's Seminary, 1980), 23.

19. For example, many famous companies have been inspired to choreograph from religious themes and have produced outstanding works. Examples of this are Alvin Ailey's "Revelations" and George Balanchine's "Prodigal Son," both well-known works which have inspired audiences around the world. For a good study on performances with religious themes, see Giora Manor, *The Gospel according to Dance: Choreography and the Bible from Ballet to Modern by the Editors of Dance Magazine* (New York: St. Martin's, 1980).

20. There are as many styles, forms, and ways to use liturgical dance in worship as we have musical expressions. For more information on the nature of liturgical dance, see the books listed in the bibliography.

21. See Schroeder, *Embodied Prayer,* 43.

22. For a more comprehensive treatment of the relationship of salvation to the whole person, see George Eldon Ladd, *A Theology of the New Testament* (Grand Rapids: Eerdmans, 1974), 76–78.

23. Madeleine L'Engle, *Walking on Water: Reflections on Art and Faith* (Wheaton: Shaw, 1980), 149.

24. Vincent van Gogh, *Van Gogh: A Self Portrait: Letters Revealing His Life as a Painter*, comp. W. H. Auden (Greenwich, Conn.: New York Graphic Society, 1961), 302.

25. Graham, *Blood Memory*, 5.

26. Not all dancers, of course, actually create. A dancer's vocation legitimately can be found in performing and expressing through the choreography of others. For example, in many professional dance companies, only the choreographer or a guest choreographer creates pieces, particularly in large well-known companies. However, small companies often allow more room for collaboration and encourage artists to test their creative impulses.

27. Cynthia Winton-Henry and Phil Porter, *Body and Soul: Excursions in the Realm of Physicality and Spirituality* (Oakland: Wing It! Press, 1993), 21. Winton-Henry has developed a helpful theology of improvisation which can be read in two articles, "Leaps of Faith: Improvisational Dance in Worship and Education" and "Landing on My Feet: Saved by Improvisation," both in *Body and Soul*.

28. See also 1 Chron. 15. The Hebrew words used in both Scriptures are *kārar*, *pāzaz*, *śahaq*, *rāqad*, and *hûl*.

29. Winton-Henry and Porter, *Body and Soul*, 21.

30. See, for example, chap. 6 of William David Spencer and Aída Besançon Spencer, *The Prayer Life of Jesus: Shout of Agony, Revelation of Love: A Commentary* (Lanham, Md.: University Press of America, 1990).

31. Some of the preceding exercises are in the exercise section in my book *Embodied Prayer*.

Chapter 7—*The Dramatic Arts and the Image of God*

1. Peter Brook, *The Empty Space* (New York: Atheneum, 1968), 42, 59.

2. David Mamet, *Writing in Restaurants* (New York: Penguin Books, 1986), vii.

3. Robert Sherwood, "The Dwelling Place of Wonder," in *The Making of Theatre: From Drama to Performance*, ed. Robert W. Corrigan (Glenview, Ill.: Scott, Foresman and Company, 1981), 12.

4. William Shakespeare, *Hamlet*, act 2, scene 2, lines 315–22, in *The Riverside Shakespeare*, ed. G. Blakemore Evans (Boston: Houghton Mifflin, 1974), 1156.

5. Murray Watts, *Christianity and the Theatre* (Edinburgh: Handsel, 1986), 7.

6. Arthur Miller, *The Death of a Salesman*, in *Stages of Drama: Classical to Contemporary Theater*, ed. Carl Klaus, Miriam Gilbert, and Bradford S. Field, 3d ed. (New York: St. Martin's, 1995), 869–70, 875.

7. Arthur Holmberg, "Waning of Spirituality Perplexes Artists Today," *American Theatre* (June 1991): 44.

8. Ibid., 45.

9. Ibid., 46.

10. Ibid., 45.

11. Ibid., 46.

12. Brook, *The Empty Space,* 56.

13. Ibid., 59–60.

14. Harold Etrensperger, *Conscience on Stage* (New York: Abingdon-Cokesbury, 1947), 29–30.

15. Robert Smyth, "A Road Less Traveled," *Lamb's Quarterly* (National City, Calif.: The Lamb's Players, 1989), 1.

16. *Christians in Theatre Arts* (Canton, Ohio: Malone College, 1989), 2.

Chapter 8—*Eyes to See, Ears to Hear, and Minds to Understand:*
Movies and Other Media

1. Alan MacDonald, *Movies in Close-Up: Getting the Most from Film and Video* (Downers Grove, Ill.: InterVarsity, 1992), 15.

2. "Before Viewing Master Control," in *A Classroom Guide to Master Control: Television Literacy for Kids* (1994): 4.

3. This problem occurs even in so-called *verite* films, which are made by taking a camera into a situation and turning it on to capture the full reality of the moment. But even these films do not capture "the full reality." For one thing, the presence of the camera skews the situation even when the filmmaker is trying to be unobtrusive. What happens in the presence of the camera would not happen if the camera were not present. Further, since no one can stand to look long at unedited film, the filmmaker must select segments to show. And once a film goes into editing (as Andy Warhol's film of twenty-four hours in front of the Empire State Building has shown it must), the result unavoidably presents someone's point of view.

4. Jo Kadlecek, "Ron Austin: Charlie's Angels and Jesus," *Christianity Today,* 6 February 1995, 61.

5. Ibid.

6. Ibid.

7. Ibid.

8. Ibid.

9. Sue Buske, "Community Access: Don't Just View It—Do It," *Videomaker* (November 1991): 87.

10. Deborah Leveranz and Kathleen Tyner, "Media and the Schools: Two Leading Proponents Offer an Overview," *The Independent* (August–September 1993): 25.

Chapter 9—*Ministry through the Arts*

1. G. K. Chesterton, "In Defence of Detective Stories," in *The Art of the Mystery Story,* ed. Howard Haycraft (New York: Grosset and Dunlap, 1946), 4–5. In my book *Mysterium and Mystery: The Clerical Crime Novel* (Carbondale, Ill.: Southern Illinois University, 1989), an analysis of the religious dimensions of the mystery novel, I present a thorough study of ordained sleuths in the fiction of Chesterton and of twenty-four other writers. These are sleuths, who, when the authorities are baffled, step in with God's clear-sightedness and solve the crimes. This quotation is cited in the chapter on G. K. Chesterton's delightful sleuthing priest Father Brown (77–100).

2. Quoted in Wendy L. Munion, "Youth Pastors Taught to Use New Tool—Rock Music," *New England Church Life* (January 1985): 5.

3. Quoted in Steve Rabey, "Fast-Growing Gospel Music Now Outsells Jazz and Classical," *Christianity Today*, 16 March 1984, 42.

4. As music technology becomes more sophisticated with satellite speakers in 3-D multimedia systems merging audio and computers in digital synchronization, the power of music's language is further augmented. Even former critics recognize, respect, and requisition that power.

In the 1995 Russian elections, Prime Minister Viktor S. Chernomyrdin, who founded the Our Home Is Russia party as a base of support for President Boris N. Yeltsin, tapped into the image conveyed by North America's high-tech futuristic music by sponsoring rapper M. C. Hammer and promising Kool and the Gang, Gloria Gaynor, Donna Summer, and even Deep Purple bassist Glenn Hughes as part of his campaign strategy. The ploy worked. Nastya Durbazhova, an eighteen-year-old Interior Ministry worker who attended after receiving a free ticket from her employer, gushed: "We came because of Hammer. After such a concert, of course we'll vote for them." An eighty-five-year-old professor of history, Mikhail Andreichuk, agreed: "It was a wonderful concert. It was like a piece of America. . . . I will vote for Our Home Is Russia. This gave me the needed push" (Sophia Kishkovsky, *The Philadelphia Inquirer*, 17 November 1995, A25). Even mainland China has generated a swelling rock music industry, sporting such bands as Tang Dynasty, a mainland band whose videos are broadcast on Asian MTV. These bands follow in the wake of Cui Jian, China's first big rock star (see Robert Benjamin, "Rock's Beginning to Roll in China Provinces," *Star Ledger* [Newark, N.J.], 20 August 1993, 62). Contemporary music speaks a language to most youth and many adults across cultures and into ground sometimes otherwise hostile.

5. Mark Schwed, "The Politics of Hollywood," *TV Guide*, 22 August 1992, 28.

6. "Can Any Good Thing Come out of Hollywood? An Interview with Producer Ken Wales," *Christianity Today*, 21 September 1984, 19–25. During the course of this interview with *Christianity Today* editors, producer Wales revealed, "My hope for the last nine years and passionate burning desire is to see *Christy*, the book by Catherine Marshall, become film" (24). Ten years later Ken Wales fulfilled that desire, bringing the poignantly beautiful series *Christy* to television. "'Christy' has become my odyssey," he told interviewer Steve Moulton. "I am the steward. It is really all part of God's timetable." Having begun plugging for the production "almost to the day [star] Kellie Martin was born," Ken Wales and the crew he selected approached the making of the series as a ministry, looking for God's guidance through every step. The enthusiastic response proved to him, as it did to David Putnam, producer of *Chariots of Fire* (see Tom Minnery, "Chariots of Fire Hits the Heights," *Christianity Today*, 19 March 1982, 34–35), that viewers yearn "not just for traditional values, but for faith values. 'Christy' has shown that stories of faith can be winners" (Steve Moulton, "For Cast and Crew, 'Christy' Is a Mission, Not a Job," *The News of the Presbyterian Church [U.S.A.]*, October 1994, 6).

7. Susan Brill, "Martha's Angels: A Touch of the Divine in Prime Time," *Christianity Today*, 13 November 1995, 65.

8. "Saturday Guidelines: 'Touched by an Angel,'" *TV Guide*, 11–17 November 1995, 79.

9. John W. Kennedy, "Redeeming the Wasteland? Christian TV Increasingly Uses Entertainment to Spread Its Message," *Christianity Today,* 2 October 1995, 98.

10. Ibid., 94.

11. Edward Lewine, "Ready, Aim. No, Wait a Second. Hold That Gun Sideways," *New York Times,* 5 November 1995, 27.

12. We must remain vigilant to ensure that what we are telling is the old, old story of Jesus and his love. Popular mythologies can appeal to the sensibilities in ways that are similar to Christianity. The affinity between the popular arts and popular religion came home again, for example, in the seismic reaction to the death of Jerry Garcia, lead guitarist of the Grateful Dead. The Internet filled with messages posted by mourners, and radio station phone lines were jammed. Sociology professor Bernard Beck of Northwestern University in Chicago observed, "In a certain sense, Deadheads are fundamentalists—those who have kept up the old-time religion" (Mitchell Landsberg [Associated Press], "Are the '60s Dead Again?" *Beverly Times* [Mass.], 10 August 1995, A14). That the chemically oriented philosophy of social interaction the Grateful Dead represented is still potently active is everywhere evident. For the church to mistake the communal expressions of this aspect of popular culture for true relational Christianity can be devastating.

Further, even when no drugs are present, Christians have to be wary of the motivation of glitzy approaches to popularizing the faith. This is the lesson the Church of England discovered when it tried to stanch its outflow of three thousand worshipers per week by sponsoring a "Rave for Jesus" in Sheffield and subsequent imitations as far away as Glasgow. In between the clouds of billowing dry ice vapor, blaring rock music, projected computer graphics on video screens, and light shows, worshipers were being sexually molested while being fed a soufflé of New Age Christian syncretism. Church of England advisor Robert Warren pinpointed the problem, "NOS (the Nine O'Clock Services) had a fine vision which must not be lost. The problem was that [the Rev. Chris] Brain did not share the vision. He was using it to go on a power trip. We have to continue looking at ways in which the Christian faith can be expressed" (William Miller, "Church's Spellbinding Call to Youth Loses Magic," *Boston Globe,* 3 November 1995, 4).

On the other hand, to outlaw all "rave services" because of the shortcomings of this one would be equally detrimental. In May 1997 we attended a rave service in London that packed a large stone church with teenagers and filled them full of song, Scripture, visuals, and small group interaction on the topic of the Holy Spirit. They were blessed, and so were we, by sound orthodox teaching and worship conveyed within an exciting setting of contemporary electronic arts. The lights, jungle music, television monitors, all working together to supplement an entire picture of the Holy Spirit at work, spoke this message: the gospel of Jesus is alive and active now. It is as relevant in the present and will be as applicable to the future as it has been in the past.

13. For a complete study of the Lord's Prayer, see William David Spencer and Aída Besançon Spencer, *The Prayer Life of Jesus: Shout of Agony, Revelation of Love, a Commentary* (Lanham, Md.: University Press of America, 1990). This is a thorough study of Jesus' prayers, teachings on prayer, and practice of prayer. A practical

sequel to applying prayer can be found in Aída Besançon Spencer and William David Spencer, *Joy through the Night: Biblical Resources for Suffering People* (Downers Grove, Ill.: InterVarsity, 1994).

14. Paul Stookey quoted in UPI-San Francisco, "Folksingers Sing for All Generations," *Beverly Times* (Mass.), 3 September 1983, B10, col. 1.

Recommended Reading

General Introduction

Adams, Doug, and Diane Apostolos-Cappadona, eds. *Art as Religious Studies*. New York: Crossroad, 1987.

Aristotle. *The Poetics*. "Longinus." *On the Sublime*. Translated by W. Hamilton Fyfe. Loeb Classical Library. 2d ed. Cambridge: Harvard University, 1932.

Begbie, Jeremy. *Voicing Creation's Praise: Towards a Theology of the Arts*. Edinburgh: HarperCollins/ T. & T. Clark, 1991.

Gaebelein, Frank C. *The Christian, the Arts, and Truth: Regaining the Vision of Greatness*. Portland: Multnomah, 1985.

Harned, David Baily. *Theology and the Arts*. Philadelphia: Westminster, 1966.

Kilby, Clyde S. *Christianity and Aesthetics*. Chicago: InterVarsity, 1961.

L'Engle, Madeleine. *Walking on Water: Reflections on Faith and Art*. New York: Bantam, 1980.

Nathan, Walter L. *Art and the Message of the Church*. Westminster Studies in Christian Communication. Philadelphia: Westminster, 1961.

Newport, John P. *Christianity and Contemporary Art Forms*. Waco: Word, 1971.

Rookmaaker, H. R. *Art Needs No Justification*. Downers Grove, Ill.: InterVarsity, 1978.

———. *Modern Art and the Death of a Culture*. 2d ed. Downers Grove, Ill.: InterVarsity, 1973.

Ryken, Leland. *The Christian Imagination: Essays on Literature and the Arts*. Grand Rapids: Baker, 1981.

———. *The Liberated Imagination: Thinking Christianly about the Arts*. Wheaton: Harold Shaw, 1989.

Sayers, Dorothy. *The Mind of the Maker*. 3d ed. London: Religious Book Club, 1942.

Schaeffer, Franky. *Addicted to Mediocrity: Twentieth Century Christians and the Arts*. Westchester: Crossway, 1981.

Seerveld, Calvin. *Rainbows for the Fallen World: Aesthetic Life and Artistic Task*. Toronto: Tuppence, 1980.

Veith, Gene Edward. *State of the Arts: From Bezalel to Mapplethorpe*. Wheaton: Crossway, 1991.

Wilson, John. *One of the Richest Gifts: An Introductory Study of the Arts from a Christian World-view*. Edinburgh: Handsel, 1981.

Wolterstorff, Nicholas. *Art in Action: Toward a Christian Aesthetic*. Grand Rapids: Eerdmans, 1980.

The Arts and the Bible

Caird, George B. *The Language and Imagery of the Bible*. London: Duckworth, 1980.

Foxvog, D. A., and A. D. Kilmer. "Music." *The International Standard Bible Encyclopedia*. 1986 ed.

Parker, Margaret. *Unlocking the Power of God's Word*. Downers Grove, Ill.: InterVarsity, 1991.

Ryken, Leland. *Words of Delight: A Literary Introduction to the Bible*. 2d ed. Grand Rapids: Baker, 1992.

———, Tremper Longman, and James Wilhoit, eds. *Dictionary of Biblical Imagery*. Downers Grove, Ill.: InterVarsity, 1998.

Schaeffer, Francis A. *Art and the Bible: Two Essays*. Downers Grove, Ill.: InterVarsity, 1973.

Spencer, Aída Besançon. "God as a Symbolizing God: A Symbolic Hermeneutic." *Journal of the Evangelical Theological Society* 24 (December 1981): 323–31.

———. "Literary Criticism." *New Testament Criticism and Interpretation*. Edited by D. A. Black and D. S. Dockery. Grand Rapids: Zondervan, 1991.

———. *Paul's Literary Style: A Stylistic and Historical Comparison of II Corinthians 11:16–12:13, Romans 8:9–39, and Philippians 3:2–4:13*. An Evangelical Theological Society Monograph. Winona Lake: Eisenbrauns, 1984. Reprint, Lanham, Md.: University Press of America, 1998.

Veith, Gene Edward. *The Gift of Art: The Place of the Arts in Scripture*. Downers Grove, Ill.: InterVarsity, 1983.

Werner, E. "Musical Instruments." In *The Interpreter's Dictionary of the Bible*. New York: Abingdon Press, 1962.

The Arts and History

Dillenberger, Jane. *Style and Content in Christian Art*. New York: Crossroads, 1986.

Ferguson, George. *Signs and Symbols in Christian Art*. New York: Oxford University, 1954.

Halewood, William H. *Six Subjects of Reformation Art: A Preface to Rembrandt*. Toronto: University of Toronto, 1982.

Mâle, Emile. *The Gothic Image: Religious Art in France of the Thirteenth Century*. Translated by Dora Nussey. New York: Harper and Row, 1958.

Milburn, Robert. *Early Christian Art and Architecture*. Los Angeles: University of California, 1988.

Miles, Margaret R. *Image as Insight: Visual Understanding in Western Christianity and Secular Culture.* Boston: Beacon, 1985.

Ouspensky, Leonid, and Vladimir Lossky. *The Meaning of Icons.* Boston: Book and Art Shop, 1969.

Whittle, Donald. *Christianity and the Arts.* London: A. R. Mowbray, 1966.

Dance

Adams, Doug, and Diane Apostolos-Cappadona, eds. *Dance as Religious Studies.* New York: Crossroad, 1990.

Blom, Lynne Anne, and L. Tarin Chaplin. *The Intimate Act of Choreography.* Pittsburgh: University of Pittsburgh, 1982.

———. *The Moment of Movement: Dance Improvisation.* Pittsburgh: University of Pittsburgh, 1988.

Brown, Jean Morrison. *The Vision of Modern Dance.* Princeton: Princeton, 1979.

Davies, John Gordon. *Liturgical Dance: An Historical, Theological and Practical Handbook.* London: SCM, 1984.

Gagne, Ronald, Thomas Kane, and Robert VerEecke. *Introducing Dance in Christian Worship.* Washington: Pastoral, 1984.

Hawkins, Alma M. *Moving from Within: A New Method for Dance Making.* Pennington, N.J.: a capella books, 1991.

Humphrey, Doris. *The Art of Making Dances.* Edited by Barbara Pollack. New York: Grove, 1959.

Manor, Giora. *The Gospel according to Dance: Choreography and the Bible from Ballet to Modern by the Editors of Dance Magazine.* New York: St. Martin's, 1980.

Rock, Judith, and Norman Mealy. *Performer as Priest and Prophet: Restoring the Intuitive in Worship through Music and Dance.* San Francisco: Harper and Row, 1988.

Sachs, Curt. *World History of the Dance.* Translated by Bessie Schönberg. New York: W. W. Norton and Company, 1937.

Schroeder, Celeste Snowber. *Embodied Prayer: Harmonizing Body and Soul.* Liguori, Mo.: Triumph-Liguori, 1995.

Winton-Henry, Cynthia, and Phil Porter. *Body and Soul: Excursions in the Realm of Physicality and Spirituality.* Oakland, Calif.: Wing It! 1993.

Drama

Brook, Peter. *The Empty Space.* New York: Atheneum, 1968.

Buechner, Frederick. *Telling the Truth: The Gospel as Tragedy, Comedy, and Fairy Tale.* San Francisco: Harper and Row, 1977.

Corrigan, Robert W., ed. *The Making of Theater: From Drama to Performance.* Glenview, Ill.: Scott, Foresman, 1981.

Forde, Nigel. *Theatrecraft, Creativity and the Art of Drama.* Wheaton: Shaw, 1990.

Mamet, David. *Writing in Restaurants.* New York: Penguin Books, 1986.
Watts, Murray. *Christianity and the Theatre.* Edinburgh: Handsel, 1986.

Fiction

Cary, Norman Reed. *Christian Criticism in the Twentieth Century: Theological Approaches to Literature.* Port Washington, N.Y.: Kennikat, 1975.
Erickson, Joyce Quiring. "What Difference? The Theory and Practice of Feminist Criticism." *Christianity and Literature* XXXIII (Fall 1983): 65–74.
Lewis, C. S. *An Experiment in Criticism.* Cambridge: Cambridge University, 1961.
————, ed. *Essays Presented to Charles Williams.* Grand Rapids: Eerdmans, 1966.
O'Connor, Flannery. *Mystery and Manners.* Edited by Sally and Robert Fitzgerald. New York: Farrar, Straus & Giroux, 1969.
Ryken, Leland, ed. *Triumphs of the Imagination: Literature in Christian Perspective.* Downers Grove, Ill.: InterVarsity, 1979.
————. *Windows to the World: Literature in Christian Perspective.* Grand Rapids: Zondervan, 1985.
Scott, Nathan A., Jr., ed. *The New Orpheus: Essays toward a Christian Poetic.* New York: Sheed and Ward, 1964.
Spencer, William David. *Mysterium and Mystery: The Clerical Crime Novel.* Carbondale, Ill.: Southern Illinois University, 1989.
Tennyson, G. B., and Edward E. Ericson Jr., eds. *Religion and Modern Literature: Essays in Theory and Criticism.* Grand Rapids: Eerdmans, 1975.
Weil, Simone. "The Responsibility of Writers." "The Morality of Literature." *On Science, Necessity and the Love of God.* Oxford: Oxford University, 1968.

Movies and Other Media

Anker, Roy M., and Quentin J. Schultze, et. al. *Dancing in the Dark: Youth, Popular Culture, and the Electronic Media.* Grand Rapids: Eerdmans, 1991.
Beaver, Frank E. *On Film: A History of the Motion Picture.* New York: McGraw-Hill, 1983.
Cook, Coleen. *All That Glitters.* Chicago: Moody, 1992.
DeMoss, Robert G., Jr. *Learn to Discern.* Grand Rapids: Zondervan, 1992.
Giannetti, Louis. *Understanding Movies.* 3d ed. Englewood Cliffs, N.J.: Prentice-Hall, 1982.
Greeley, Andrew M. *God in Popular Culture.* Chicago: Thomas More, 1988.
Griffiths, Richard. *Art, Pornography and Human Value: A Christian Approach to Violence and Eroticism in the Media.* Grove Booklet on Ethics No. 7. Ottawa: Grove, 1975.
Jewett, Robert. *Saint Paul at the Movies: The Apostle's Dialogue with American Culture.* Louisville: Westminster/John Knox, 1993.
Kern, Mike. "Sleuthing the Silver Screen." *IVCF.* Spring 1992.
MacDonald, Alan. *Movies in Close-Up: Getting the Most from Film and Video.* Downers Grove, Ill.: InterVarsity, 1992.
Medved, Michael. *Hollywood vs. America.* New York: HarperCollins/Zondervan, 1992.

Schultze, Quentin. *Winning Your Kids Back from the Media*. Downers Grove, Ill.: Inter-Varsity, 1994.

Veerman, David. *Video Movies Worth Watching: A Guide for Teens*. Grand Rapids: Baker, 1992.

Music

Baker, Paul. *Why Should the Devil Have All the Good Music? Jesus Music—Where It Began, Where It Is, and Where It Is Going*. Waco: Word, 1979.

Collins, John. *West African Pop Roots*. Philadelphia: Temple, 1992.

Cone, James H. *The Spirituals and the Blues: An Interpretation*. New York: Seabury, 1972.

Copland, Aaron. *Music and Imagination*. The Charles Eliot Norton Lectures 1951–52. Cambridge: Harvard University, 1952.

Ewens, Graeme. *Africa O-ye!: A Celebration of African Music*. Middlesex, United Kingdom: Guiness, 1991.

Lawhead, Steve. *Rock Reconsidered: A Christian Looks at Contemporary Music*. Downers Grove, Ill.: InterVarsity, 1981.

Manuel, Peter. *Caribbean Currents: Caribbean Music from Rumba to Reggae*. Philadelphia: Temple, 1995.

Turner, Steve. *Hungry for Heaven: Rock 'n' Roll and the Search for Redemption*. Downers Grove, Ill.: InterVarsity, 1995.

Warrick, Mancel, Joan R. Hillsman, and Anthony Manno. *The Progress of Gospel Music: From Spirituals to Contemporary Gospel*. New York: Vantage, 1977.

Visual Art

Blom, Dorothea. *The Prophetic Element in Modern Art*. Pendle Hill Pamphlet 148. Wallingford, Pa.: Pendle Hill, 1966.

Caemmerer, Richard R., Jr. *Visual Art in the Life of the Church: Encouraging Creative Worship and Witness in the Congregation*. Minneapolis: Augsburg, 1983.

Dyrness, William A. *Rouault: A Vision of Suffering and Salvation*. Grand Rapids: Eerdmans, 1971.

Edwards, Betty. *Drawing on the Right Side of the Brain: A Course in Enhancing Creativity and Artistic Confidence*. 2d ed. Los Angeles: St. Martin's, 1989.

Goldstein, Nathan. *The Art of Responsive Drawing*. Englewood Cliffs, N.J.: Prentice-Hall, 1973.

Kessler, Charles S. *Max Beckmann's Triptychs*. Cambridge: Belknap, 1970.

Lehmann, Arno. *Christian Art in Africa and Asia*. Translated by Erich Hopka, Jalo E. Nopola, and Otto E. Sohn. St. Louis: Concordia, 1966.

Nicholaides, Kimon. *The Natural Way to Draw: A Working Plan for Art Study*. Boston: Houghton Mifflin, 1941.

Starkey, Mike. *Fashion and Style*. Crowborough: Monarch, 1995.

Takenaka, Masao. *Christian Art in Asia*. Kyoto, Japan: Kyo Bun Kwan, 1975.

Ministry through the Arts and to Artists

Adams, Doug. *Congregational Dancing in Christian Worship.* 2d ed. Austin: Sharing, 1984.

————, ed. *Dancing Christmas Carols.* Austin: Sharing, 1978.

Barnard, Floy Merwyn. *Drama in the Churches.* Nashville: Broadman, 1950.

Beall, Patricia. *The Folk Arts in God's Family.* Fisherfolk Resources for Worship, Teaching, and Festivity. London: Hodder and Stoughton, 1984.

Benton, Rita. *The Bible Play Workshop.* The Abingdon Religious Education Texts. New York: Abingdon, 1923.

Brandt, Alvin G. *Drama Handbook for Churches.* New York: Seabury, 1964.

Brown, David M. *Dramatic Narrative in Preaching.* More Effective Preaching Series. Valley Forge, Pa.: Judson, 1981.

Deitering, Carolyn. *Actions, Gestures and Bodily Attitudes.* Saratoga, Calif.: Resource, 1980.

————. *The Liturgy as Dance and the Liturgical Dancer.* New York: Crossroads, 1984.

Edland, Elisabeth. *Principles and Technique in Religious Dramatics.* Training Courses for Leadership. New York: Methodist Book Concern, 1926.

Fisher, Constance. *Dancing the Old Testament: Christian Celebrations of Israelite Heritage for Worship and Education.* Edited by D. Adams. Austin: Sharing, 1980.

Fisk, Margaret Palmer. *The Art of the Rhythmic Choir: Worship through Symbolic Movement.* New York: Harper, 1950.

Jones, Mary. *God's People on the Move: A Manual for Leading Congregations in Dance and Movement.* New South Wales, Australia: Christian Dance Fellowship of Australia, 1988.

Kelso, Andy. *Drama in Worship.* Grove Booklet on Ministry and Worship No. 35. Ottawa: Grove, 1975.

Litherland, Janet. *The Clown Ministry Handbook.* 3d ed. Colorado Springs: Meriwether, 1982.

Long, Anne. *Praise Him in the Dance.* London: Hodder and Stoughton, 1976.

Osgood, Phillips Endecott. *Old-Time Church Drama Adapted.* New York: Harper, 1928.

Robertson, Everett, ed. *The Ministry of Clowning.* Nashville: Broadman, 1983.

Schroeder, Celeste. *Rediscovering the Arts in Worship.* Calgary: Baptist Union of Western Canada, 1987.

Taylor, Margaret Fisk. *Dramatic Dance with Children in Education and Worship.* Edited by Doug Adams. North Aurora, Ill.: Sharing, 1977.

————. *A Time to Dance: Symbolic Movement in Worship.* Edited by Doug Adams. 2d ed. Austin: Sharing, 1980.

Toomey, Susie Kelly. *Mime Ministry.* Colorado Springs: Meriwether, 1986.

Walden, Carol, ed. *Called to Create: Christian Witness and the Arts.* San Jose: Resource, 1986.

Contributors

Bruce Whitney Herman, a painter living and working in Gloucester, Massachusetts, is chair of visual arts at Gordon College, where he teaches and directs the college's art gallery. Herman lectures widely on subjects related to modernist art and its implications for both the church and the culture at large.

Herman holds a B.F.A from Boston University, where he also received an M.F.A. in painting. He has received many awards, including the Smith-Wesson Award in Drawing from the Springfield (Mass.) Museum of Fine Arts, the Philip Guston Traveling Prize from Boston University, and exhibition prizes at public institutions.

Articles and reviews of Herman's work have appeared in *Image: A Journal of the Arts and Religion,* the *Boston Globe,* the *Washington Post,* and other publications. The book *Golgotha: The Passion in Word and Image* features the artist's work on the theme of Christ's suffering. His work has appeared in solo and group exhibitions in the United States and abroad and is represented in many private collections.

Norman M. Jones is a theater director, actor, writer, and teacher. He is chair of the theater department and associate professor of theater at Gordon College, where he has directed over twenty-four plays since 1985 and won the Junior Faculty Excellence in Teaching Award. He is also renowned in the region as artistic director of History Alive, whose play *Cry Innocent: The People versus Bridget Bishop* has been broadcast on BBC, CNN, Nickelodeon, National Public Radio, and viewed in performance by over 100,000 people. As an actor, he specializes in one-person performances of such characters as Nathaniel Hawthorne, and he has written a play, *Play of Light.* He has an M.A. in theater from SUNY Buffalo and a B.A. in English and music from Houghton College.

Richard Peace is Robert Boyd Munger professor of evangelism and spiritual formation at Fuller Theological Seminary. He is a graduate of Yale University (B.S.) and Fuller Theological Seminary (M.Div.) and holds a Ph.D. from the University of Natal (South Africa) in biblical studies. He has worked as a consultant in media production and education, has received several awards for his media productions, and has worked on films for BBC and PBS television stations.

Peace has nearly a hundred titles to his credit, including the widely used *Learning to Love* trilogy of Bible studies (InterVarsity), *Pilgrimage: A Handbook on Christian Growth* (Baker), and *Small Group Evangelism* (InterVarsity).

Celeste Snowber Schroeder is a dancer, writer, and educator who focuses her work in the area of spirituality and the body. She has choreographed and performed pieces in the context of Christian universities, seminaries, churches, and theaters in the United States and Canada. She periodically teaches on the faculty of interdisciplinary studies at Regent College and on the fine arts faculty at Trinity Western University, both in the greater Vancouver area of British Columbia. She is the author of *Embodied Prayer: Harmonizing Body and Soul* and *In the Womb of God: Creative Nurturing for the Soul*. She is completing her Ph.D. and has recently accepted an appointment to the faculty of education at Simon Fraser University.

Aída Besançon Spencer is professor of New Testament at Gordon-Conwell Theological Seminary. She has a Ph.D. in New Testament from Southern Baptist Theological Seminary and an M.Div. and a Th.M. from Princeton Theological Seminary. An ordained Presbyterian minister, Spencer is pastor of organization with the Pilgrim Church of Beverly.

Spencer has authored numerous books, including *Paul's Literary Style* and *Beyond the Curse: Women Called to Ministry* (Hendrickson). She has also coauthored or contributed chapters to a number of books, including *The Prayer Life of Jesus* (University Press of America), *The Goddess Revival* (Baker), and *The Global God* (Baker). She has published articles and reviews on literary studies, the New and Old Testaments, and the role of women in ministry.

William David Spencer is adjunct professor of theology at Gordon-Conwell Theological Seminary. He holds a Th.D. in theology and literature from Boston University School of Theology, an M.Div. and a Th.M. from Princeton Seminary, and a B.A. from Rutgers University. He is also pastor of encouragement at Pilgrim Church.

Spencer has published articles, stories, and poems in a variety of journals and periodicals. He has received several prizes, including the 1992 Earl Award of the Popular Culture Association for outstanding new scholarly paper, and among the books he has written or coauthored are *Mysterium*

and Mystery: The Clerical Crime Novel from 130 B.C. to the Present (Southern Illinois University), *Chanting Down Babylon* (Temple), *The Global God* (Baker), and *Joy through the Night: Biblical Resources for Suffering* (InterVarsity). The songs he has written have been sung all over the world.

Jasmin Sung's vision to integrate her profession and her desire to serve God led her to become a missionary with Emmanuel Gospel Center in Boston, where she is director of media ministry. She has an M.A. in mission and evangelism from Gordon-Conwell Theological Seminary and a bachelor's degree in mass communications with an emphasis in video production from Emerson College.

Gwenfair M. Walters is assistant professor of church history at Gordon-Conwell Theological Seminary. Walters holds a B.A. in English literature and art history from Wellesley College, an M.Div. *(summa cum laude)* in church history from Gordon-Conwell Theological Seminary, and a Ph.D. in ecclesiastical history from Cambridge University. A conference and retreat speaker, Walters is Director of Education for Media and the Arts at Gordon-Conwell. Her specialties in teaching are medieval and Reformation studies.

Subject Index

Absalom, 22
abstraction, 81, 160
Afro-Caribbean, 57–60, 178n10
Allen, Reginald, 58
Amerindians, 62–63
Aristotle, 31, 37, 41, 130
art(s): for art's sake, 135, 162–63; as communal, 20–21; church's use of, 153–69; defined, 17–18, 24, 26, 41; employment in, 9; evaluation of, 136, 152–54, 162, 189n12; examples of, 14, 19–22, 166, 168; functions of, 9, 19–20, 66, 162, 165; history of, 152–53; limitations of, 136, 160–61; as natural part of life, 13, 19, 26, 66; and teaching, 20–21, 163–64, 167. *See also* lingual arts, music, visual arts
artists, 76–77, 80, 82, 138, 147; development of, 74–75, 79–80, 85, 90, 94; downfall of, 75, 167–68; motivation of, 73, 78, 80, 160
*artuō,*17
Asaph, 19–20
atmosphere, 38–39
Auden, W. H., 35, 42
Austin, Ron, 147
avatars, 63

Baba, Meher, 76–80, 84–85, 90, 181n6
Bastien, David, 79
Batchler, Lee and Janet Scott, 147
Bathsheba, 22
Batman, 40
Bazilian, Eric, 62
Beastie Boys, 63
Beckmann, Max, 81–83
Bezalel, 20–21, 162
Bible. *See* Scripture
Black Sabbath, 61
Blake, William, 73
Brazil, 59
Brook, Peter, 131, 137
Buber, Martin, 80, 85–86
Buddhism, 64

Burroughs, Edgar Rice, 34, 41
Byrne, David, 59

cable, 148
Calvin, John, 105, 107
Carnaval, 59
catharsis, 130–31
Chapman, Lionel and Marilyn, 134
Chesterton, G. K., 32–33, 151
Christian artists. *See* artists
circumscribed, 104, 183n12
Clark, Claudelle, 66
Clement of Alexandria, 64–65
climax, 41
Clinton, Bill, 9, 157
Cocteau, Jean, 147
common grace, 12
consistency, 37
Constantine (Emperor), 99–100
Cooke, Sam, 50
Cooper, Alice, 61
Cowan, Tommy, 58
creation: as art, 17–18, 125; defined, 73; as good, 17, 132–33, 165; and image of God, 45–46, 151
criticism, Christian, 42
Cruz, Celia, 60
Cubans, 49, 59

dance, 165; defined, 19, 117, 122, 126; in Scripture, 19, 117–23
darkness, 23–26, 63, 74
David, 19–22, 26, 30, 36, 52, 55–57, 125, 151
Davis, Carlene, 58
Davis, G. H., 25
Deborah, 54, 57
DeMille, Cecil, 145–46
dénouement, 41
Descartes, 118
Disney, Walt, 73–75
Dobson, James, 168
Dodd, C. H., 33
Dominican Republic, 12, 163

Subject Index

Scripture Index

Genesis

1 22
1:1–27 27
1:2, 4–5, 7 17–18
1:9–12 18
1:20–21, 24 18
1:26–28 12, 18
1:31 132
2:15 18
2:21–25 27
4:21 19
4:23–24 50–51
5:1 18
11:1–9 75
15:1 23
19:1–26 42
27:28–29 51
31:27 51

Exodus

1:8–11 19
3:2–3 32
3:7 51
5:1–3 23
10:21–23 23–24
11:5 23
12:5, 12–13 25
15:1–21 19, 51–53,
 117, 120
20:4 108
25:18–20 20
28:2 21
31:3–6 20
32:4, 19 19
34:6–7 29
35:5, 21–22, 29,
 30–34 21
37:1 20
37:7–9, 17–22 109
38:22 20
39:24 109
39:32–38 21

Numbers

21:8–9 20
21:17–18, 27–30 54

Deuteronomy

4:15–24 23, 109,
 184n45
5:8 108
8:3 164
26:10 68
32:4 23
32:4, 8, 10–15,
 19–20, 46 54

Judges

5:1–2, 4–5, 9,
 11–13, 20 54
21:21 19

Ruth

4:22 36

1 Samuel

2:2–10 54
16:14–23 26

2 Samuel

6 125
12:1–13 22, 30
12:1–5 22
14:1–24 22, 45
20:14–22 45

1 Kings

4:32 56
6:23, 29 184n42
7:13–14, 19–20, 25,
 29 21, 184n42
8:10–11 184n42
18:26 185n12

2 Kings

17:22–23 36
22:2 36

1 Chronicles

16:1 55
16:8–42 19–20, 55
23:30 19
25:5–6 20

2 Chronicles

2:13–14 21
5:12–14 20–21, 55
6:41–42 55
8:14 20
29:26 20
35:15 20

Nehemiah

12:45–47 20, 52

Job

21:7–12 19
30:9 56
35:10 52
38–41 73
38:7 49–50

Psalms

8:5 132
19:1 18, 132, 151
27:4 21
29–30 52
30:11–12 120,
 171n5
31:9 119
37:27–28 55
38 53
40 53
45–50 52–53
63 53
63:1 119

69 52
69:12 56
72 56
73 52
75–80 52–53
80:1 23
84 52
84:2 119
86 53
89 52
90–100 52–53, 55
100:1 57
101:2 105
103 53
104 165
111 53
113–14 53
118 53
122 56
124 56
127 56
129 53
131 56
135 53
137 55
139 53
139:7 23
144:9 52
145 53
147 53
147:19 105
149–50 53

Proverbs

8:1–21 45
22:29 147
25:20 56

Ecclesiastes

2:24 156
3:11 131
7:5 52, 56

207

95185

Isaiah

5:1 19
24:9 56
26:1–21 55
30:8 105
30:29 171n5
40:11 100
40:18–19, 21–23
 109
42:10 52
44:9–20 23

Jeremiah

4:19 119
23:9 119
27:2 106
31:4, 13 19

Lamentations

1–4 55
2:11 119
3:14 56
5:15 171n5

Ezekiel

4:1 20

Jonah

4:9–11 167

Micah

6:8 156

Zechariah

13:7–9 55

Matthew

1:19–25 32
4:4 164

6:11–14 164
6:34 33
11:16–17 121
20:1–16 29
21:28–46 29, 33
25:31–46 164
26:17–30 167
27:51 25
27:54 24
28:19–20 159, 161

Mark

11:9–10 55
13:5–6 78
13:21–23 79
15:39 24

Luke

1:46–55 55
1:69 55
2:7 32
2:14 55
4:18 33
7:31–32 57, 121
8:5–8 156
8:10 22
12:16–34 22
15:11–32 123
19:38 55
19:40 167
20:3–4 22
20:9–18 22, 43
23:44–48 24
23:54 25

John

1:3 25
1:9 181n32
1:14 121
4:21, 24 23

6:35 23
8:12 23
10:7–8, 1, 14 23,
 78, 100
11:25 23
13:35 35
14:6 78
14:9 111
15:1 23
17:6–19 164, 167
21:15–17 164

Acts

1–28 21
1:8 144
16:25–34 20, 156
17:24–29 23, 110,
 132

Romans

1:18–20 18, 45,
 132, 151
1:21–25 110
7:15 132
8:22 132

1 Corinthians

5:7 25
8:14 106
13:12 11

2 Corinthians

4:4 111
9:7 21

Ephesians

5:19 56

Philippians

2:6–8 23
4:8–9 36–37, 162

Colossians

1:15 111
3:16 56

1 Timothy

3:1–13 168
4:4 17

Hebrews

10:1–18 60,
 179n12
11:16 72

James

3:13–18 75
5:13 55

1 Peter

2:5, 9 20

3 John

11 55

Revelation

4:8, 11 56
5:9–10, 12–13 56
7:12 56
15:3–4 56
18 56
18:22 57
19:1 56
21:2, 11, 18–21 21

208